FLOWER PAINTING

PAUL RILEY

FLOWER
PAINTING

How to paint free and vibrant watercolours

BROADCAST BOOKS

British Library Cataloguing in Publication Data
Riley, Paul
 How to paint free and vibrant watercolours
 1. Watercolour paintings
 I. Title
 751.422

 ISBN 1–85404–001–4

Published by Broadcast Books
The Old School House
The Courtyard
Bell Street
Shaftesbury
Dorset SP7 8BP

First impression 1990
Copyright © 1990 Paul Riley

Typeset by Editorial Enterprises, Torquay
Printed in Hong Kong

To Tina – Ja tě miluju

CONTENTS

INTRODUCTION

On seeing yet another book on painting flowers you may be forgiven for thinking that you will be confronted by the standard format for the successful completion of a flower painting. Placing a bunch of flowers in a vase, then taking up brush and paint in the fond hope that a tastefully produced picture will result simply by employing step-by-step procedures is more likely to end in a stereotype of a flower picture. In short, the kind of painting frequently found in galleries and shops everywhere. My twenty years experience in teaching students of all ages has enabled me to develop an approach which frees the novice from the constrictions so often imposed by tutors.

What this book is going to do is offer the reader an entirely new way of both seeing and painting flowers in all their variety, complexity and delight. To do this I shall be adopting a somewhat different formula to the usual by placing the emphasis on research and investigation, planning and preparation so that your whole understanding of what excitement can be obtained from painting flowers can be enhanced.

Flowers are about colour in all its vividness and clarity. I shall try to explain what that means both technically with respect to materials and tools and also how we respond sensually with our eyes and with our emotions.

Throughout the book emphasis is laid on colour. The reason is that for me the business of painting flowers is synonymous with colour. Without the understanding of how colour works, and how it feels, you cannot but produce a parody which lacks freshness and spontaneity. So what we will be doing is looking at colour as related to flowers, and investigating it in all its aspects including how to put that intensity of colour down with the appropriate tools so as to lose none of the freshness that emanates from nature.

Each chapter will show both 'what to look for' as well as 'how to do it'. So often I have found students who have wanted to gain a more open, free expression in their work but who have spent far too little time on simply looking and contemplating their subject matter.

This book attempts to set out a method whereby that 'looking process' can be analysed to the point that when you take up your brush all the information is there and confident work will result.

CHAPTER 1

MASTERCLASS

One of the most fascinating things about flowers is their huge variety both in form and colour. You only have to pick up a seed catalogue or botanical treatise to see the incredible variety. Nature seems to enjoy an almost unlimited palette when it comes to painting our countryside, gardens and even our homes.

It is this unlimited palette that confounds many a painter who is trying to come to terms with it and impose some kind of 'control' over the 'chaos' in nature. Flower painting has fascinated painters for centuries. There are many examples from both Eastern and Western cultures where the richness of flower form has served to decorate every conceivable surface from walls to pots and books to clothing.

We should always take the opportunity to learn from others especially the past masters.

Past Masters

Our artistic heritage is a huge source of inspiration to plunder at will; endless avenues to explore, none of them cul-de-sacs. It amazes me that artists complain that there is 'nothing new, that it has all been done before'. For me the artists of the past gave us tantalising glimpses of what was possible and even after their exhaustive efforts massive areas of unexplored territory still lie undiscovered. Take, for example, Monet's enormous study of his lily pond at Giverny. Although I had seen a very large representation of his works devoted to this subject, when I went to Giverny recently to see the magnificent restoration I was immediately gripped by the possibilities offered without necessarily plagiarizing Monet.

When I set up a group, selecting flowers and organising their colours, shapes and masses, niggling at the back of my mind are flashes of images I have seen from these past masters. I use the word 'masters' loosely because some of the images may come from quite primitive or naive sources – no less exciting for that. My mood can be such that I might be looking for something that has the formality and dignity of a 'Dutch' oil. Another day I am searching for the classic simplicity of a Chinese-brush painting, or needing the intense concentration to produce the exquisite detail of an Indian botanical study. All these are my inspirational sources. I can spend a considerable part of my day poring over books of works by Persian miniaturists and Abyssinian sculptors, or visiting exhibitions of the works of Japanese screen painters or Renaissance costume designers.

Quite often it is not only the flower portraits themselves that are inspirational but also the setting which compliments them; for example the water in Monet's 'Water lilies', or the interiors of Dutch genre painting. Try mixing flowers with fruit or vegetables which may compliment both their forms and their colours. Flowers in portraiture is another common device which gives endless possibilities and is typical of works by Renoir, Klimt and Odilon Redon.

Naturally, all these sources have to be seen in terms of watercolour painting where the sheer transparency and delicacy of the medium has a versatility of its own.

Water lilies (Les Nympheas)
Claude Monet 1840-1926
Although this is an oil painting its feel is very definitely that of a watercolour. The colours are diffuse, the forms are very delicately drawn. Monet has achieved a lightness of touch and a quality in the painting rather akin to the way of watercolour when it has been worked in the wet state. Its inspiration to the watercolourist is related to the speed of his touch together with the control in colour.

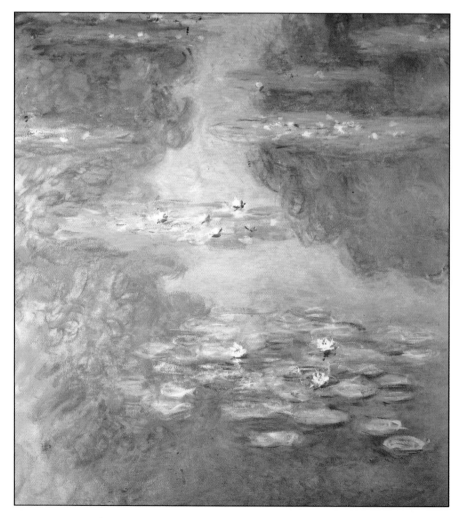

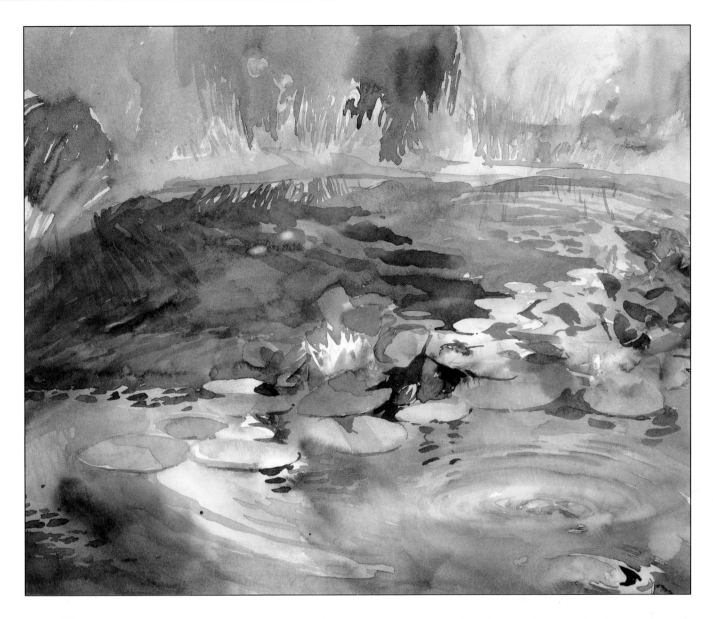

Water lilies
This painting was the result of a visit to a friend's pond when the water lilies were just coming into bloom. My interest in it was subliminally influenced by what I knew of Monet's explorations but was wholly conceived in a watercolourist's manner. The initial stages in its development were very much concerned with the soft blending of wet-into-wet. I then picked out the delicacy of the lilies themselves with crisp, dark tones in order to emphasise their fragility.

Nearly all the Eastern paintings and early botanical studies were done in watercolour and many of the studies painted in egg tempera and oils were meant to simulate the delicacy and detail of watercolours. Some of my own work has taken the whole notion full circle in following the staccato and pointillist brushwork of the oil paintings by Monet, Vuillard and Van Gogh, although you perhaps might not notice it!

The interesting quality of watercolour is that it can vary between quite dense, saturated colour and delicate veils of colour. Saturated colour was used by the Indian and Persian painters and also by Western monks who embellished

their religious books with rich detailed motifs. Delicate veils of colour were used by Chinese and Japanese poet-painters, and even Cézanne produced studies which delicately hinted at rhythm of form in flowers and leaves.

If you study the techniques used by the early painters you will see that they tend to fall into two broad categories, both of which I use. The first involves the use of line drawing which can be either monochrome or coloured and tinted with whatever colour necessary to give the flower or plant its identity. This was fairly typical of the pen and wash studies by the Renaissance artists. Leonardo de Vinci used the sinuous quality of

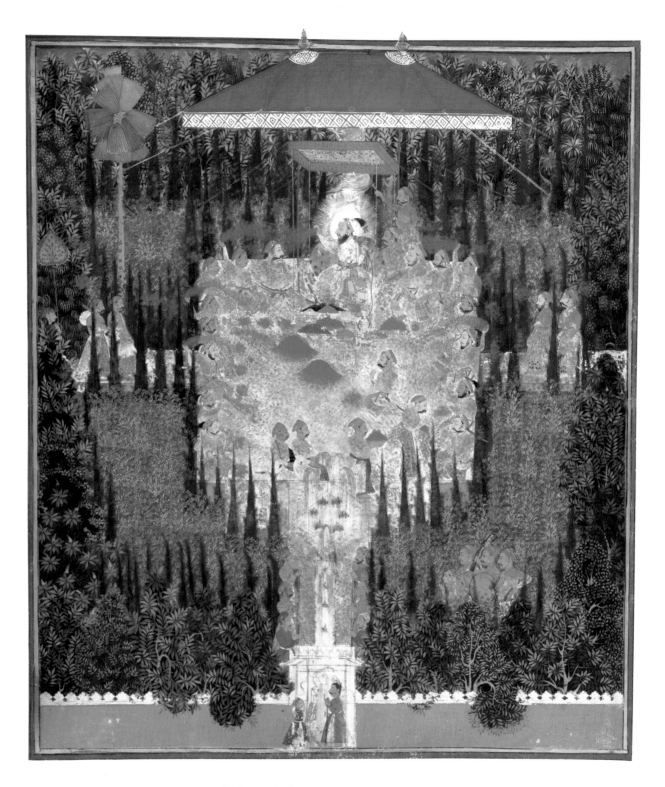

Indian painting
Maharan Amar Singh celebrating Holi in a Garden, Voliapur, c. 1709-10. Anon
This is typical of the intensity of Indian and Persian painting. It is characterised by very strong, detailed work with an awareness of pattern. There is a singular concentration of pink against quite dark greens which gives a glowing colour contrast. Although the subject matter is oriented around a human event, it is a celebration of the garden philosophy. This painting demonstrates that forms can be intensely observed without losing their pattern-making possibilities.

Daffodils (detail)
This painting follows a very conventional way of watercolour painting, where the lightest tones are laid down first. The subsequent tones of colour are laid separately, layer by layer, until an intensity of detail has been reached. You will see that on the left a silhouette in white shows how the contrasting tones can be used to delineate form. This is a form of negative painting which describes how the lightest tone in the subject matter can be delineated. This painting uses no white paint at all and uses only the whiteness of the paper to describe the forms. The Persians and Indians used very crisp edged detail in order to delineate their inspired forms.

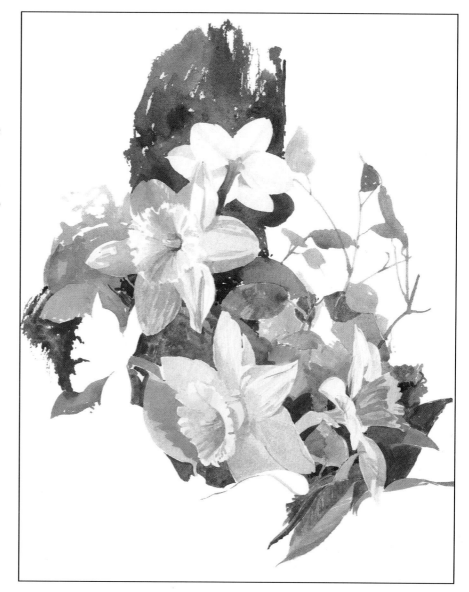

line to express movement and rhythms which he found echoed those of water and clouds. The great Albrecht Dürer made marvellous studies of clumps of earth teeming with grasses, leaves, flowers and roots. In these he displayed his gargantuan talent for line not only in his watercolour studies but also in his woodcuts. The intensity in his detailed analysis of the way plants grow displays a similar interest to Leonardo in the rhythms of nature and the fascination with texture.

Early 17th and 18th century botanical studies used similar techniques of line and wash to detail accurately the nature of plants collected during extensive expeditions throughout the world. Some of these studies appear like exotic collages with snippets of information delicately coloured and dotted over the surface of the paper.

The second category of techniques used a system of building up a picture from light tones through to dark tones. This system varied. One way was to apply pure watercolour where the tones were built up using transparent overlays of successive washes to produce the detailed finish. Highlights had to be left untouched, using only the white paper. Most often the artist used a pale, local colour and then softly blended in the tonal changes using either greys, browns or black. In the case of the bright colours, tonal variety was mainly achieved by simply increasing the pigment content and reducing the amount of water. Great draughtmanship was exercised and accuracy rarely gave way to artistic expression. The exceptions were the Eastern masters, who had different objectives, often associated with poetry or literature. Interestingly, both approaches were, in their way, illustrative.

The other system involved the use of a mixture of both watercolour and body colour. Body colour is simply watercolour (pigment, water and gum arabic) mixed with precipitated chalk to make the colour opaque. This enables the artist to overlay

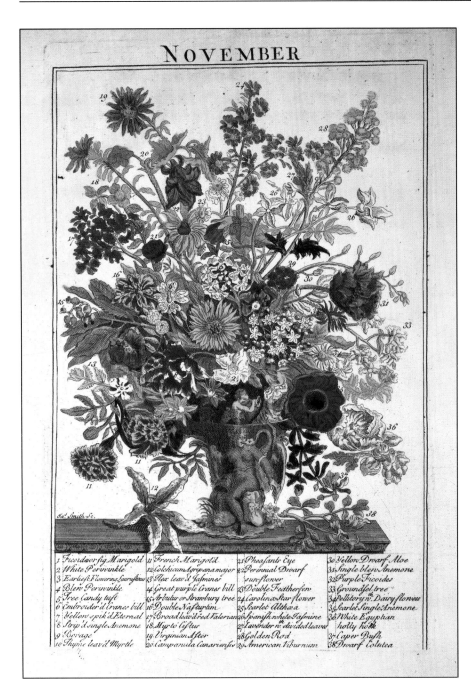

NOVEMBER

1 *Ficoidior fig Marigold*
2 *White Periwinkle*
3 *Earliest Flowering Lauruftinus*
4 *Blew Periwinkle*
5 *Tree Candy tuft*
6 *Embroider'd Cranes bill*
7 *Yellow spik'd Eternal*
8 *Strip'd single Anemone*
9 *Borrage*
10 *Thyme leav'd Myrtle*

11 *French Marigold*
12 *Colchicum Agrippanamajor*
13 *Ilex leav'd Jasmine*
14 *Great purple Cranes bill*
15 *Arbutus or Strawbury tree*
16 *Double Nafturtium*
17 *Broad leav'd red Valerian*
18 *Myrto Ciftus*
19 *Virginian After*
20 *Campanula Canariensis*

21 *Pheasants Eye*
22 *Perennial Dwarf sunflower*
23 *Double Featherfew*
24 *Carolina Star flower*
25 *Scarlet Althea*
26 *Spanish white Jasmine*
27 *Lavender w. divided leaves*
28 *Golden Rod*
29 *American Viburnum*

30 *Yellow Dwarf Aloe*
31 *Single blew Anemone*
32 *Purple Ficoides*
33 *Groundfel tree*
34 *Pellitory w. Daisy flowers*
35 *Scarlet Single Anemone*
36 *White Egyptian holly hock*
37 *Caper Bush*
38 *Dwarf Colutea*

Ja.ᵗ Smith Sc.

November

(from Flower Garden Displayed)
Robert Furber c.1732
This delightful study is typical of its period and shows a natural use of penmanship together with delicate colour tinting. You will see that the colours are purely descriptive and at no stage attempt to give any indication of depth or atmospheric changes. Although essentially a botanical study there is still a natural feeling of spontaneity and the artist's sheer delight in the subject matter. The penmanship owes much to early Renaissance theories of tonal gradation in the use of cross-hatching and stippling to indicate texture.

tones one over the other with highlights or light tones being added last.

Surface textures could be achieved by stippling or hatching in a very delicate manner. Persians and Indians were great masters of this technique, which brought about a jewel-like quality to their work. Often they included gold leaf to add sparkle and a certain preciousness to the finish. In examining the composition of these paintings one is struck by the complex pattern-like quality where every incident and item is clearly delineated and intensely coloured. There is very little incidence of overlapping so that the subject matter climbs up the surface of the paper in a joyous tapestry of vivid reds, blues, greens and golds, often bordered by yet more flowers painted in formal patterns.

Up until the time of Turner, who was painting in the 1840's, most artists were restricting their colour to tints to achieve tonal variation. However, theories were being developed to change our perception of colour in a quite revolutionary way. Goethe wrote *Zur Farbenlehre* in which he expounded a colour theory which was to inspire generations of painters. The notion that colour had mood and could be manipulated in the same way as form, resulted in all kinds of experiments in both the handling of paint and the use of colour. In the case of flower painting, with its abundant supply of colour variations, all kinds of opportunities were available to try out the new theories.

Impressionism was born and liberated a whole new view of the world, something which is familiar now but must have been wildly exciting for those who had been battling with paint.

The 'Moderns' are a constant source of inspiration – especially artists such as Monet, Bonnard, Van Gogh, Vuillard, Klimt, Odilon Redon, Gauguin, Renoir, and Charles Rennie Mackintosh. All these painters have opened our eyes to extraordinary colour combinations and methods of handling paint.

Two significant events occurred which radically altered their outlook on composition and, more particularly, their painting objectives.

Firstly, photography practically overnight revolutionised previous concepts of how things looked. For example, it was at last possible to freeze in motion the flight of birds and the movement of animals and man. Whole notions of perspective could be analysed and readjusted. Candid shots of people at play and relaxing in their home showed unusual relationships of tone, texture and, because of the 'freezing' element, gesture.

In the case of flowers whole gardens were photographed and studies made to note the endless depths and details that are not apparent when nature is seen as a mass. Gone was the necessity for endless detailed analyses of how things actually looked, although in some instances this was not necessarily a good thing. Artists, who always have an inquiring minds, seized this new tool as though it were a brush and exploited it.

At first, interestingly enough, some photographers attempted to ape paintings of the 'salon' variety and frankly fell far short of what was expected. But soon painters themselves took hold of these instruments and the far-sighted among them used the camera as a kind of sketch book. They recorded those fleeting moments which they could ponder at their leisure and then, most importantly, adapted them to suit their current thinking. The camera liberated the artists from the need to record in full

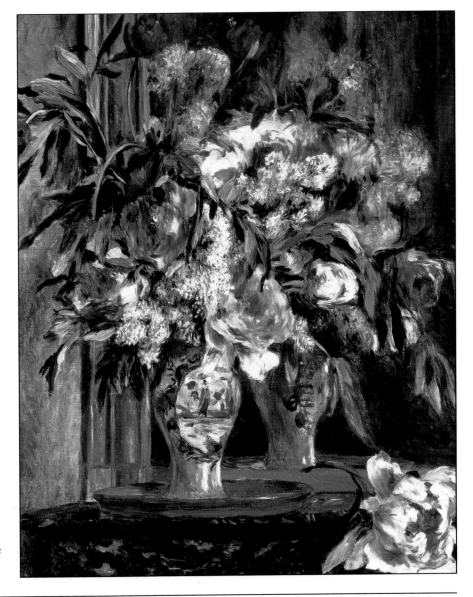

Vase de Fleurs
Pierre Auguste Renoir 1841-1919
Renoir had a passion for flower painting. He started life as a decorator of porcelain, which enabled him to understand the delicate nature of pigments. This painting is a celebration of his ability to adjust colours to accurately reflect the passion he had for flower studies. Note the soft liquidity of the shapes and merging of the colours.

Chrysanthemums

I very rarely paint a simple vase of flowers. In this case I was tempted by the fact that, firstly, I had made the vase myself and, secondly that I wanted to aim for the blaze of colour and simplicity of shape that so stimulated Renoir in his work. When attempting a simple study of this kind more interest is created if the flowers are not placed symmetrically in the vase but if they intersect the sides of the painting in an asymmetrical way. I have used quite a neutral backgound tone in order to emphasize the primary colours of the flowers themselves. The thing to try for is the warmth of character that a bouquet of this kind can evoke.

detail the world about them, enabling the senses to delve deeper into the mysteries of colour and form.

This resulted in a great depth of exploration, particularly of the mind. Artists began to concentrate much more deeply on their motives for painting. The arts of poetry and philosophy, together with the emerging science of psychiatry, were avidly read to give an extra dimension to work which had hitherto been more a public tool for

record purposes only. Photography was able to open up the visible world whilst freeing the artist to look inwardly.

One aspect of the camera's technical features that, for example, Monet was able to exploit was the fact that the lens could be set out of focus to produce a blurred image. This enabled Monet to look at soft focus qualities and these subsequently permeated much of his work, particularly the great series *'Nympheas'* (Water lilies.)

Early cameras relied greatly on time exposures. They used large lenses and large format plates which gave a great depth of field and resulted in great detail, even in the distance. Monet's work shows how, in order to emulate this myriad of detail, he utilised tiny, flick-like brush strokes over criss-crosses of interrelated colour. It is interesting that although everyone was perfectly aware that Monet took photographs he did not like people to think he painted from them. The

reason was that he was considered a *plein air* painter and should, therefore, have no need to refer to photographs. The fact was that good weather, and time, being in short supply he had to retouch extensively in his studio. This is where the photographs played their part, but in no way could one accuse Monet of copying them. As many painters found out, they could be an *'aide memoire'* and, dare they admit it, a source of inspiration.

The other great event which was to radically alter modern thinking was the fact that Perry, an American, opened the gates to a hitherto closed society – Japan. In so doing he released a flood of extraordinary images that shook the intelligentsia of the western world.

Painters were particularly affected by 'view point' (what the artist selected to 'see') and how they organised space. All kinds of images arrived; woodcuts using watercolour instead of oil based ink; watercolours; screens painted on gold leaf; fabrics; costumes; ceramics. Flowers, which formed a central part of Japanese culture, permeated throughout. All of these artifacts were avidly collected and exhaustively studied. Van Gogh copied dynamic woodcuts into oils. Gauguin used the vivid gold back drops to give vibrance to his Tahitian paintings. Whistler even got into trouble for simplifying a painting of

Chelsea bridge in which he emulated the classic simplicity of Japanese composition. The Nabis, Vuillard and Bonnard, used large areas of pattern, which was typical of Japanese composition. Monet had a large collection of prints which he hung throughout his house to stimulate and excite his imagination. The reason that these prints and paintings were so exciting was that they were so wholly different from anything that western artists were producing.

For far too long the Establishment had been churning out the formulas that had been originated during the Renaissance. They had become tired and lacked the power which Michelangelo and Titian had invested in them. Paintings were even artificially aged to attract a public whose taste had atrophied to the point where modern, original work had no place in their vocabulary. It is not surprising, therefore, that when the more enlightened of the painters began to experiment with some of the devices demonstrated by the Masters like Hirohige, Hokusai, Wakai and Utamaro, the viewing public were shocked into ridiculing these efforts.

Artists were simplifying colour and using strong primaries in close juxtaposition. They also used unrelieved areas of paint which simulated the flat areas produced in Japanese woodcuts. Flowers gave ample opportunity for this

approach, something which Van Gogh exploited to the full. The irony is that today considerable sums have been spent by the Japanese in purchasing these masterpieces.

It took the public a long time to absorb these revolutionary changes. Fortunately this did not deter the more adventurous painters, who developed their vision in complex and sophisticated ways using a palette that had been liberated from the 'treacle' and 'tea' of the past.

The lessons for us, the aspiring and ever hopeful, are all beautifully laid out by these enquiring minds of the past. How do we assimilate them? What are the procedures for putting into practice all the nuances that this kaleidoscopic, historic tapestry offers us? The principle object of this lesson is to be inspired and not overawed by the contributions of the past.

Copying paintings or drawings is one sure way of coming to grips with all sorts of problems, such as the quality of line used by Leonardo de Vinci. Do not worry unduly if somehow your efforts fall short of the spontaneity of the master – considering how long he spent perfecting it! It is the journey of discovery that matters, not necessarily the end result. Copying teaches you to strive for those delicate colour variations as seen in a Monet, or the dextrous brush strokes of a Chinese watercolourist. Copying on the basis of a

Oriental painted scroll
The art of the oriental painters was their ability to state forms very simply. Here delicate washes express leaf shapes and very simple line work indicates veining. Petals are faithfully recorded using simple brush gestures. Much can be learned from their breadth of handling and acute observation.

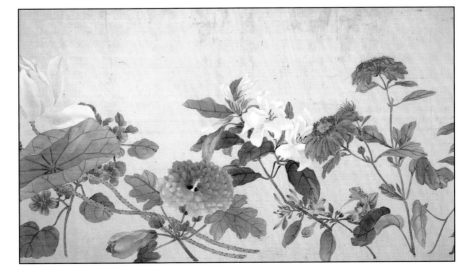

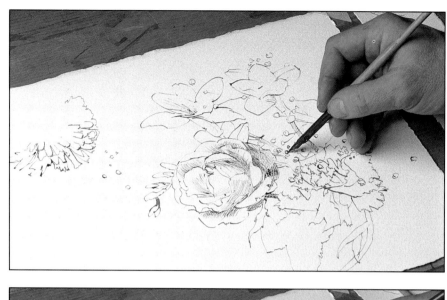

Pen and wash drawing

1 I am using a steel pen on a Not surface paper in a similar way to the style of the early botanical illustrators. Firstly I use brisk strokes to outline the basic forms and then I develop them with cross-hatching to give form to the flowers. I pick out small marks and gestures to exaggerate the large forms of the rose and the carnation. In order to give the line variety in thickness pressure must be applied occasionally.

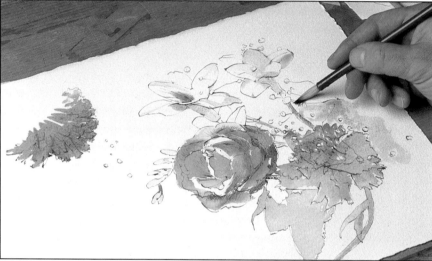

2 I am now using watercolour to lightly tint the various components of the study. For stalks I use light-green. Background areas will be in a blue-grey. The carnation is simply a mottled orange, using cadmium yellow and cadmium red. For the rose I have chosen a rose madder light tint as the early botanical illustrators would have used. For white flowers a grey can be easily obtained by using a mixture of cobalt blue and alizarin in equal amounts. The strength is adjusted to give tonal variations.

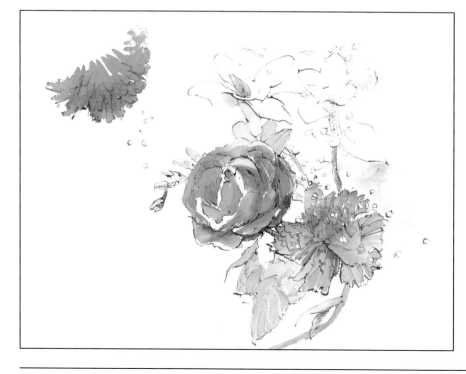

3 This demonstration shows how free botanical studies in pen and watercolour wash can open up possibilities and ways of looking at flowers. The important thing to remember is that the whole study rests on the strength of the linework. The ink should not be water-soluble, otherwise when the wash is applied the ink line will disappear or fade. The watercolour washes should be delicate and simply be an adjunct, but should also indicate the local colour of the flowers. Studies of this kind should be rapid and spontaneous. If laboured too much they start to look wooden.

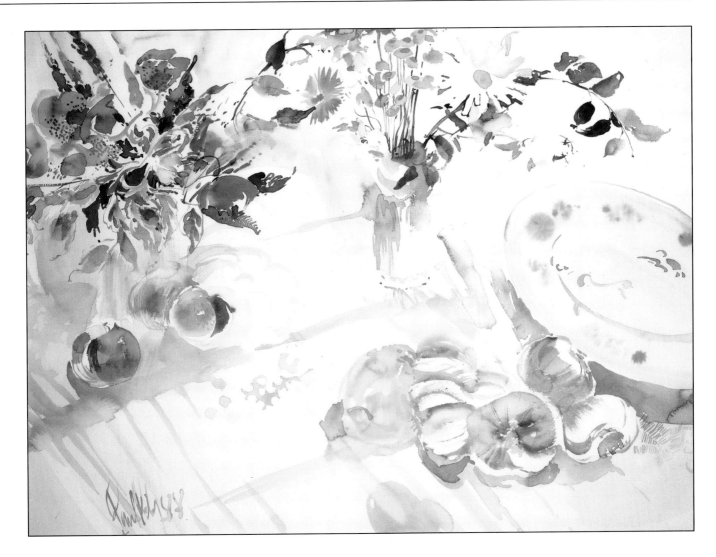

Flowers and garlic

In this painting I was very conscious of the standards set by the oriental painters. I have used very basic brush strokes in order to describe as simply as possible the flower shapes. Leaves have been lightly drawn with simple infill to suggest the leaf forms. The composition is laid out to leave as much of the white paper as possible and give emphasis to the sparkling nature of the flower colours. I have tried to indicate more of what is not stated than that which is. This enables the viewer to 'fill in' and exercise his or her imagination.

line by line procedure or trying to obtain an exact likeness is not the prime objective. It is entering into the spirit of the work.

Firstly, try analysing the purely technical aspects. Namely, how concentrated or diluted is the pigment, or when to incorporate detail as opposed to 'quiet' areas. These will be aspects I shall explain in subsequent chapters but it is as well to note from the Masters how they tackled these eternal problems. I always take the opportunity, whenever possible, to look at originals. Firstly I like to see exactly what type of materials have been used, then to note the actual finish of the surface colour, and more importantly, its intensity.

As a change from copying, try to set up compositions in the manner of various painters. Analyse their sim-

plicity and how colours have been harmonised. You can approach painting these compositions in the manner of the painter of your choice, or even experiment using procedures from another era or culture.

The phenomonal splendour of flowers has stimulated the imagination of generations of painters. Our investigation of how they captured the illusive nature of plants although fascinating and undoubtedly of enormous value is no substitute for the real thing. Observation of Nature is the only answer. 'An artist under pain of oblivion must have confidence in himself, and listen only to his real master: Nature', wrote Renoir who, like his fellow Impressionists, knew the value of coming face to face with the subject to carefully scrutinise its every nuance.

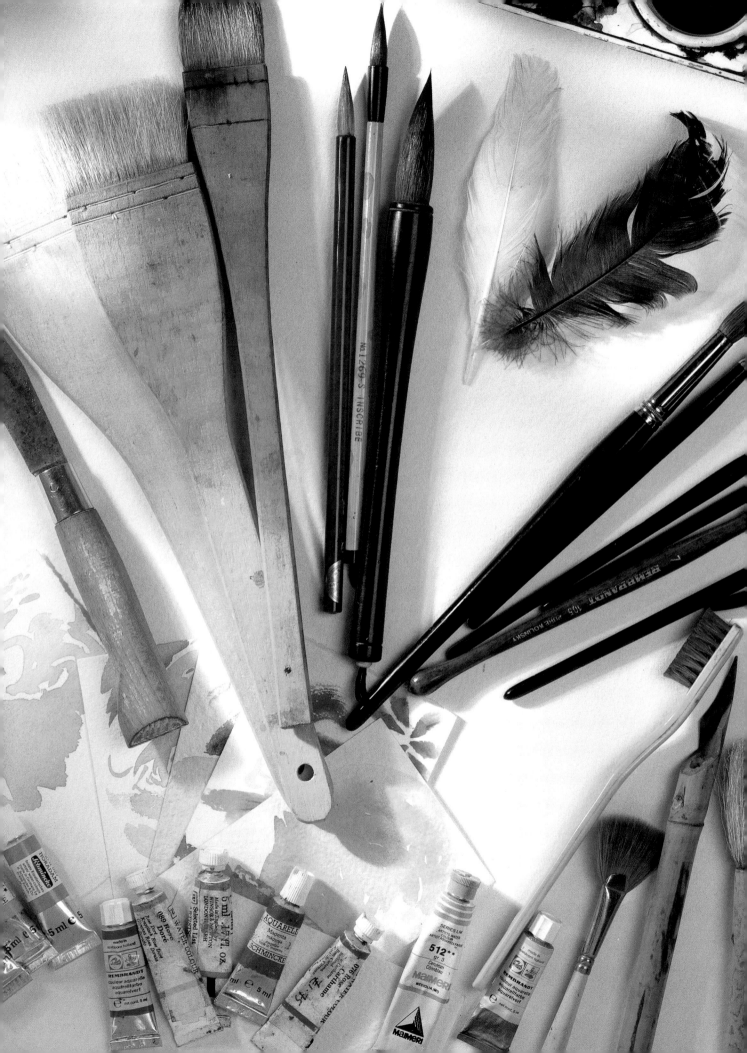

CHAPTER 2

MATERIALS

To keep your colours fresh and lively you must use high quality pigments because flowers themselves have colours of such intensity.

You must also choose your brushes carefully. When painting, the whole focus of your attention should be on the tip of your brush. The tip is the means by which you express the culmination of all your thoughts and research. Do not treat your brush as some kind of pencil, or pen, with a grip so rigid that it allows no delicate brush marks to be made. The handling of the brush forms your 'signature', and every slight nuance of personal feeling and thought is immediately transmitted to the paper. Everybody has their touch, be it bold, delicate, tentative or detailed. This profusion of styles is what makes looking at painting both fascinating and rewarding.

The colour palette

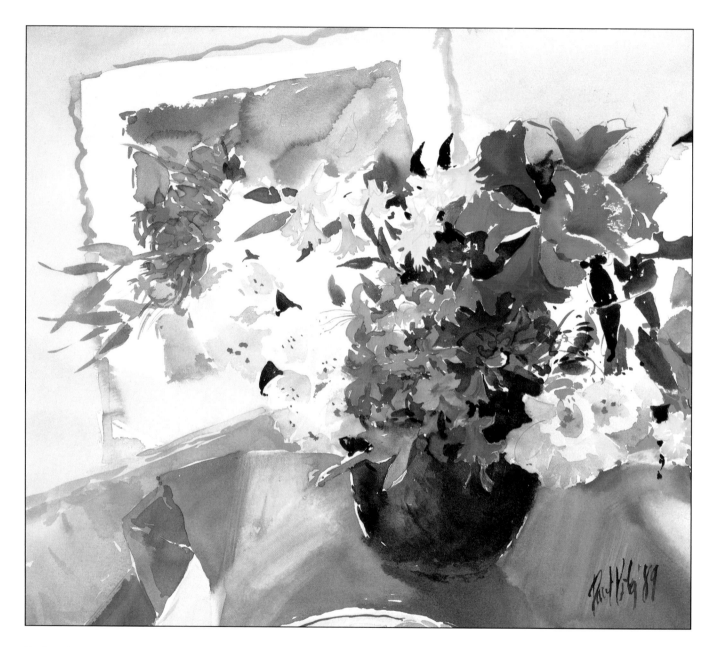

Red azaleas on a blue cloth
I have used primary colours with greys and near blacks. The near blacks are obtained by mixing contrasting reds and blues. The darkest black is obtained by mixing alizarin crimson with ultramarine blue in equal amounts.

For the greys I used a cobalt blue with alizarin (well diluted) plus a small touch of lemon yellow.

All artists have a little of the scientist in them. This is due to the fact that the artist, like the scientist, is always investigating, experimenting and developing on the basis of increased knowledge. The understanding of how pigments are arrived at and how they are converted into watercolours may be a little technical but some back-

ground knowledge does give an insight into what will or will not work when trying to obtain that illusive colour.

One of the biggest mistakes I have seen students make is to say, 'Oh, I'm only starting, any old paint will do!' Fine, but you will end up with 'any old painting'.

Broadly speaking, watercolour is

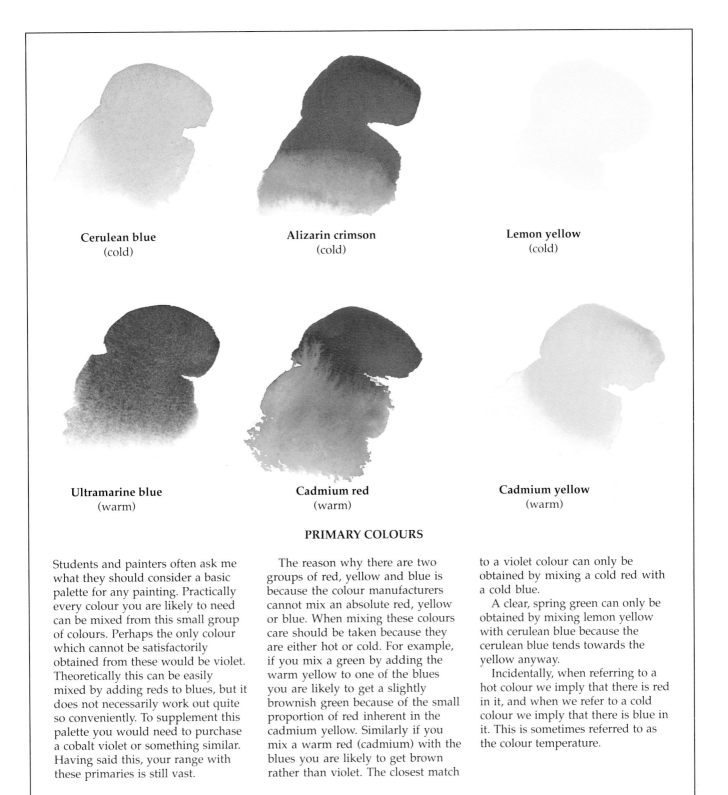

Cerulean blue
(cold)

Alizarin crimson
(cold)

Lemon yellow
(cold)

Ultramarine blue
(warm)

Cadmium red
(warm)

Cadmium yellow
(warm)

PRIMARY COLOURS

Students and painters often ask me what they should consider a basic palette for any painting. Practically every colour you are likely to need can be mixed from this small group of colours. Perhaps the only colour which cannot be satisfactorily obtained from these would be violet. Theoretically this can be easily mixed by adding reds to blues, but it does not necessarily work out quite so conveniently. To supplement this palette you would need to purchase a cobalt violet or something similar. Having said this, your range with these primaries is still vast.

The reason why there are two groups of red, yellow and blue is because the colour manufacturers cannot mix an absolute red, yellow or blue. When mixing these colours care should be taken because they are either hot or cold. For example, if you mix a green by adding the warm yellow to one of the blues you are likely to get a slightly brownish green because of the small proportion of red inherent in the cadmium yellow. Similarly if you mix a warm red (cadmium) with the blues you are likely to get brown rather than violet. The closest match

to a violet colour can only be obtained by mixing a cold red with a cold blue.

A clear, spring green can only be obtained by mixing lemon yellow with cerulean blue because the cerulean blue tends towards the yellow anyway.

Incidentally, when referring to a hot colour we imply that there is red in it, and when we refer to a cold colour we imply that there is blue in it. This is sometimes referred to as the colour temperature.

Mixing Greens

Because of the number of greens in most flower paintings you should investigate how these variations can be mixed without using specific green pigments, say Hookers green, phthalo green, turquoise and so on.

Most greens can be made by admixtures of the two yellow primaries and two blue primaries. The difficulty arises when going for a specific green and not using the correct original primary.

When walking in the countryside it is well to note the variations in greens about you be they cool, blue greens or brown, warm, yellowy greens. Try mixing these and see how many variations you can obtain.

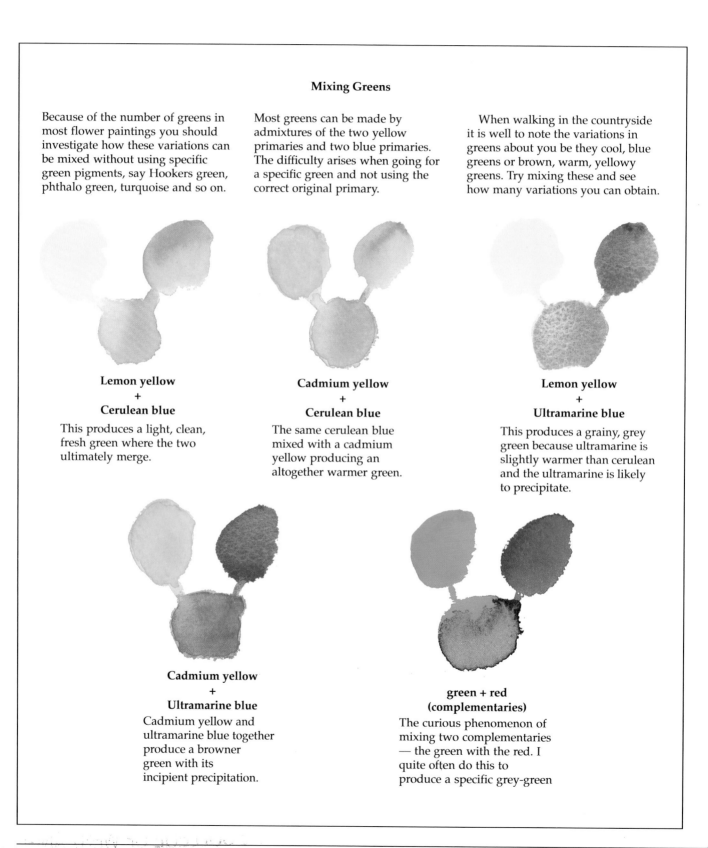

Lemon yellow
+
Cerulean blue

This produces a light, clean, fresh green where the two ultimately merge.

Cadmium yellow
+
Cerulean blue

The same cerulean blue mixed with a cadmium yellow producing an altogether warmer green.

Lemon yellow
+
Ultramarine blue

This produces a grainy, grey green because ultramarine is slightly warmer than cerulean and the ultramarine is likely to precipitate.

Cadmium yellow
+
Ultramarine blue

Cadmium yellow and ultramarine blue together produce a browner green with its incipient precipitation.

green + red
(complementaries)

The curious phenomenon of mixing two complementaries — the green with the red. I quite often do this to produce a specific grey-green

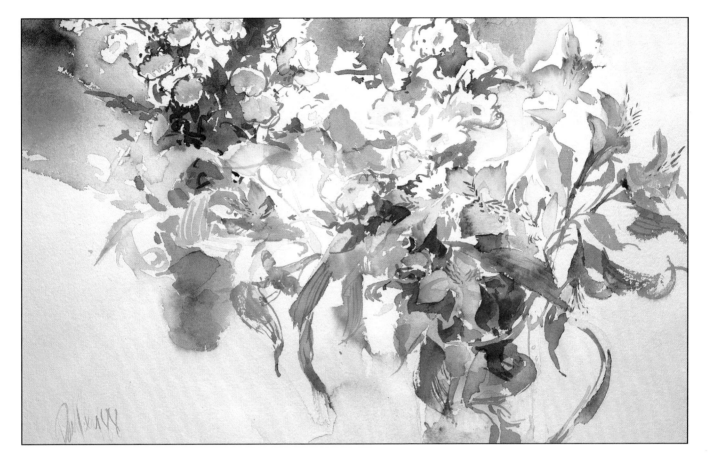

Green leaves with glass jug
There is a considerable variety of greens in this painting, which range from almost pure yellow through to dark blue - the two colours which are mixed to provide the greens.

Very cold greens in the vase to the rear help to make this area of the painting recede. Cold colours have the tendency to do this.

In the foreground I have warmed the greens up and made them slightly yellower to produce a local colour and bring this section foreward.

In certain of the greens I have allowed the reds from the flowers to merge into them. This produces complementary hues.

a transparent form of painting . It uses a system of merging or overlaying of pigment on to white paper. The dilution of the pigment with water enables the whiteness of the paper to show through and in so doing lightens the tone of the pigment. Europeans refer to this as aquarelle – a more specific term. I have seen many 'watercolours' in exhibitions that are in fact paintings using water as a medium for dispersion but using paints which are opaque in nature, that is gouache and acrylic paints.

Watercolour paints are essentially pigments which have been ground extremely finely in a solution of distilled water. This is filtered and natural gum arabic is added. The gum acts a binder for the particles of pig-

ment and assists in the adherence of the pigment to the paper surface. The pigments do not lie on the paper surface but are absorbed to a greater or lesser extent into the paper. The watercolouring technique is, therefore, a staining process. It is this staining that results in a painting that is well integrated with its surface.

This can give rise to problems where alterations need to be made, so a very direct approach to colour application is used. In fact the more spontaneous the laying on of colour the more likely you will have a satisfying painting.

The pigments which do all this work come from all kinds of sources and have varying properties. In the past, certain kinds of earth materials

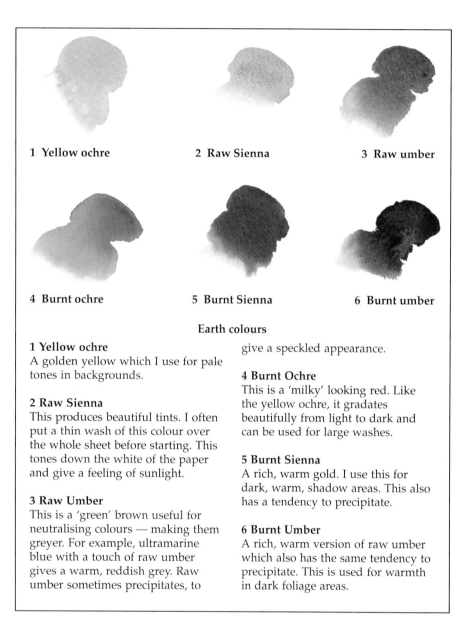

1 Yellow ochre **2 Raw Sienna** **3 Raw umber**

4 Burnt ochre **5 Burnt Sienna** **6 Burnt umber**

Earth colours

1 Yellow ochre
A golden yellow which I use for pale tones in backgrounds.

2 Raw Sienna
This produces beautiful tints. I often put a thin wash of this colour over the whole sheet before starting. This tones down the white of the paper and give a feeling of sunlight.

3 Raw Umber
This is a 'green' brown useful for neutralising colours — making them greyer. For example, ultramarine blue with a touch of raw umber gives a warm, reddish grey. Raw umber sometimes precipitates, to give a speckled appearance.

4 Burnt Ochre
This is a 'milky' looking red. Like the yellow ochre, it gradates beautifully from light to dark and can be used for large washes.

5 Burnt Sienna
A rich, warm gold. I use this for dark, warm, shadow areas. This also has a tendency to precipitate.

6 Burnt Umber
A rich, warm version of raw umber which also has the same tendency to precipitate. This is used for warmth in dark foliage areas.

the development of various synthetic compounds.

Many old pigment types had all sorts of problems. Some, like lead, were poisonous and others had the tendency to turn black or fade over a period of time. The selection of colours in relation to their permanence is extremely important. Fortunately modern technology, with its research into dyes for the garment industry, has developed entirely new and much more permanent colours whose intensity would have been the envy of the old masters.

Students have asked me many times what basic range of colours should they have and from which manufacturers. There is a basic requirement, but the potential flower painter will find that certain colours in nature can only be reproduced with specific kinds of pigments. Reds in particular are notorious for not being quite right unless you have a fairly broad range on your palette.

The paint manufacturer cannot produce absolute primaries of red, yellow and blue without a slight bias towards hot or cold in colour temperature. So your basic palette should have at least two of each primary to make an approximation of all the other colours. It works out therefore as follows:

Yellow = cadmium yellow (warm) and lemon yellow (cold)
Red = cadmium red (warm) and alizarin crimson (cold)
Blue = ultramarine (warm) and cerulean (cold)

(Ultramarine can be substituted for cobalt blue, which is slightly nearer to a true blue.)

With these colours a wide range of secondary colours can be mixed.

made up a large proportion of our colours. Names like ochre, umber and sienna denoted the origins of that earth. These earths could also be calcined to produce burnt umber, or burnt sienna, which are much warmer in hue than in their normal state. In addition there were vegetable colours such as indigo, madder, and gamboge. Certain metals could be oxidised, the obvious being iron to give a red. Subsequently other metals were used including cadmium, zinc, manganese, and copper. Animal products were also used. The most famous being the cochineal beetle which produced carmine. The urine of cows fed on mango leaves resulted in Indian yellow. The shellfish murex trunculis gave a purple. None of these animal products are used today because of

Dried flowers

It is not often that I have the opportunity to try out all the earth colours whilst painting a flower picture, but these dried grasses give ample opportunity to explore their qualities.

For the main bright pinks I used mixtures of alizarin and yellow ochre. Yellow ochre proved to be ideal for the yellow corn and wheat ears.

In the middle, where the stalks criss-cross one another the lighter tones were mixtures of yellow ochre and raw umber. Shadow areas were produced by adding stronger concentrations of raw umber together with ultramarine blue. The main bulk of the pot was raw umber heightened with cadmium yellow and red.

In the background I wanted a strong, dark, warm colour to show the profile of the pot. Raw sienna and raw umber, mixed with a little alizarin crimson, were just the right hue. When mixing earth colours you need to be as careful as mixing primaries to avoid any muddy looks to the finished painting. Again, try not to use the colour too thickly otherwise the painting will appear dull. It is important to allow the paper to shine through the pigment to give the finished work luminosity.

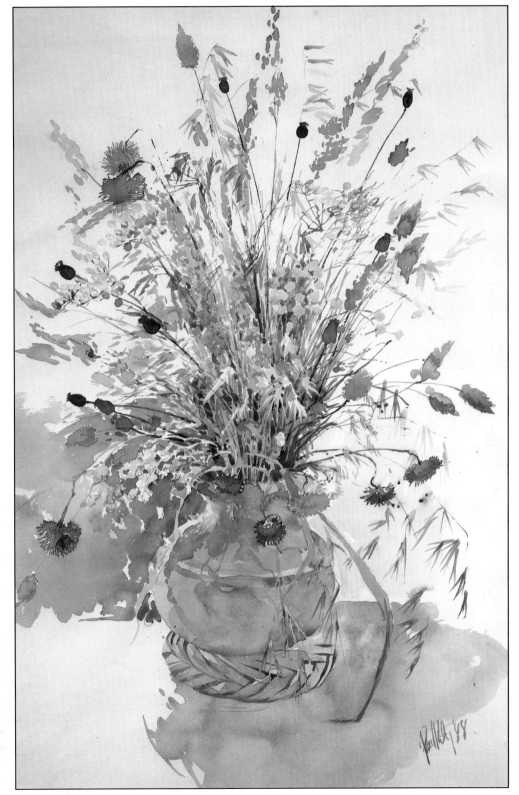

ADDITIONAL BLUES AND REDS

Although I have previously stated that you can work quite satisfactorily with a limited palette of two reds, two yellows and two blues, the enormous variety of colour in flowers sometimes means a larger palette is helpful. This is particularly so with reds. The more different types of reds I can lay my hands on the closer I can get to nature's colours.

The range of reds and blues shown here gives some indication of the varieties available.

1 Rose madder (Winsor & Newton)
This is a reasonably cool colour.

2 Madder lake (Schmincke)
A finely ground colour which produces delicate pink tones.

3 Permanent rose (Schmincke)
This is richer, warmer and more intense than madder lake.

4 Rose doré (Winsor & Newton)
An unusual colour which looks quite vivid when seen in conjunction with other reds.

5 Vermillion (Maimeri)
This has a slightly grainy, precipitating quality. It can appear heavy when applied to delicate blooms but is useful for dark tones in red flowers.

6 Carmine (Winsor & Newton)
I use this regularly when I want a very cold red with a lot of character. Unfortunately it is not cheap.

7 Scarlet lake (Schmincke)
This has a coral-like quality. Again, this is useful for the more delicate types of flower colouring.

8 Phthalo blue (Winsor & Newton)
The strongest and most powerful blue manufactured. It has a strong phthalocyanine content. It must be handled with respect because it tends to invade the entire palette if not kept under control. It produces the most vivid greens for dark, intense shadows.

9 Cobalt blue (Winsor & Newton)
Very clear, very clean and similar in some respects to an ultramarine blue but without the precipitating characteristics.

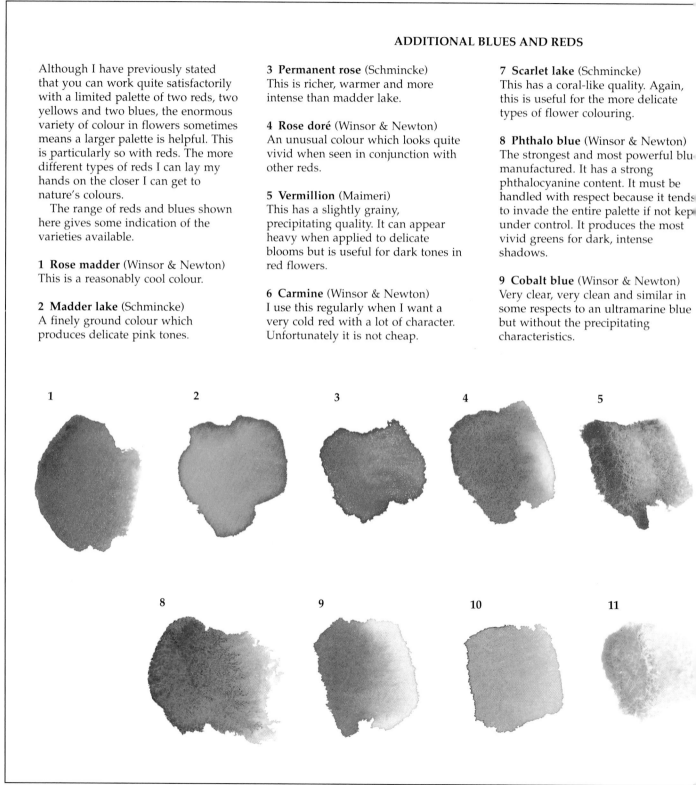

1 2 3 4 5

8 9 10 11

10 Cobalt turquoise (Winsor & Newton)
This is a near green and is made from the same base as cobalt blue. I use it principally when I need a cool green.

11 Manganese blue (Winsor & Newton)
A most interesting blue. It has strong precipitating qualities and is a favourite of mine for certain delicate shadow areas.

12 Indigo (Winsor & Newton)
This is a near grey which if handled carefully is quite useful for dark accents and shadow areas, but take care because it can make the painting look dirty.

6 7

12

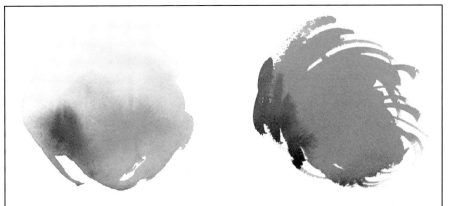

OX-GALL AND GUM ARABIC

There are two additives used in watercolour painting. One is ox-gall and the other gum arabic. These are constituents to be found in most watercolours as sold by the major manufacturers. However, further additions can produce specific effects which you may wish to use.

The best way to describe them is to show you these two samples using exactly the same paints – phthalo blue and violet.

You will notice that there is a considerable difference between the two patches of colour. On the left hand side the phthalo blue has been mixed with two or three drops of ox-gall and water. The result is that the ox-gall, which acts as a wetting agent, has made the colour disperse very finely and very thinly. When the violet is added to this section whilst wet the edge of the violet is finely gradated into the blue pigment.

On the right hand side, when the same quantity of phthalo blue is added to a similar quantity of gum arabic the opposite occurs. Here the gum arabic has acted like a varnish and has made the colour much crisper and darker. It has also produced a slight sheen to the surface. Adding the violet has the same merging qualities but the edges become much more strongly defined.

The main reason for adding ox-gall is to allow fine dispersal for wet-into-wet areas. For example, in backgrounds or where fine gradations in petal colouring are required. The addition of gum arabic helps in detailed areas where crisply defined edges are required. Gum arabic can also be used for giving body to a painting.

In terms of depth, where gum arabic is used the paint will tend to appear nearer to the viewer. However if ox-gall is added the paint will tend to recede.

Having this basic range teaches you the discipline of colour mixing, bearing in mind the complexities involved in the nature of the pigments themselves.

When painting flowers one of the main constituents is the green of the foliage. Colour mixing for greens has many pitfalls because of their varia-tions in temperature. Cadmium yellow mixed with cerulean blue will give a warm green which is slightly brownish. The reason is that in this mixture there is a yellow, with a little red in it, added to blue with a little yellow in it. In effect there is a mixture of three primaries which make a tertiary colour, or a kind of brown. A

similar situation arises when mixing ultramarine blue with lemon yellow. This results in a slightly warm green due to the red hue in the ultramarine. A cold, fresh green can only be produced by mixing a yellow blue with a bluish yellow, that is cerulean blue with lemon yellow. It is only by practising with these mixtures that you will reduce the incidence of muddy colours which permeate so many flower pictures. Oranges are extremely easy to obtain with cadmium yellow and cadmium red. If lemon yellow is used slightly browner oranges will result because of the slight blue inherent in the yellow.

Purples should theoretically be obtained by the use of a cold red alizarin with a red/blue ultramarine. However, because of the nature of the two pigments the result is a rather dirty purple or mauve. Let us examine these two pigments.

Ultramarine, for example, can be what we call a precipitating colour – in other words it has a slightly grainy look on the paper. It used to be made from a semi-precious stone, lapis lazuli, but now is a complex of silicate of sodium, aluminium and sulphur.

Alizarin crimson, which used to come from the madder plant, is now a pigment made from dihydroxyanthraquinone and aluminium hydroxide. Sometimes this is contaminated with iron and can be slightly brownish if adulterated. In landscape painting these niceties are toned down somewhat but in flower painting any such adulteration can be disastrous. (Good paint manufacturers take great care over the mixing which results in a much more rosy alizarin which mixes well.) Most cold reds have their roots in the compound mentioned above. The cadmium reds, or yellow reds, have their roots in cadmium sulphide with the addition of barium sulphate for oranges and yellows. Reds with iron in them will seem slightly brown.

On the subject of blues, together with the ultramarine we have the cobalt blues. Cerulean contains cobalt and some tin. Cobalt blue itself is combined with aluminium. These are beautiful clear stains which I use frequently. A very powerful blue originates from copper phthalocyanine, which gives it a slightly greenish hue. This is useful for providing dark tones in foliage. Phthalocyanine is also produced as a dark green. Another comparatively new blue is manganese blue (barium manganate with barium sulphate); a beautiful transparent azure which is slightly greenish. Some manufacturers' versions of this blue tend to separate on the paper giving what I can only describe as a veiny look which I utilise mercilessly.

To truly understand how these pigments are likely to act, either by themselves or as mixtures, you need to spend a little time simply diluting and mixing them. See how they change and decide whether or not you like the colours. It is absolutely imperative if you want primary or secondary colours that your water, brush and palette are clean. If not you will be introducing a third colour and you will instantly have a dirty, muddy result.

There are some watercolours which can best be described as opaque. A prime example is Naples yellow, which is derived from lead antimoniate. This is poisonous and is sometimes substituted by a mixture of cadmium sulphide (yellow) and nickel titanate, a white yellow. Chinese white has a zinc base and is sometimes used for highlighting.

Opaque or semi-opaque colours have to be carefully used in watercolours for if they are used for lightening they can look murky. Any over painting can look very dull indeed. The best way to introduce them is in the final stages of a painting or as an integral part of a design on tinted paper. Two artists who used this technique successfully were Turner and Hercules Brabazon Brabazon.

One of the many problems associated with differing pigment types is their handling properties and you should be aware that there are chemical factors which influence this. Some students complain of a streakiness or oily feel to the paper. This is quite possible due to the lack of wetness in the pigment, or the paper being not quite absorbant enough. You can add a little ox-gall to the water which will improve the uniform flow of the paint. To harden the finish of the colour a little further addition of gum arabic will help. Some painters add a little honey to improve the smoothness in paint handling when doing fine work on a smooth paper. If you wish to improve the smell of your paints add oil of cloves. This also helps prevent mould growth – an all too frequent occurrence in badly kept watercolour paintings. Talking of caution, it is as well to ensure that whatever water you use should never contain salt. Distilled water is ideal but tap water, providing it genuinely is clean, is acceptable.

Most paint manufacturers provide their colours in two ways – hard pan or tubes. Hard pans of artists quality are very pure because they lack the additives which are used in tubes to maintain a liquid state. Their only drawback is trying to keep them clean. I also

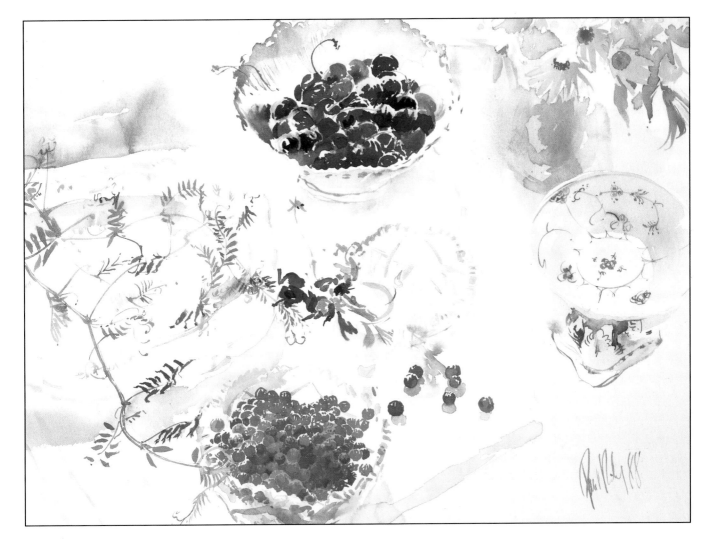

Redcurrants and blue cherries
Playing with blues and reds can give one a great deal of satisfaction for the power they have in the tension of opposites. Here I have combined redcurrants with blue cherries and blue vetch. Although the redcurrants look as though they are the same red I actually used about four varieties. If you look closely you will notice that some of the reds are almost orange in appearance, and others appear more milky. In the deep shadow areas they are undoubtedly a cold, dark red.

tend to resent the time it takes to wet them sufficiently for speedy work. Tubes on the other hand are very convenient. They can be easily kept clean and even paint left out overnight or longer can be reactivated by simply adding water. If your tube paints go hard through lack of use, or you have inadvertently left the top off, they can be cut open and used as hard pan types. Some companies sell liquid paints which you may wish to try. These are mainly intended for airbrush work. They are rather expensive for the watercolourist who,

after all, does not find it that hard to obtain water.

Always choose your colours carefully and only choose the best. It is quite feasible to make your own colours by grinding up the pigments and adding the necessary gum, however, the quality of grinding required is so fine that it is practically impossible to improve on that which most reputable suppliers provide. The best quality paints have such intensity that a little goes a long way. So look after your colours for they are as precious as the flowers you paint.

Sable brushes

The importance of the brush cannot be exaggerated. It is far better to buy one good brush than ten cheap or indifferent ones. Painting presents enough problems without the inhibitions caused by a bad brush.

Which brush is the ideal one? Versatility and quality are found in only one brush – the sable. Ideally you will need a selection of brushes, and my experience has taught me that these specific types are particularly suitable for flower painting, dependent as it is on so many shapes and marks.

The sable is a versatile brush because of the way it is manufactured, the nature of the hair itself, and the animal from which it is derived. The best is kolinski hair, which is from the Siberian mink or Tartar marten. These creatures live in a cold climate and require a coat which is impervious to harsh weather. Consequently they have a springy type of hair; short, with a fair curve which tapers from root to tip. The hair is selected from the tail.

In a good brush the amount of hair seen emerging from the ferrule of the brush is slightly less than is encapsulated in the ferrule. The skill of the brush maker is in plac-

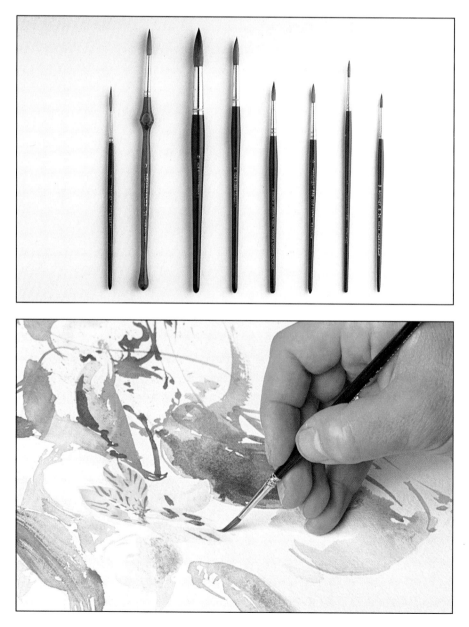

Sables are extremely fine tools for the watercolour artist. Their virtue lies in their flexibility and their water-holding properties. They are extremely stable brushes with highly predictable behaviour. Their ability to reform into a fine tip means that extremely delicate work can be achieved. This picture shows my range of sables.

The largest sables are extremely expensive. For beginners the intermediate size, 6, will be adequate for most uses. Sables are graded by number, with the lowest number being the finest. Generally speaking they range from 000, which is extremely fine, to a 12 which is large.

Here you see a small sable in use doing what it is designed to do, which is to introduce fine detail into a painting. When holding this brush, in order to steady my hand, I allow only my little finger to touch the surface of the paper. Resting your entire hand may dirty or smudge your work. Keep the angle almost vertical to the paint surface. The fingers should grasp the brush lightly above the ferrule and allow the swell in the handle to rest in the hand.

ing all the hairs around a centre to provide the characteristic 'body' and extremely fine tip. The body is the paint reservoir. The tip is the articulating part of the brush. It is such a beautiful thing that any form of maltreatment, like scrubbing its ferrule on the paper, or leaving it hair down in a water container, is sacrilegious.

The brush types are designated by their ferrule and tip conformation. The round has a round ferrule and fine tip. The 'flat' has a flattened ferrule and is square or chisel-shaped at the tip. Sizes vary from 000 (the smallest) to 12 (the largest). You will find a number 5 or 6 a handy size

and it should not be too expensive. The round is particularly useful for 'drawing in' because of its resilience and fine line. It is often referred to as a 'pencil' in France. Its shape naturally produces leaf like shapes and is ideally suited to forming pointed petal forms. For blunted petals, like the daisy, a flat sable with a chisel end is best.

The flat has two different uses. Firstly, full width to cover flat areas, and secondly, on end as if it were a chisel, to draw fine lines. Using a twisting action all kinds of tapering forms can be achieved. It is ideal for painting long tapering leaves like the iris.

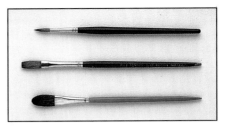

These brushes show the variety of types available. The one with the round ferrule is called a round or pencil. It is used for drawing in, and general painting. The flat has a flattened ferrule with a chisel end. This is useful in creating areas like iris leaves. The filbert has a ferrule similar to that of the flat but has a rounded tip. This is especially useful for certain leaf and petal shapes.

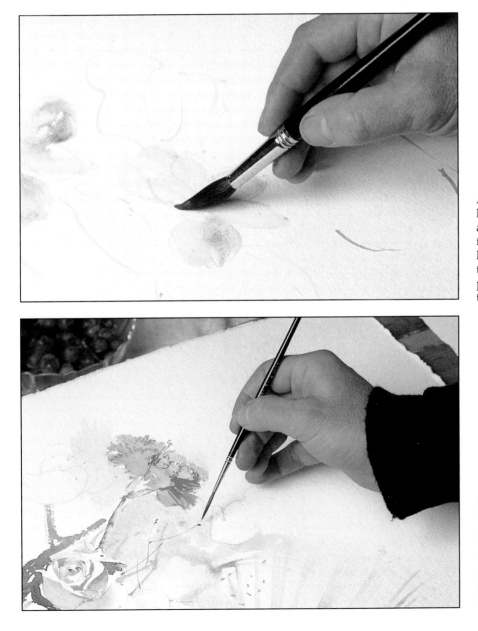

A large sable has many uses - from laying washes to producing leaf shapes and filling in areas such as petals and fruit. A good quality large sable will have a tip which you will barely be able to see but it will still enable you to paint fine detail. A large sable is therefore an extremely versatile brush.

A rigger is a long-haired brush. I use this regularly for drawing and fine detail work. Because of its length it is capable of producing very regular straight lines when required. When making lines the action is slightly trailing, which is a different action to that of a small sable.

Squirrel and ox-hair brushes

Brushes other than sable hair are also useful for the flower painter. The slight problem with the virtuous sable is its very springiness. Sometimes it can seem a little hard for certain applications when there is a need for a softer, more delicate touch. A brush you might find appropriate for this purpose would be one made from squirrel hair. *Petit gris pur* as it is sometimes labelled. These come as rounds, quite often with wired quill ferrules, and are very attractive objects in their own right. Large

floppy petals and big irregular shaped leaves are perfectly rendered by a brush of this type. Squirrel hair brushes also come in a long pointed flat type which is ideally suited for long trailing stalks and veins on leaves.

Ox-hair, which comes from the ears of a specific breed of cattle, is a fairly stiff hair and is often used for 'mops'. These are large, round-headed brushes suitable for washes and covering large areas. Badger hair is also sometimes used for this purpose.

Another brush shape you will find especially useful is the filbert. This has a flattened ferrule with the hairs rounded at the tip to give an oval shape reminiscent of certain petal and leaf shapes.

There are occasions when particular needs will result in borrowing brush types from other disciplines; for example the calligrapher's 'rigger' which is a very long-haired, round, blunt-ended brush. It is incidently, used for painting in rigging lines for marine pictures but is especially good for long stalks.

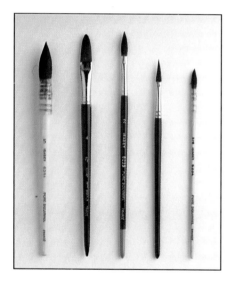

Squirrel hair brushes are softer than the sables and lack their springiness. I find these very useful in flower painting when trailing or tremulous lines are required. Their soft quality enables me to produce quite unique leaf shapes. They have very good waterholding properties which helps when working very quickly. Here we see a range of shapes and sizes from fine-tipped filbert types to rounds. These brushes are quite often known as *petit gris pur*.

This photograph shows me using a squirrel hair brush to fill in some detail where a soft, tremulous line is required. This particular size brush is useful when painting small flowers, especially wild ones. The flexibility of this brush enables the painter to move it in almost any direction without the tip losing contact with the surface of the paper.

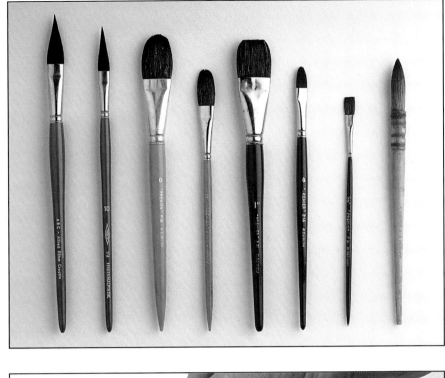

Ox-hair is commonly used for the cheaper brush because its price is somewhat less than the squirrel, and much less than the sable. It is very economical for large brushes, which would be very expensive in sable hair. Ox-hair brushes can vary in shape, and the trailing ones with the long tips are very useful for certain types of petal or leaf shapes. The largest size of rounds are often referred to as mops. These mops can be used for locally wetting areas with water in preparation for a wet-into-wet painting.

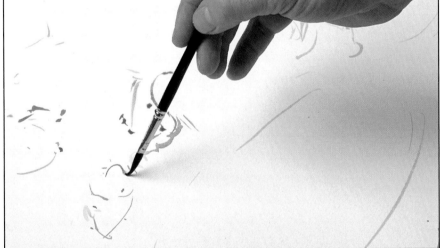

Because of its fine trailing tip I quite regularly use the squirrel hair brush for what I call drawing in. This is in lieu of a pencil which would give hard lines. The small squirrel brush has a slightly blunter tip than a sable but this makes it easier to draw circular shapes and broken lines.

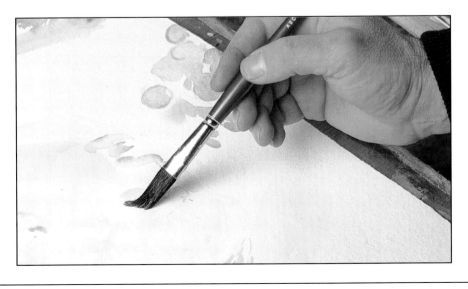

This ox-hair brush is being used to lay in soft background tones. It is useful for producing a wide variety of strokes.

Oriental brushes

I am a complete fan of many types of oriental brush. Given the long history of flower painting in the East, it is not surprising that they have evolved brush types which exactly suit the art.

Their construction is completely different to western brushes. In the West we tend to use one hair type per brush, or mixed at random. The orientals quite often use two or three types of hair in a quite unique way. The centre hairs are the longest and stiffer than the outside hair, which is soft and graded to the point. The centre hairs act as the drawing tip with the outer hair functioning as the paint reservoir. These outer hairs have the added characteristic of performing as trailers to the tip. This gives the painter a large repertoire of different broken style strokes. The brushes are generally soft with little springiness, so they are held vertically to allow gravity and the weight of water to maintain their shape. In the hands of a master the oriental brush is a versatile tool.

Another brush, which can only be described as a 'gang' type, has two or more bamboo-handled brushes fixed side by side to form differing widths. These are used for washes and specific strokes in large paintings.

The Japanese equivalent of our flat is the hake. An exquisitely made, light-weight, brush with a wooden handle. It is made of goat hair which is stitched into the handle. When manipulated at various speeds (as the watercolour flat) a vast range of fluid and broken strokes can be produced.

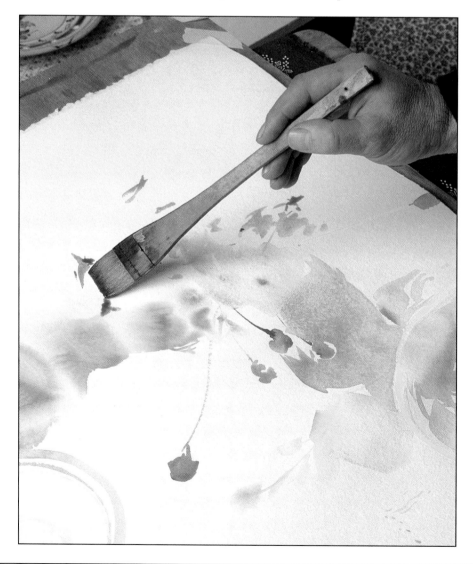

In this instance I am using the hake by trailing it on edge to produce a knife - like stroke, which shows the versatility of this kind of brush. By twisting and turning the tip various edges and flats can be attained. A hake, however, can produce quite mannered strokes if used too extensively, so use with discretion.

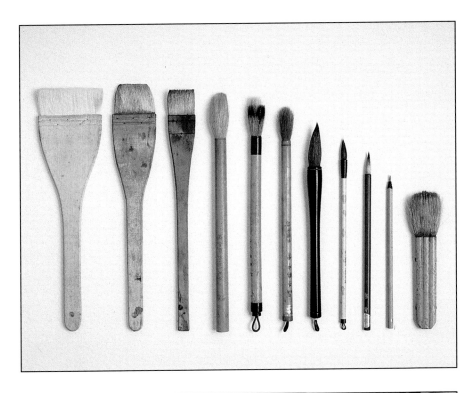

The oriental brush is made of either sheep or goat hair, and sometimes even rabbit. These will be occasionally mixed with stiffer hair in the centre to produce a fine drawing tip. The outer hair has the water carrying property. The joy of these brushes is that by manipulating them with a slight twisting action various types of broken edge are achieved. A good quality, large, oriental round brush will prove an invaluable asset. The flat brush is a hake; similar to our flat but much softer. It is excellent for very rapid movements without any feeling of clumsiness. There is also a brush which looks like Pan pipes. These brushes are made in multiples of different widths for large or small wash laying. The tips make up in a most extraordinary way, providing multiple trailing points. This can be useful for leaves which have many striations in them.

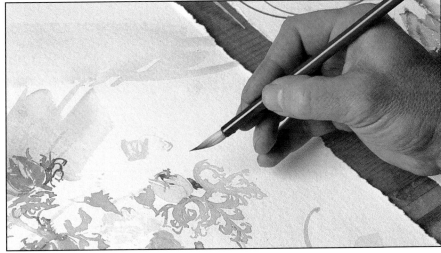

I am using an oriental brush to paint a succession of quite curly anemone leaves. Because this particular brush has the ability to produce a trailing edge when used slightly flat it is eminently suitable for this kind of work. It needs to be held in a vertical position because the hair in this brush is extremely soft. Most oriental brushes are used well loaded. It is not a suitable brush for dry brush work.

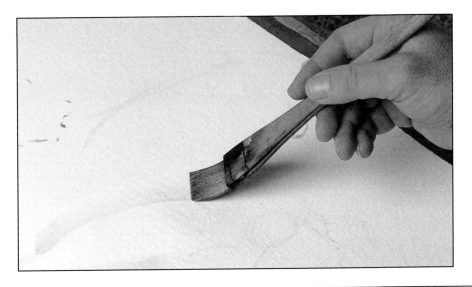

The hake has many potential applications. The most obvious is to simply use it to lay in large flat areas. This is shown in here where I am laying in some quite soft flat colour.

Improvised tools

As general aids to painting, and to produce a range of textures, there are many tools. Some of these are not particularly orthodox. The most important is a small natural sponge for softening contours and washing down colours. Soft tissue is good for blotting out areas and draining excess colour from some strokes. A piece of cotton rag is used for similar purposes, and for 'ragging' textures. Ragging simply means dipping the screwed up rag into wet colour and dabbing it over the paper surface. An old tooth brush is excellent for splattered texture. This, like similar techniques, should not be overplayed or the effect is dull and obvious.

Another device is a piece of straight-edged card. When the edge has been dipped into the paint it can be used for short, straight strokes – for instance in painting a dandelion seed head.

Feathers are useful for creating trailing, wispy lines.

Bamboo and steel pens can be dipped directly into the watercolour for multi-line work, hatching and stippling. The bamboo pen has the advantage that it can be cut and shaped to whatever tip is required. A scalpel or razor blade is handy for scratching out white lines. Finger nails can be a useful substitute, and even Turner used this technique.

Having experimented over many years, I find this simple palette serves all purposes. The deep pans provide large containers for washes, and I can lay my colours round the edge in whichever manner I choose. I tend to lay my colours with the hot colours at one end and the cold colours towards the other.

When working in the field I take one simple six-holer, but whilst working in the studio I bank them up to provide as many pans as I wish.

They are made of rigid plastic and may need a little scouring with an ordinary household scouring agent to break the surface tension before use.

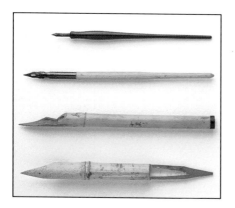

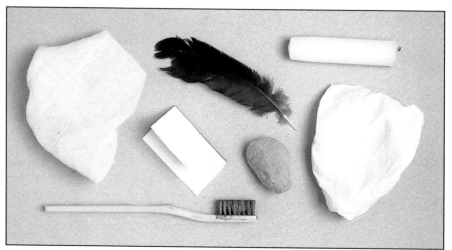

Pens are best for certain types of line work. I use them with watercolour, not ink. This selection includes steel nibs and bamboo. The bamboo can be sharpened to whatever width you want. Add a little gum arabic to the paint to help it flow freely, and always test on a similar paper before using these tools.

I show here a range of my various tools. I use all these in different ways. Overuse of contrived tools can make the painting look a little obvious, but, certain discreet touches can produce quite magical results.

The soft tissue paper is for blotting and ragging. The piece of folded card is for creating straight lines. The soft natural sponge is an indispensible tool for blending colours and mopping up areas of saturated paint. The feather acts a little like a brush for certain types of trailing lines. Soft muslin is useful for blotting and textural marks.

The candle is used for resist purposes. Wherever the candle is applied the watercolour is repelled and leaves light or white marks. The toothbrush is for splattering.

Some people regard resists of different kinds as an essential tool. The principle is to use an element like wax, or a specially formulated rubber solution, which when applied to the paper will resist the watercolour. This can be done at different stages in the development of the painting to leave behind white or pale-coloured areas. The wax cannot be removed but the resist mediums can be rubbed off with a finger or rubber.

This device can be useful for building up intertwining twigs, grasses and stalks. Do not use rubber resist on paper which is even slightly damp, or paper of the softer type, or you will tear your work to shreds when removing it.

Candles, when lightly rubbed over the paper texture, can give a random broken tone. Be careful, or it may look mannered and might not occur where you want it to

because you will be working blind.

I use plastic palettes with deep pans to hold plenty of colour. This avoids the frustration of running out of colour half way through a wash. These inexpensive types of pallette can be ranged together to provide a huge palette with many options for colour layout. They are lightweight and can be stuck easily on to a board by using a roll of masking tape inside out.

Provided the sponge is soft it should not damage the paper surface. I use it extensively for blending colours. Always use clean water and present the sponge with a clean surface for each wipe. Failure to do this results in dirty smudging. Certain soft papers require very delicate handling in the exercise of this movement. If extensive blending is required use a harder paper.

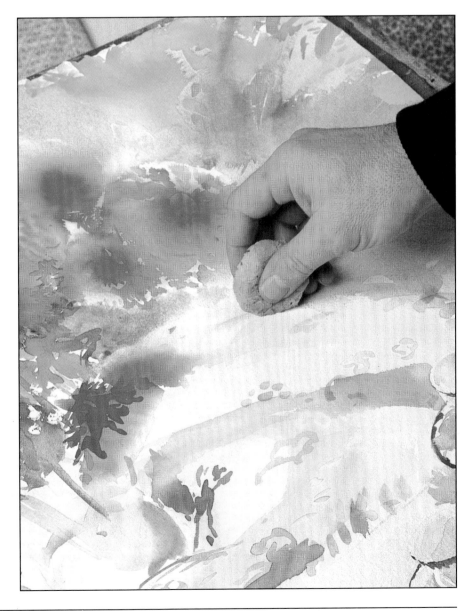

Paper

Paper is of paramount importance. If need be search high and low to find the kind of paper which suits *your* work. Much depends on its texture and absorbancy, so consider your choice carefully. As with brushes and paint, any old paper will not do just because you might be a beginner. Paper made specifically for watercolour purposes has a character all of its own and should not be confused with other paper types suitable only for writing or printing.

Whether you sell your work or not the paper you use must have a good life expectancy. Most modern papers using wood pulp will ultimately disintegrate. Carefully made papers using archival techniques will last indefinitely.

The traditional material is a mixture of linen and cotton rag which is beaten to a fine fibrous pulp and mixed with 'acid free' water. The use of acid free water also helps to prevent the growth of mould on the finished paper. The head of the papermaking process is called the 'vat man'. The vat is the tub of pulp from which the paper is made. The vat man has a frame (which dictates the size of the finished sheet of paper) over which is stretched a woven screen of bronze wire mesh. This gives the paper its name – 'wove'. A separate frame, the same size as the former, is called a 'deckle' and lies over the mesh to form a temporary sieve. The vat man scoops up a portion of the pulp sufficient to form a scum on the surface of the mesh. He uses a slight backwards and forwards, side to side motion which causes the cotton fibres to interlock. The deckle is then removed, and where the paper has slightly crept under the tempo-rary frame the 'deckle edge' is formed. This wavy edge denotes a hand-made paper. The screen is turned over and the infant paper is then 'couched'; peeled off on to felts, and a felt laid over it. The operation is repeated until a 'post' of felts about 8 inches (200 cms) high has been completed. This pile is then put into a press which compacts the paper. The result is then hung to dry. A watermark, usually a design in bronze soldered to the mesh, will indicate the face side of the paper. The other side is generally slightly whiskery due to having been in contact with the mesh.

If the paper has only been pressed once it is called 'rough'. A second pressing will give it a finer texture, and is called 'cold pressed' (CP) or 'Not' which means not hot pressed. This term, Not, distinguishes it from a hot pressed (HP) surface where

Arches Torchon 140lb (300gsm) Not
This is a very robust paper due to the amount of sizing in the fibres. This texture is interestingly random and not too dominant. It enables good dry brush effects to be achieved and also well graded washes. The hard surface allows you to wipe out areas and to scratch out highlights without damaging the paper. With paper of this weight it is sufficient in most instances to simply pin or tape it to a board.

the paper is put between zinc sheets and passed through rollers to give it a smooth surface.

Sadly today there are almost no commercial handmade papermakers. The quality of their product is unsurpassed by modern methods. The closest is the mould made paper which displays many of the characteristics of the handmade version. Machine made paper, where the texture of felts is impressed with steel rollers, is not suitable for flower painting. The pattern is repetitive and the surface of the paper is hard.

The vat man can vary the thickness of his paper by adjusting the amount of pulp on his screen. This is referred to as its weight. The weight is either expressed in pounds per ream (470 to 500 sheets) or grammes per square metre (gsm). The lighter weights are 90 lb (190gsm) to 140 lb (300gsm) and the heavier, board-like types are 260 lb (356gsm) to 300 lb (638gsm)

The relative absorbancy of the paper is extremely important for the watercolourist. This is adjusted by the vat man by the addition of a sizing agent. The absorbant nature of

paper depends on the amount of sizing and at what stage this takes place. This quality is of such significance you need to experiment yourself. Most manufacturers will happily supply sample papers.

The paper thickness also plays a slight part in this. Light-weight papers need to be stretched to avoid cockling. Simply soak the paper in clean water and fix it to your drawing board with gum-strip on all four edges. You can begin painting as soon as the paper is dry. Heavy papers can be pinned to the board.

If your paper is cockled when you have finished then all you need to do is spray the back with water and press it under weights between blotting paper. If left overnight the cockling usually disapears.

The wove texture of the paper is another factor to consider carefully. Different manufacturers produce different textures. The minute hills and valleys of the paper surface are often referred to as the 'tooth' of the paper. They 'bite' the paint off the brush. Tooth and absorbancy will make or break a painting, and for the flower watercolourist they

are indispensable to success.

The beginner will probably need a paper with not too much absorbancy. It will make manipulation of the paint easier and also allow water and sponge erasure of unsatisfactory areas. The more advanced might be attracted to a somewhat more absorbant surface which does quite subtle things to the colour. One of these is 'edge creep', as I call it, where the outside edge of an area of paint has a slight contour of intense colour.

When choosing paper textures (rough, Not/CP or Hot Pressed), the flower painter will be naturally attracted to the Not finish. The texture is even and fine enough for detailed work. The rough also has its uses, especially for flower studies out of doors when a quick impression is required without detail. The HP is not generally suitable for pure watercolour but it is ideal for pen and wash. Washes seem to slide over the surface, so a little ox-gall will help. You can use an HP surface for very small flower studies where the rougher texture of Not would interfere with the fine detail.

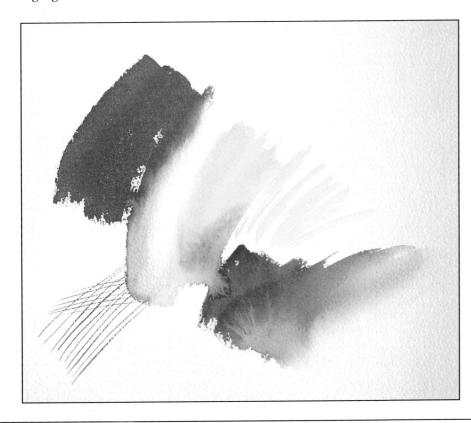

Saunders RWS 140lb (300gsm) Not
A very reasonably priced paper with all the strength and character required for good watercolour painting. It can take any amount of handling and I recommend it for beginners and professionals alike. The colour is slightly creamy and it gives a little warmth to a finished painting. The texture is finer than that of the Arches paper and more absorbant.

Moulin Du Gue 128lb (270gsm) Text
In fact this is not a watercolour paper but a print paper for etching! I came across it whilst looking for an absorbant paper with interesting texture and light tone. This fits the bill perfectly. There is very little size in it, which gives it absorbancy. It is ideal for very rapid working because the colour soaks in rather in the manner of an oriental painting. The paper is very white and gives good highlights and a broad range of tones.

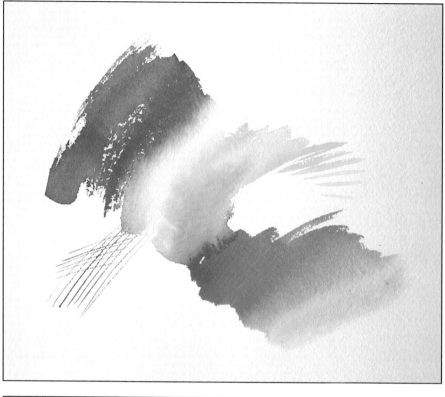

Barcham Green De Wint 90lb (190gsm) Rough
This is an example of a tinted paper which has colour impregnating the whole of the fibres. It allows the opportunity to introduce light body colour for highlights. The warm tone of the paper is good for contrasting with cool blue tones, or where you might want a more earthy kind of painting. The very rough texture does not allow much detailed work and paint needs to be handled broadly. If you stretch this paper a lot of the rough quality is ironed out to give a smoother surface.

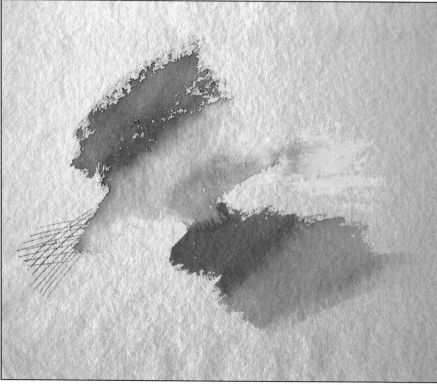

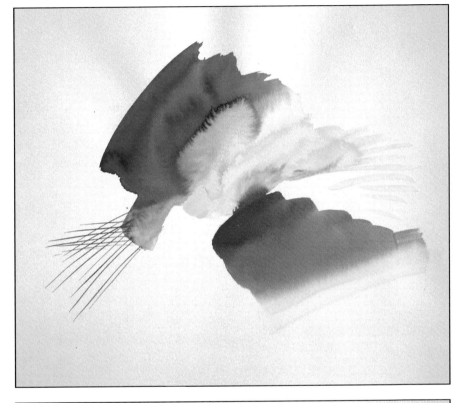

Fabriano 90lb (190gsm) HP
Hot pressed (HP) papers have an altogether smoother surface than the others. This example has a good clean surface which takes detailed work exceptionally well. Because the surface is slightly glazed the normal process of grading washes does not work in the same way as on the textured papers. Large areas of colour can tend to 'pool' and give a slightly marbled effect, which has its uses. I quite often use a sponge to produce large areas of tone with a pronounced 'wiped' look.

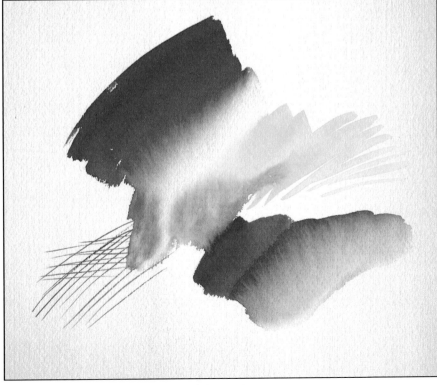

Fabriano Artistico 300lb (638gsm) Not
This has a fine textured Not surface which shows its wove quality. This enables you to produce more detail and finer gradations than a paper with a more pronounced texture. This paper is also softer than most and gives you the opportunity to explore delicate tints which saturate the paper surface. It is advisable not to bully the paper by wiping too much. Because of its soft nature this would result in a damaged surface that would be impossible to work over.

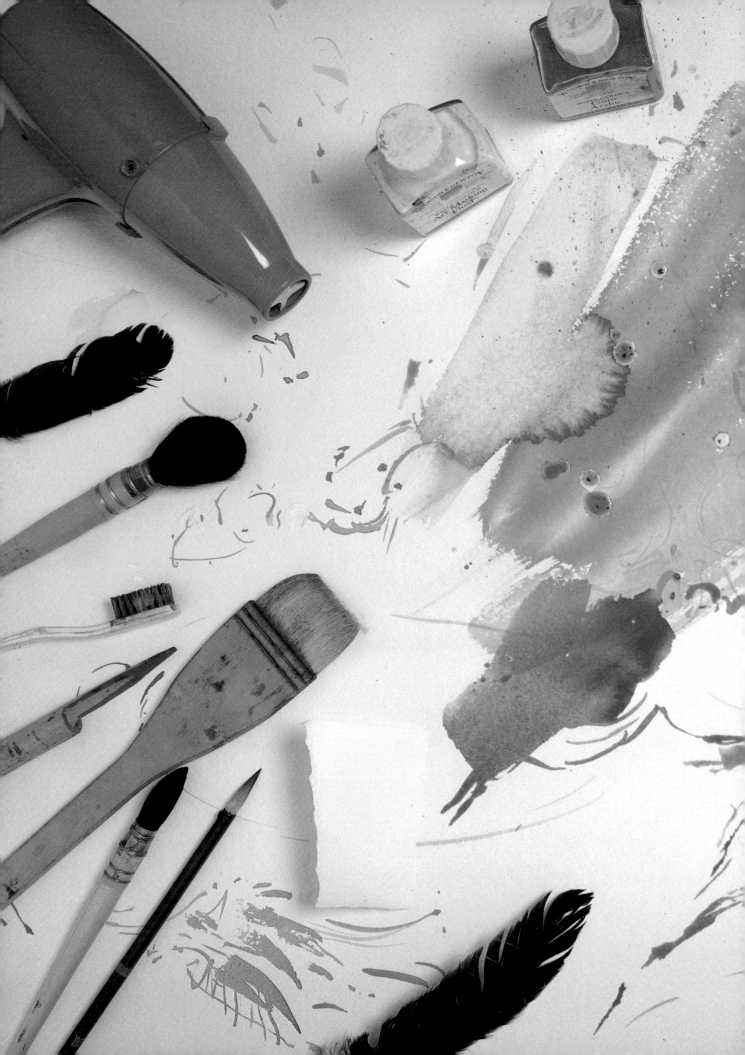

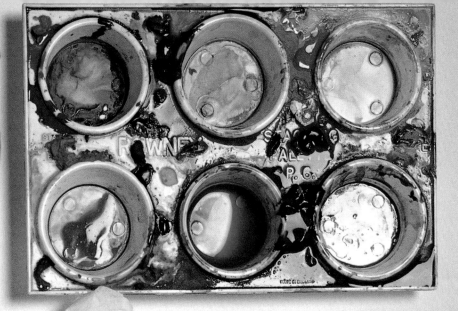

CHAPTER 3

PAINT
MANIPULATION

When painting flowers, as opposed to landscapes,
there are significant differences in the way the paint
is applied. Landscapes are invariably a series of
washes applied horizontally. The picture tends to
have two parts – sky and land, or sky and sea. The
flower painter has a more complex game to play with
flowers and foliage breaking up the background and
foreground in a haphazard and informal way.

Many books on watercolours refer to techniques in
paint handling but do not necessarily touch upon the
specific difficulties which the flower painter is likely
to encounter. The following tips are the culmination
of my own experiments and experience.

Basic techniques

Flat wash

The traditional flat wash relies on gravity for its even distribution of colour. Your board support must, therefore, be on a slight tilt from the horizontal. I usually have this in such a way so that I can move my board at will. This enables me to move the wash occasionally from side to side. The usual horror experienced by painters is not having enough paint to complete the wash so always make sure you have plenty. Equally important is to choose a brush big enough for the area of wash you intend to lay, anything from a size 6 sable for small areas to a large mop for the big ones. Sometimes I will lay a tint wash over the whole paper prior to detail painting. In this case the paper is first dampened. Do not proceed whilst the paper is soaking. Wait for it to start drying and acquiring a dull bloom. The laying of this kind of wash needs to be done deliberately and not too fast or you will end up with streaks and misses. Overlapping horizontal strokes from top to bottom completes the job, then with a drained brush draw off the residue

of paint from the bottom stroke. Do not touch the surface for any reason. A hair, a blob of paint, or anything you do will only make it worse. It is possible to start painting before this type of wash is completely dry if the object is to obtain soft edges. We will explore these later.

If you are applying a flat wash later on in the painting then you must first allow the initial stages of colour to dry. If you do not do this then everything will bleed all over the place. An example would be if you had a complicated flower head, light in tone, and you wanted to put a darker wash background to it. Here you would have to employ a strategy of bringing the wash first horizontally down to the flower then work one side, followed by the other. You would then progressively work in and out of the intricacies of the petals until the wash was taken right round the flower. With a lot of flowers this is quite exacting but all the more fun because of it.

Graded wash

A graded wash is similar to the above, and applied in the same

way. This time the tone will gradually lighten as you proceed down the paper. To do this you add small increments of water to your mix as you move downwards with your horizontal strokes. You can gradate from dark to light and back to dark again, or produce graded stripes.

You might like to effect another approach which will give your picture a different type of tension. Turn your board 90° to your intended finished state, and produce a graded series of uneven stripes. When dry, and the board is turned back, you will have a series of vertical gradations which quite often suits flower studies best.

Polychromatic wash

Gradations can also be made polychromatic by changing the colour as you go, both in different tones as well as intensity. Polychromatic washes can also be achieved in a completely random way by dropping colour on to wet areas of paint where they will bleed in all kinds of ways. Try tilting the board at different angles and watch the colours move.

Flat wash

For a flat wash set your drawing board at a slight incline. Using a well loaded brush, in this case a medium sized sable, progress in horizontal strokes from left to right. Pick up the bottom trailing edge as you go down.

In laying this wash I need to maintain a wet edge to the right hand side whilst bringing the wash down on the left.

Practise in laying flat washes is invaluable for those areas of the painting which need to be as quiet as possible, and they can be applied to large or small areas.

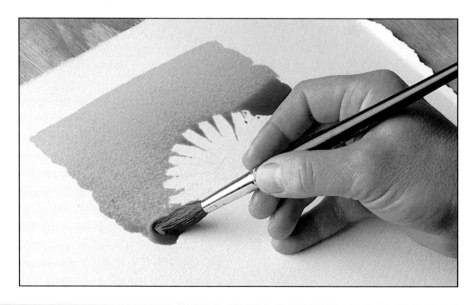

Washing out

A very beautiful quality is evoked by a process of 'washing out'. With any of the above washes you can take your painting to the sink and lightly wash off all or part of your wash with a sponge and clean water. You will not completely get rid of it, but that is not the intention. What you will have is a very delicate staining. You can then apply a complementary coloured wash over that and, if necessary, repeat the process up to three or even four times. What happens is that the paper, which comprises millions of tiny fibres, becomes stained in a myriad of sparkling colours with some colour in the 'hollows' and other colours on the 'peaks'.

After washing down, blotting the surface speeds up the drying process. Use clean, white, dry blotting paper. Blotting out in specific areas whilst a wash is wet is another way to achieve a soft white, or soft light colours where two washes are superimposed.

A method I employ to achieve quite dramatic washes is to dip my soft natural sponge into colour and simply wipe the wash on with it. Occasionally I leave white areas to add impact. You need to be quite direct in this method, using light tones and not worrying about going over the occasional flower. Any victims can be picked out at a later stage when the wash is dry. It is best to take your strokes beyond the edges of the paper because any stops or starts look clumsy.

To improve the 'wetting' of a wash try adding a little ox-gall to the mix. This will help overcome any surface tension between paper and paint, and enable the wash to flow smoothly.

Colour intensity

I have mentioned colour intensity on several occasions and would like to expand a little on the subject to show you how this is achieved. Flowers depend a great deal on their high colour, but when the watercolourist attempts the same it does not work. The important quality of watercolour is its translucency. Simply putting down the strongest, full strength red on to the paper just looks dull. Why? The paint in the tube at full strength is almost opaque, so if painted as such it will appear dull and heavy. If it has been laid in this way, any deepening of tone will make it even more opaque and dull.

The trick is to lead up to it. Many petals are semi-transparent, which suits the watercolour technique. Because of this, it is best, even with strong colour, to let the paper shine through. This enables you to add both detail and any subsequent darker tones. Red flowers particularly need to be handled carefully. Darkening can really only be achieved with red in greater concentration, or by using a darker red like alizarin. Any other colour will turn the whole thing into mud.

It is best to start by painting all the intensely coloured flowers, particularly if they are in primary colours. You should then work outwards from these. When the whole painting has been developed it will be necessary to further intensify the main flowers to bring the whole picture into focus.

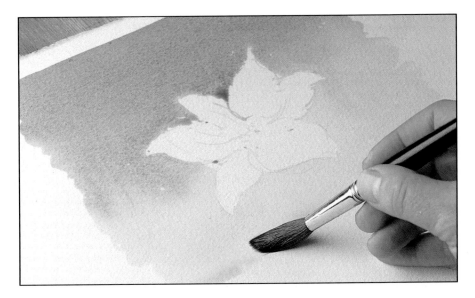

Graded wash

For a graded wash the application is the same as for a flat wash, but as you progress downwards you add more and more water to the colour. This results in a gradual change of tone from dark through to light. For this exercise you should have your board only very slightly propped otherwise you will get uneven gradations.

The transparent quality of watercolour is similar to glazing in oil painting. It gives you the wonderful opportunity to lay veils of colour one over the other and produce all kinds of beautiful secondary colours. A pale yellow over a blue will give strange greens, depending on the blue and yellow. To do this you must ensure that the preceding colour is dry. Overlapping works up to about four colour overlays. After that the pigment density gets to a stage where opacity develops and dullness will result.

When laying in background washes, provided they are fairly pale in tone, you can use the wash to overlay sections of your flower group. This will help to push sections back in space, thereby gaining a sense of depth. If you are working in a studio, and are impatient to apply your overlays, you will find a hairdryer will speed up the process considerably. I often warn my students to be patient and allow the paint to dry if they want crisp, clean overlaps.

Pointillism

One variation of overlapping is the pointillist technique, where a mixture of dots of colour are superimposed on either a coloured background or over one another. This is similar to the miniaturist method of painting and was perfected by several Victorian painters, notably 'Bird's Nest' Hunt (a nickname derived from one of his typical subjects).

Instead of dots try stripes of colour and build up a web of rainbow-like tones to simulate the iridescence of petals.

White lines

If you are irrepressibly impatient you can adopt a technique which does not rely so heavily on drying time. When you paint an area of colour, and wish to paint an area immediately adjacent to it, if the first colour is not completely dry the two will immediately start to merge. A way out of this problem is to put

the colours close, but leave a slight space between them. Hence a 'white line' will surround each colour. Obviously some complicated shapes will present difficulties, but this only adds to the fun. The white line need not be exactly the same width all round but can be varied to create expressive spaces of its own.

However careful you may be you will sometimes find that you occasionally touch the wet paint you are trying to avoid, and a sudden touch of colour invades the other. These are happy accidents and watercolour painting is full of then. If necessary you can arrest this migration of colour by blotting lightly until you have stemmed the flow. The white lines can be left as part of the integral design or can be blended in with colour once the painting is dry by using the overlays described previously.

Edge

Where two colours join together an edge is formed. Where a flower joins its background, or its stalk, or where it abuts another flower or leaf, all these edges require different handling.

Differing light conditions may affect the atmosphere of a group. To achieve this in watercolours you must modify the edge conjunction of objects with each other and with the space behind.

Broadly speaking, the further away an object is the less defined the edge will appear. Close up objects have clearly delineated profiles. There are a number of ways to simulate this in watercolour. The most obvious is to add wet paint to wet paint so that edges become extremely soft. If you do not want such a soft edge first allow the paper to become semi-dry. If you allow the paper to become totally dry the edge will be crisp. You can still wet areas locally with clean water where you need a soft edge and control it with blotting or a hairdryer. Another way to soften these junctions is to use a natural sponge, cleaned out with clear water

and squeezed until damp. Careful teasing with the sponge will blend colours together even in quite small areas. For much smaller areas use the tip of a sable brush with clean water.

Broken edges

Where a form curves away from the viewer, like the side of a vase or a curving petal, you may need to contrive an edge that will 'go away' from you. One method is to give it a 'broken edge'. This can be done quite deliberately by dragging the brush so that it hits and misses the surface texture of the paper. To do this you need to use a round brush and work the side of it so that only the length of the bristles is in contact. It must also be a fairly brisk stroke. Broken edges are a way of producing a shimmering outline. To achieve this first dilute the paint and simply dab the brush using ever diminishing strokes.

Dry brush work

Final details are always a matter of personal judgement. There is the temptation to overdo it. In many respects it is better to have too few rather than too many. You will find that the viewer will be able to fill in the rest. These details are invariably textural – veins on leaves, stamens, anthers, patterns on petals, seed heads, tendrils and fine stalks. Sometimes these details need a slightly broken quality. To achieve this the colour should be fairly saturated with pigment with only just enough paint on the brush to dampen it. You will also need a small piece of spare paper of the same type as the one you are working on. This is used to test the stroke. The stroke should be deft but with enough pressure to just bounce over the surface of the peaks in the paper. Needless to say, practice makes perfect.

Another dry brush method involves opening up the hairs in a round sable or flat so that the hairs form a fan. This can be very delicately dipped into the paint and used as above. This is a useful way

of suggesting the fine striations you find in some petals. Remember that the brush has many actions other than the tip simply stroking the paper. You can stipple in dry colour and also use the side body of the brush. The oriental brush is particularly adept at this because the soft outer hairs trail behind and leave all kinds of delightful marks.

Painting solids
By painting a solid I mean when the brush has to execute either a leaf or petal in one go. So often I have seen the situation where beginners have outlined their flower, usually too thickly, and then proceeded to put blobs of colour on indiscriminately. All this in the fond hope they will blend together at a later stage. Alternatively they have painted their flower petals pale then, after the paint has dried, they have attempted to put in the tonal gradations. This usually results in hard edges. Both these approaches tend to give the flower the appearance of a piece of crunched up cardboard.

It is far better to select the brush size relative to the petal size. Then take up enough paint, approximately a mid-tone of the finished colour, and execute the whole stroke in one movement with no white paper

showing through in the middle. Whilst the paint is wet take a little strong colour and just touch the paint at the point where the petal joins the stalk or centre. The pigment will then creep up and give a fine gradated tone.

Sometimes a petal has one colour in the centre and another at its tip, say red and yellow. One way of achieving this, and having clean, gradated colour, is to use a round brush. First dip it in a mid-saturated red and, holding the brush level, dry the tip with blotting paper or simply squeeze it dry with the fingers. Then dip it into the yellow. To execute the stroke you should have the brush at a flat angle and press from the tip through to the body and pull along slightly. It calls for practice, but variations of this method can create all kinds of petal types.

The same kind of technique can be applied with a flat brush. This time you dip one corner in one colour and the other into a different colour. Using the brush edge on you can produce stalks with colour variations.

Occasionally you may wish to produce a shape which appears to have no outside edge. This is contrary to the normal practice of many painters who delineate the

edge of a form, sometimes quite firmly, with an outline of some kind. A softer approach is the oriental 'boneless' method. For this your surface should be slightly absorbent and the pigment should have a little ox-gall in it. Lay the form down in a light tone and wait until it is nearly dry, then add the detail in strong colour. This will result in a little bleeding and will create a reasonably natural feel.

Some colours repel others when adding wet-into-wet, for example alizarin crimson and sap green. This was a device used by the early Rimpa school of Japanese painters called Tarashikomi. Skilfully done, it can produce a halo effect of a separate colour to the main body. This can give an alluring look to certain pale-coloured stalks.

There are many touches and gestures in painting. Some have become classic and standard and many books have been written about them. Some techniques have died with their inventors, leaving behind a tantalising glimpse of their creative minds. It is our legacy to add to this wonderful store by pushing ourselves to new limits devising original ways of expressing that suddenness of seeing.

Mixed wash
Proceed as the other washes but as you work horizontally down the surface of the paper add whatever colour changes you require. This will produce striations of colour which softly merge one into the other. This effect can be used for horizontal banding, and the paper may be turned 90 degrees to produce vertical banding.

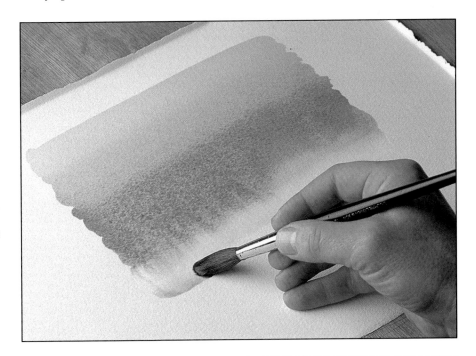

Negative painting

1 For this sequence I have already laid a flat wash. As I progressed downwards I left the silhouette of the white daisy behind. To enable me to do this accurately I drew in the white daisy using a very pale blue colour. To lay a large area of wash a reasonably large size brush can be used but for detailed areas a much finer brush is needed. I add some colour whilst this particular wash is wet. This is what we mean by wet-into-wet painting. The colours blur and blend and, by adding yellow to the blue, a particular kind of green results. I have added purple to the bottom left edge to bring this area slightly forward in space.

2 Once the background wash has dried I use a slightly smaller sable, with a more manipulative tip, to introduce a delicate tone to the shadow side of the white flower. We now have the beginnings of negative painting.

In order to produce a white flower I have had to first darken the background. Now comes the stage where I need to adjust the whites to give the flower form.

3 Whilst the toning in the centre of the flower is slightly wet I add the heart of the daisy. I could have waited for this section to completely dry but this would have produced a harder heart and I wanted it to bleed a little.

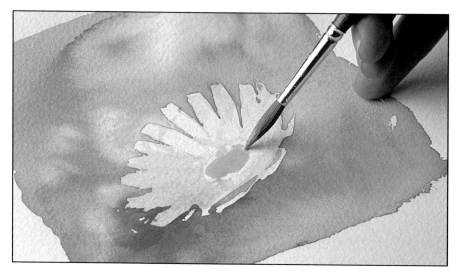

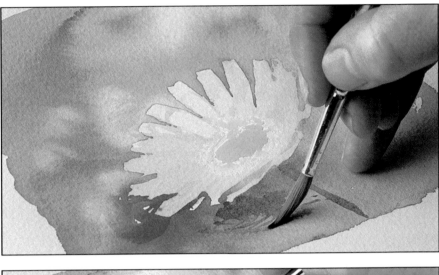

4 Because the stalk leaves are darker than the background I am able to superimpose them upon it. The paper must be quite dry to get good definition. I try to make the leaf interesting by leaving white open spaces to create a texture. All this has been done with a sable brush.

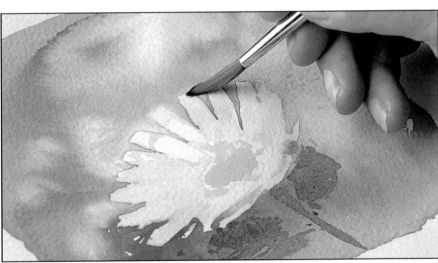

5 I want the furthermost petals to be slightly softer in edge. I use a stiff sable brush and a little clean water. Gently teasing the paint in this region will produce the desired effect.

Alternatively, add water and rub gently with the brush, then pull the paint away by blotting with soft tissue.

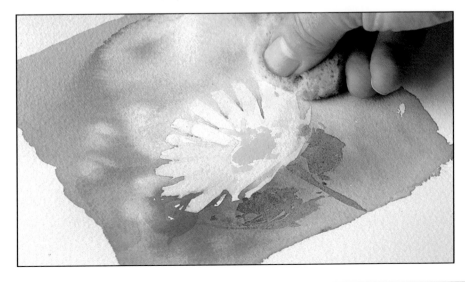

6 The final finishing touch is with the natural sponge. I hold this relatively firmly. Because I am using a hard Not surface paper I am able to give the now dry petal and background area a merging wipe in the area to the rear of the flower. This creates depth.

This demonstration is the kind of thing that could occur in several areas in one painting.

Although it is a white flower not a single drop of white paint is used.

White lines

1 The value of the white line technique is being able to paint extremely rapidly without too much drying time.

In this first stage I am laying down very wet poppy shapes. I am using a springy sable brush. I allow the colour deliberately to drain towards the centre of the poppy in order to give a variation in colour and intensity. I try also to vary the size of the marks to add interest.

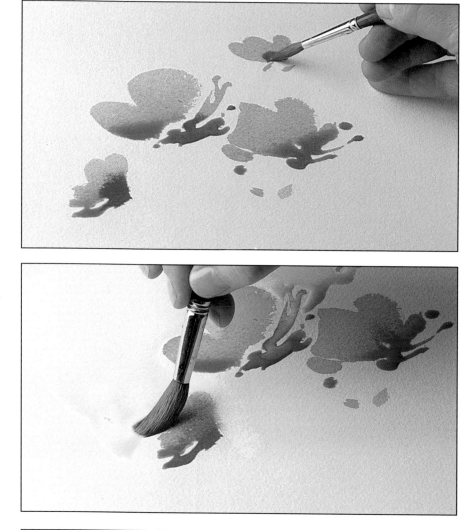

2 At this stage I must be careful because I now have to work a reasonably flat wash around each of the shapes and leave a very slight white space. This is to stop the two colours from bleeding into each other. Occasionally, out of sheer devilment, I allow little tiny touches of it to do just that. This provides some of the nicer water colour 'accidents'.

With the poppy on the left I have deliberately allowed the wash to touch the edge of the flower. This shows the consequence of allowing the wash to touch a wet section.

3 I have very carefully placed small, dark parts in the centres of the poppies. I have used the same white line technique for the middle poppy but allowed it to bleed slightly into the poppy on the right. To stop the continuous bleeding of the poppy on the left I have lightly sponged the bottom edge of the wash. Here I am using a hair dryer to chase some of the colour around the edge of the poppy petal. This produces all kinds of accidental colours. It also allows me to accelerate the process of the completion of the painting.

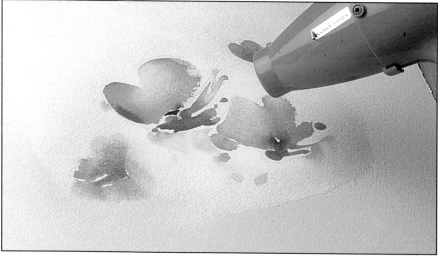

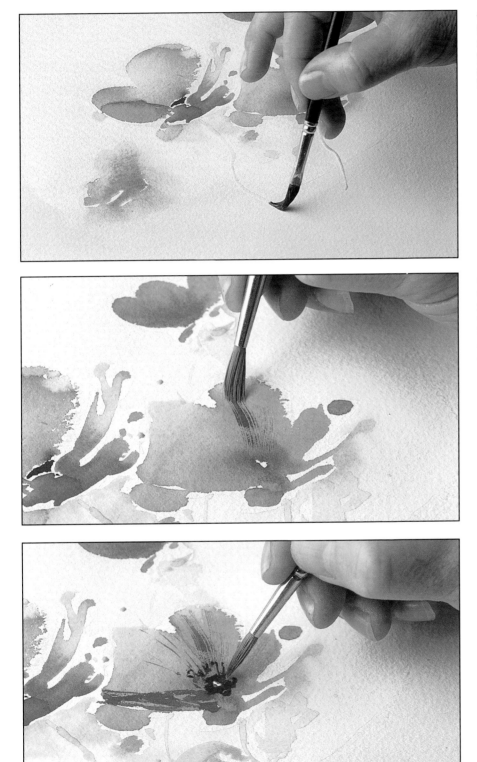

4 Lightly holding a squirrel brush I trail in the poppy stalks. The colour is a mixture of cerulean blue and lemon yellow. I keep the paint very wet and add darker tones which are allowed to bleed to give the stalks variety.

5 Having introduced light delicate stalks and leaves in the same manner as in the daisy sequence (page 56) I now proceed to add more detail. To create the delicate veining in some of the poppy petals I have carefully split the hairs on my sable brush and dipped them (relatively dry) into quite strong pigment. By drawing the brush gently across the surface of the painting very fine parallel lines can be achieved.

6 Final details are now added using a fine sable with a pointillist technique of fine dots. This helps to simulate the centre of the poppy. This whole exercise was carried out using cadmium red and carmine for the poppy, with lemon yellow and phthalo blue for the background washes and stalks.

Two colour brushwork

1 An oriental brush is best for this, but it is possible with a medium sable. Slightly dampen it and put the body into one colour (rose madder) and the tip in another (cadmium yellow).

These flowers have a yellow heart with cool, red outer petals. I first apply the tip of the brush toward the centre of the flower and then, while drawing the brush outwards, press gently down and allow the red saturated part of the brush to come into contact with the paper. This will give you an automatically blended two colour brush stroke. Study the petal shape carefully before executing the stroke.

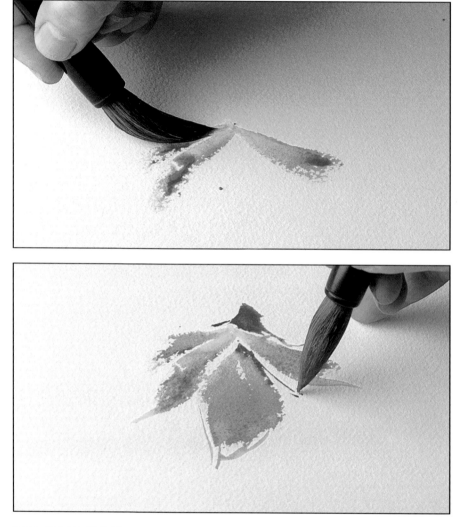

2 Having executed the petals I now need to add a little detail to give the flower realism. I am using the same large brush, but this time drawn to a fine tip, to put in the back of the flowers together with their stamens and anthers. For this I use the colour at full saturation.

3 I have now put in the bulk of the flowers and have included a few preliminary details - the backs of the flowers and some of the anthers and stamens. I next make another type of two-tone brush stroke. The body of the brush has been saturated in a light yellow and the tip has been put into a stronger blue-green mix. With a slight sideways stroke, which allows the hairs to spread, I produce the start of a leaf form.

In executing this stroke a little speed is necessary to allow the paint to skip over the peaks of the paper texture.

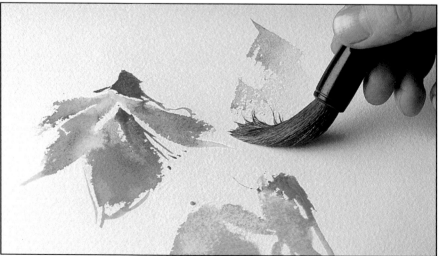

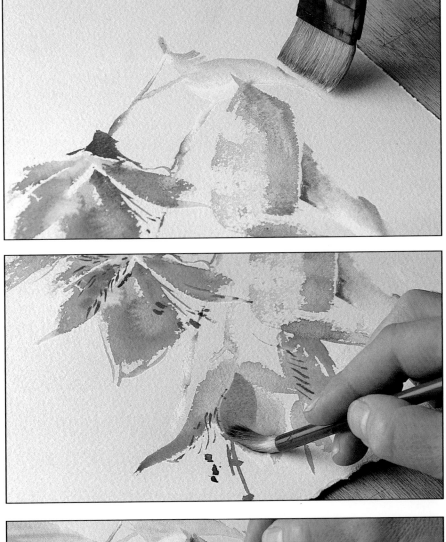

4 This time I am using a hake brush where the right-hand side of the brush has been dipped in yellow and the left-hand side dipped in green. Using a winding stroke I make another leaf form. As the hake is a flat brush it will produce a more ribbon-like stroke.

5 All the leaves have been added and I have included some additional detail to give realism to the lilies. This was done with the brush you see in the photograph - a red-handled oriental brush. This brush has stiffer hair in the centre and soft hair on the outside. It can be used for both detailed work and laying in larger areas.

Here I am introducing additional tones to the petals to give the flowers solidity. Again I saturate the body of the brush with one tone of red whilst putting a little darker tone on the tip.

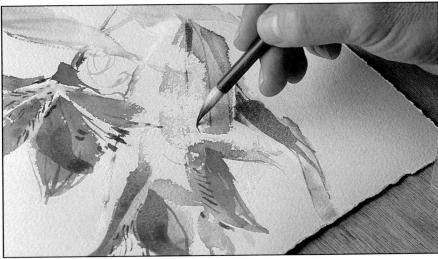

6 I now include my final details with striations to the leaves. This will help to link the white spaces together.

When applying two colour brush-work a little practice may be required on an adjacent piece of paper to develop the skill in working from tip to body of the brush.

Straight lines

1 There may be occasions when you need to produce very straight lines. This can be achieved by using folded paper. Here I am using a piece of 140lb Not paper cut to a straight edge. I dip it into wet paint and simply lay it on to the surface of the paper. I have, in effect, printed lines on to the surface.

2 The card can be trimmed down to produce smaller and shorter strokes. A slight sideways twisting motion will give different forms and imply different types of seed heads. The thickness of the line can be varied by making the fold in the paper either softer or crisper.

3 With a soft squirrel filbert I have indicated some teasel heads. To paint the stalks of these I am using a long piece of paper. This can be bent at different angles to produce sweeping curves. In my right hand I hold the brush, which is saturated with paint ready to apply to the edge of the card.

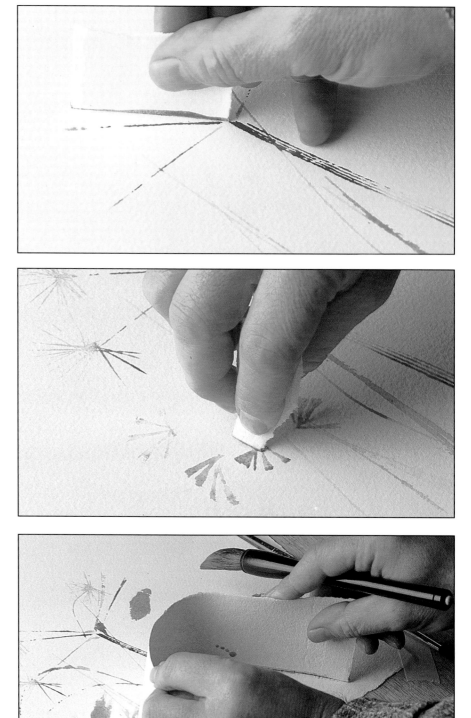

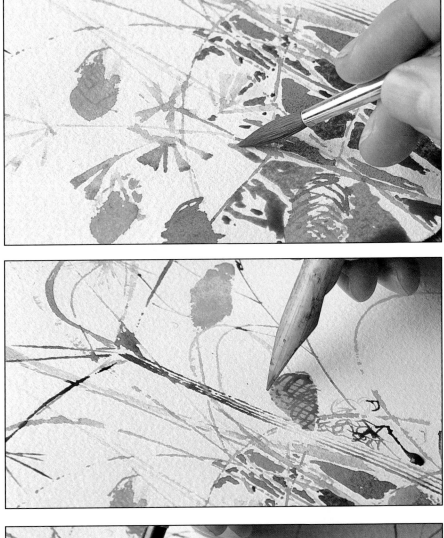

4 This is always a tricky part of the painting and some patience and skill is needed. I am using a fine sable to paint dark tones in between all the stalks. This will help to give depth and strength to the subject. The result depends upon the amount of care taken. A certain amount of freedom in executing these shapes will give a greater feeling of spontaneity. Try not to let the colour remain too consistent. Add small quantities of colours like red and gold to vary the mosaic. This will add interest.

5 For the surface details of the teasels I am using a bamboo pen with quite a fine point to draw in the lines. The slight blotting tendency only adds to the realism. Some less tense lines than those achieved with the edge of the paper can also be added by this method.

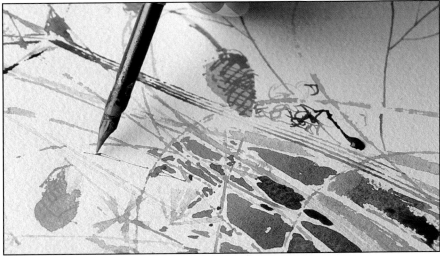

6 For final, very fine details a steel nib is used to make lines similar to that of the bamboo pen but with much finer texture.

The above techniques are suitable for any stage in the painting which requires fine lines of a consistant thickness. The grasses do not have to be dead - anything which has these characteristics will be suitable for this technique.

Reactive colour

1 This demonstration shows how some colours can move others aside. Here I am using a large oriental brush on a 140lb Not surface paper. With the tip of the brush I dot in the centres of the anemones, first by using a combination of very dark violet, alizarin crimson and a small amount of phthalo blue. I use the side of the brush to describe the broad petals and the tip to indicate the petals when seen on edge. I keep the paint very wet at this stage.

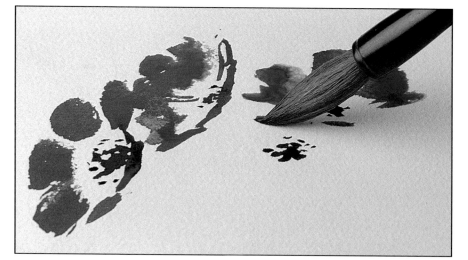

2 Continuing with the same brush I now use a strong phthalo blue and simply touch it in the centre of the petals of the violet anemones. This has the effect of pushing the violet back and creates the illusion of two-tone colour work in the petal.

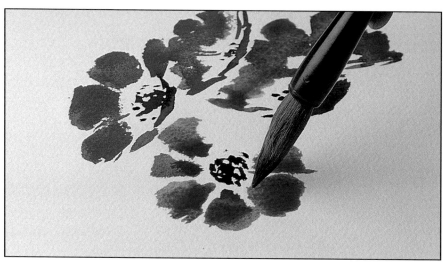

3 Anemones have translucent stalks. Generally they are pale green with very slight red tints to their outside edges. To achieve this I use a springy sable and first paint a line using alizarin crimson. I keep this area extremely wet whilst drawing in the rest of the stalks. You will find you will need to add water to the initial stroke as you go on.

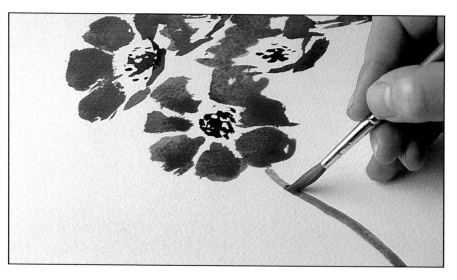

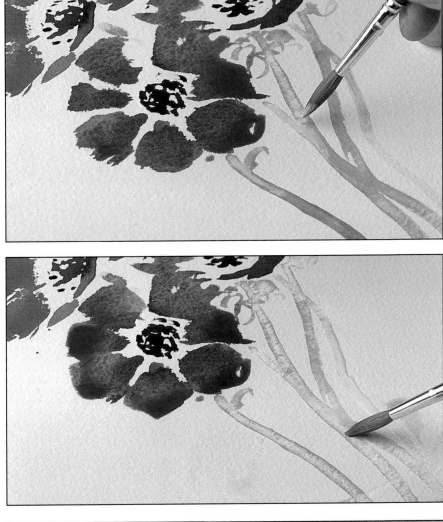

4 Whilst the red paint is still wet, a strong mixture of lemon yellow and cadmium blue is mixed and taken up by the tip of the brush. I now lightly touch this paint on to the centre of the stalks. This has the effect of pushing the red alizarin crimson to the outside edge of the stalk.

5 As the two colours in the stalks begin to dry the effect has been achieved. I now add a little background tone to throw them into relief.

I have also added some more blue to the anemones to give further depth to the composition.

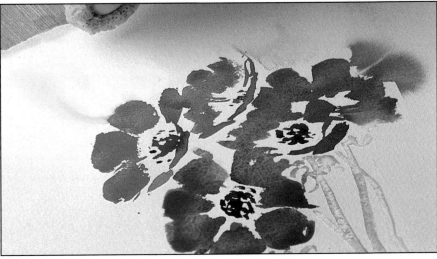

6 Here I am using a sponge to produce a background wash, instead of a brush. This is done merely to wipe in colour which you can vary according to the mood you are trying to establish. To the right I have literally taken the sponge over part of the anemones in order to produce a bleed edge.

Textures

1 Having laid a flat wash in yellow I now proceed to add background colour variations using a screwed-up piece of tissue paper. To do this I blot the paper into my palette using various colours, sometimes quite wet and other times quite dry. I allow these to merge with the background.

2 Further texture is added by using the toothbrush. I dip my toothbrush into a palette of quite strong colour, in this instance red. Holding the handle of the brush firmly in the palm of my hand I draw my forefinger over the bristles to splatter the paint over the surface. To avoid paint going into areas you do not wish it to reach you can mask off these areas with torn sections of newspaper.

3 I put in the leaf stalks whilst the spots of colour are still wet. This gives a variety and depth to the line. I have allowed the line to make and break so that I can put in leaves which will cross over the stalk area.

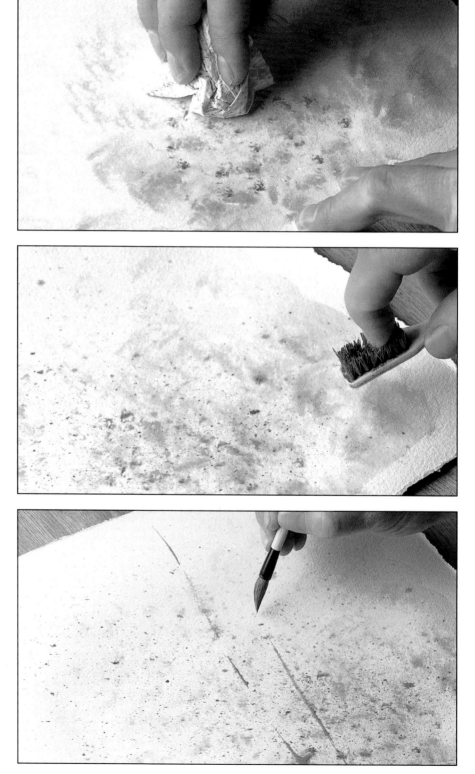

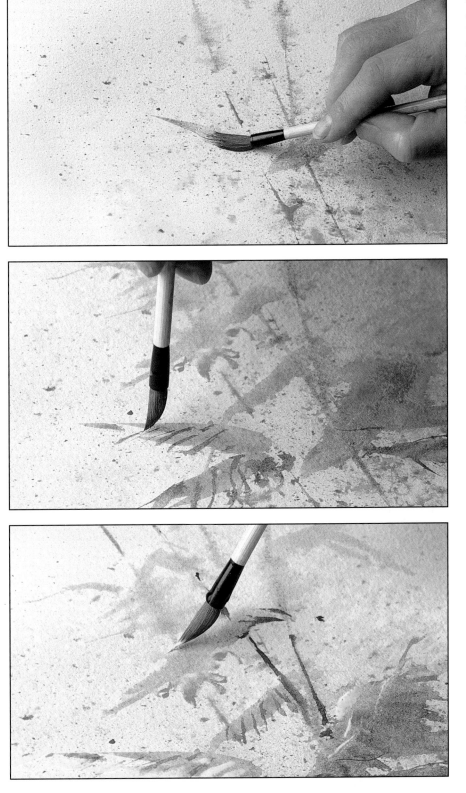

4 To put in the leaves I am using an oriental brush with a slightly divided tip. This brush has great calligraphic qualities. The nature of this brush enables you to draw leaf forms by firstly laying the tip of the brush down and then subtly increasing the weight on the brush to provide body for the leaf, and then lifting it off to form the back of the leaf.

5 Using the same brush I now add detail in a slightly stronger green. This is the occasion when I can increase the depth of tone in the painting. Again the nature of the brush allows a trailing quality in the action. Notice that the angle of this brush is nearly vertical so that only the tip is doing the work.

6 I next add almost unadulterated cadmium yellow to the edges of the leaves to give a feeling of light. Since I have been working very rapidly this can bleed where the paper is just damp.

The beauty of the background splattering is that it helps to bring the whole subject together. Introducing small speckles of red like this helps to complement the green of the leaves.

Pointillism

1 Pointillism was a term used by the French impressionist Seurat to describe a method of painting which involved the use of dots of colour. When seen from a distance these dots merge to form varying hues. A form of this technique can be applied to flower painting.

I first establish the central theme, the lily head itself, by the simple broad brush technique of twisting the brush, and using the paint very fluidly.

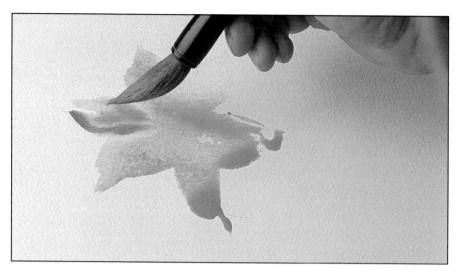

2 Using the tip of my brush, I dot various mixtures which include violet, cobalt blue, alizarin crimson, and a green made from lemon yellow and cerulean blue. I do not just make simple dots but include ticks, squiggles, swirls and lines. This is to show a feeling of light passing through dense foliage.

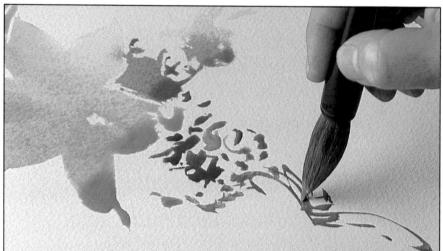

3 I now leave the second stage to dry a little in order to add further areas later. This enables me to work on the lily itself whilst it is still slightly wet.

To create a soft effect of light I am applying a slightly dampened clean sponge, and then I leave this area to dry.

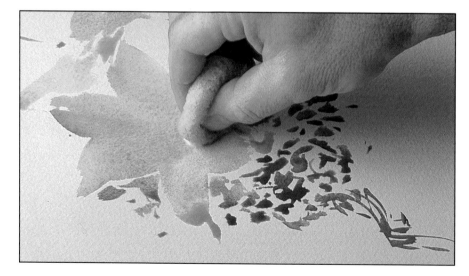

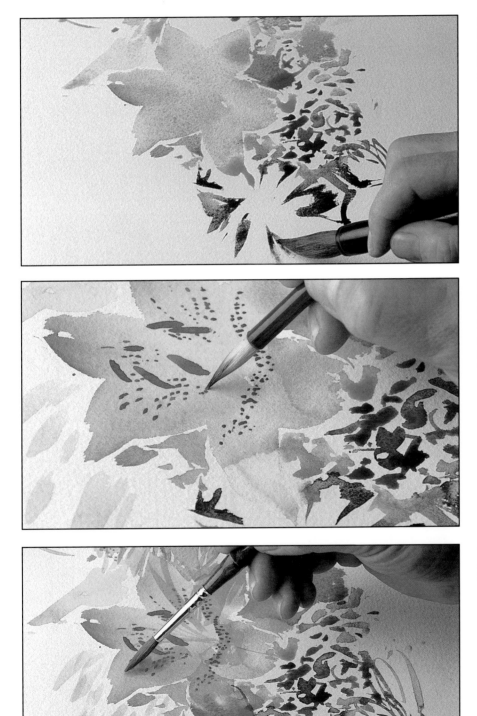

4 As the dots become broader I can use this method to show up, in this instance, a white daisy hidden behind the lily. This technique can be as broad or as detailed as you wish.

5 Within the lily head itself I use fine spots of colour to create form within the petal. For this I use a finer oriental brush with quite rich colour. At this stage the detail may be rather dark but subsequent washes on the petals will tone them down.

6 Finally, with a sable brush, I mix a slightly richer orange using cadmium red and cadmium yellow and indicate further form within the petals to create a greater degree of solidity. The whole painting then comes together with its striations and dots of near primary colours. In the background I have introduced stripes of cerulean blue and violet to help break it up.

Sometimes this technique is better for backgrounds than a solid wash because you can dissipate it as you wish by tapering your brush strokes out towards the extent of the white paper.

Resist painting

1 This method shows how certain areas can be left behind, either white or tinted, whilst the work progresses. A resist medium is used to achieve this. This is a form of rubber solution. It may be applied with any kind of brush, but extremely fine detail is very tricky.

Here I am using a fine oriental brush to produce lines for the lily stamens and small buttercups in the foreground. It is essential to use a hard, dry paper for this technique, and I am using a 140lb Not surface. If the paper is damp or soft you will be unable to remove the resist at a later stage and risk tearing the paper surface.

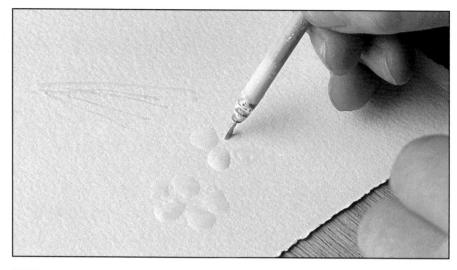

2 The resist medium must be dry before adding any paint. Once this is done, I proceed with a broader brush, in this case a round squirrel. I lay in the basic petal shapes. Already you can see how the resist is beginning to push away the paint from the stamens.

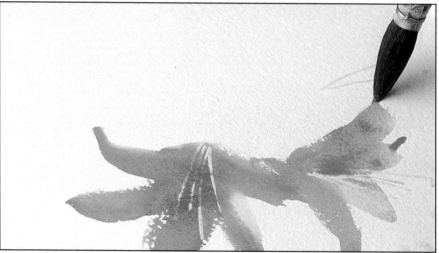

3 Once the lily colour has dried I can go ahead with the background tone. The resist areas shown here are where the buttercups will be placed.

As a further resist technique I have rubbed the surface of the paper lightly with a candle. The candle wax will rest on the peaks of the paper surface and resist any colour applied to it. You can already see this white, speckled appearance to the right of the picture.

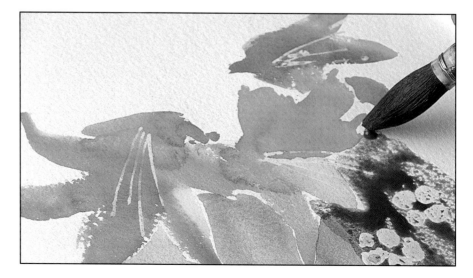

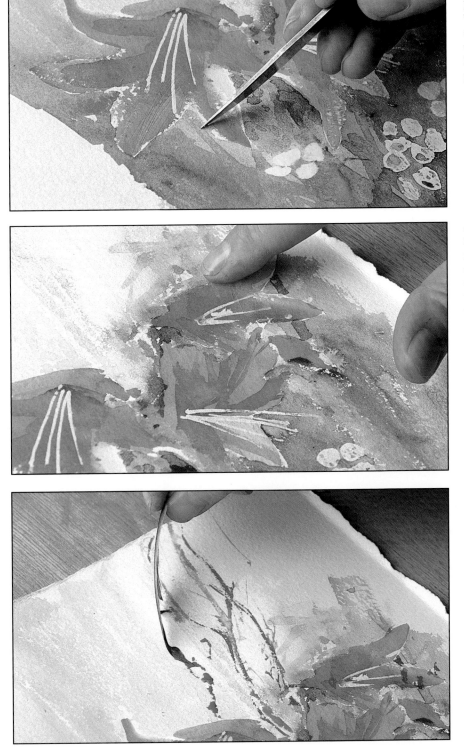

4 I am using a knife to score the surface of the paper and to cut back into some of the wax areas. Using a knife in this way creates highlights. Various kinds of knives can be used for this purpose, either scalpels for fine work or craft knives for broader areas. It is best to use a reasonably robust paper for this exercise.

5 Once the painting is dry I remove the resist by lightly rubbing it with my fingertip. Some areas I leave white, but other areas are tinted with colour. An example is the buttercups, where I have used a mixture of cadmium and lemon yellow. Further details can be added at a later stage. Rather than using your fingertip you can use a soft rubber, but always ensure that the painting is completely dry first.

6 As a final touch I am indicating some trailing, hanging fronds using a feather. By twisting it between the finger tips curving and twisting marks can be produced. The separate barbs of the feather produce accidental marks which can only be achieved using this tool.

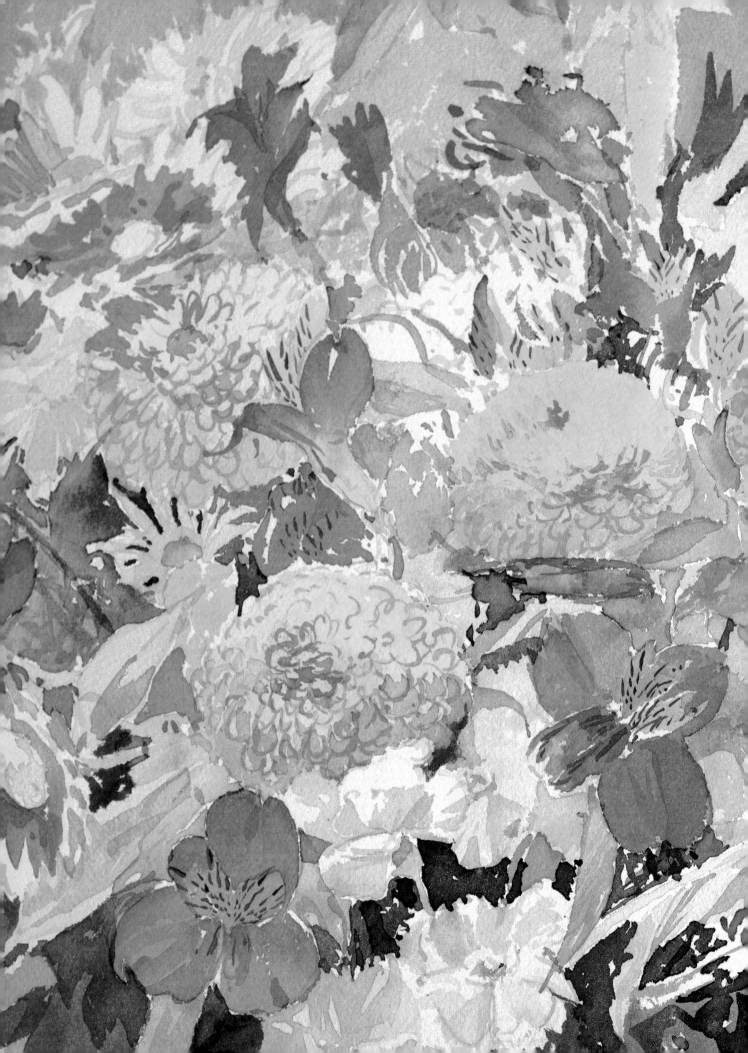

CHAPTER 4

INITIAL
OBSERVATION

It is not surprising that flowers have been likened to jewels. The notion of preciousness, vividness and sparkle makes us respect both their fragility and their temporal nature. The sheer variety provides an endless source for study, from great floppy petalled kinds like the iris to the crisp petals of the lotus; multi-headed as the delphinium or foxglove to the miniatures of the forget-me-not and scarlet pimpernel; flowers in bushes, trees or on stalks, or in masses like carpets; isolated like kings or queens. The spectacle is bewildering but exciting. The artist needs to evaluate his or her relation to this feast both optically and emotionally.

Flower Behaviour

Firstly, consider our physical relationship to these humble plants. Mostly in the wild they are shorter than us, and we look down on them. Their heads are raised to catch the light and attract the insects necessary to cross-pollinate them. When they are bought into the house they are usually displayed either at or below eye level. This way the flower head is presented as nature intended. Some flowers are dramatically phototropic in that they will follow the sun or whatever light source beckons them. This occurs with sunflowers. It can be disconcerting when you are painting a field full of them and they continually turn to face the sun during the course of the day.

When you are confronted with flowers en masse they present an interesting challenge. Where they have the same aspect do look for the various rhythms which superficially may seem repetitive but, bearing in mind the irregularity within individual flowers, can produce subtle sub-rhythms. Remember that flowers move with their delicate stalks. Movement of light, the amount of water they receive, and even movement in the air, mean that a group of plants are never static. They are living things. So often I have seen paintings where the flowers seem dead – perhaps they are.

In looking you need to adopt a flexible frame of mind. This brings out all sorts of emotional responses. The fact that they have a perfume can produce in some instances a feeling of euphoria – something to capitalise on when getting into the mood for painting. I really believe that in contemplating this living movement a magical interaction takes place that is essential to the good in a painting.

Lilies
The fascination of painting these lilies was in interpreting their forms, and how they varied as the plant turned. The nearest flower head, which faces forwards, is picked out in sharp contrast. Those in the background are almost merged with it in order to give depth to the painting. Focusing on forms like these and painting them is both informative and rewarding because the end result is often an interesting picture in its own right.

Looking at Flowers

In my 'staring sessions' I see an extraordinary mixture of textures in plants from furry to shiny, speckled, streaked, sharp-edged, and hairy. There are petals that glisten, and dusty anthers and stamens. It is amazing how plants have evolved for their various purposes.

Anchored to the ground; absorbing water; reaching for light; breathing; attracting insects and birds for cross-pollination and reproduction. In searching for ways to express this in paint it helps if you can relate to these needs and effects.

My father, also a painter, taught me the value of observation. I remember, when I was quite young, trying to paint a clump of pink dahlias. I thought that I was never going to untangle this seeming mess of curling petals and separate one flower from another. My first thought was that I only needed a few squiggly marks in pink paint and that would do it. In no time at all I realised that this was not the solution. My appeals to my father were simply met with 'just look'. Sure enough, after some considerable, seemingly asinine, staring, I noticed that these apparent squiggles seemed to emanate from a centre in the plant – starting small then gradually spiraling out and getting larger. My squiggles were still squiggles but now they had some purpose. The flower told me where to go. For me, in my naivety, it was stunning. Firstly, that the flower in its apparent irregularity, had a structure and order. Secondly, that the order was irregular.

I still look for that now – not only in the flower or plant itself but also in its relationship to other plants. Flower heads vary considerably. Some appear quite regular with a centre from which petals simply

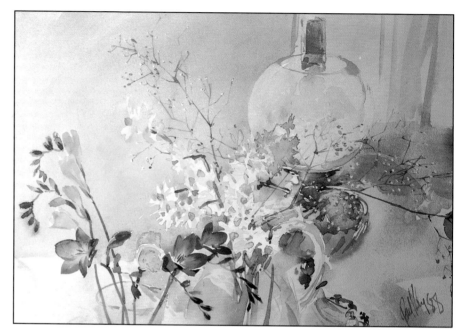

radiate – a daisy for example. Others are considerably more complex, with odd numbered petals of differing length and colour going in extraordinary directions – like the orchid. However, even with the simple type like the daisy and, even within one particular type, the variety is immense. The colours may change subtly depending upon the age of the plant or its relation to the light. If the plant is light or white coloured this can change due to its proximity to other coloured flowers. The form of the flower will change dramatically depending on its position in relation to the viewer – straight on, to the side or from behind. The petals themselves will twist and turn and be at slight or exaggerated distances apart, or vary in size. The colour within the petal will change from root to tip. The centre of the daisy is not just necessarily a yellow blob but a solid mass which has form and is indicated by yellows, greens and oranges with a texture which radiates from the

Pink freesias and lamp
This study of freesias is intended to show how their delicate nature can be contrasted with soft, very pale tones. Their crisp edges are countered by the soft edges of the lamp and background.

In this particular painting I have 'picked' the surface of the paper using a scalpel to indicate the white dots of the gypsophila. For the background I have used a delicate wash of alizarin together with cobalt blue to suggest a soft background against the yellow of the narcissi.

It is important to control the colour changes in a delicate painting of this kind; for example, the difference between the intensity of the pink in the freesias against the delicate pink of the bowl in the lamp.

Red poppy

In painting this giant poppy almost at the end of its life span I wanted to make it seem almost larger than life. I have used strong, dark blue-greens in order to make the red stand out vividly. I have likened the flowers adjacent to the poppy to small colour patches which flutter around.

Painting reds is always difficult as it is all too easy to make them look muddy. I start with very, very pale cadmium red and then add successive layers. I increase the strength until I reach the darkest tones, which have an addition of cold alizarin red. The blue geraniums and yellow buttercups are a typical example of how nature can scatter colour to enhance the principal blooms.

middle. There is much to explore in the humble daisy, which at first may seem comparatively simple.

In the case of a more complicated flower, say a carnation, which has crinkly petals looking like a cabbage, you have to 'sense' the underlying structure in order to make it work. Most plant heads emanate from a centre, and so it is with the carnation. Some flowers more obviously than others. The edges of the petals may be serrated, and although the colour may be monochromatic it will vary from middle to outside edge. Flowers like the carnation, rose, dahlia and chrysanthemum tend to spiral out from the centre. The petals are small, tight and crisply defined in the middle and as they rotate outwards the petals increase in size and become softer and more delicate in colour.

With flowers like the lily, orchid and iris the watercolourist has other forms to contend with. Larger curling petals with complex markings,

anthers and stamens which are very tricky indeed when seen against a darker background. Sometimes these come as splendid single examples like the water lily, whereas other lilies come in clusters, nudging each other for space.

In attempting to analyse these shapes try keeping the flower from the time it buds through to its maturity. Watch its petals expanding, and the stamens elongating, and then notice the colour changes as it gradually dies and falls off the stalk.

So far we have analysed the flower in isolation and noted the complexity within itself. This analysis should be continuous, for it is surprising how the eye tends to get lazy and assumptions are made that tend to result in boring approximations about the true nature of the flower form. This true nature depends entirely on observation and not thinking that there is any one single device which will symbolise the character of any one plant. Observation has to be supported by

putting down on paper the fruits of your investigations. This will develop your co-ordination between hand and eye without the confusing problems of whether or not it is 'Art'. The Art is in the seeing.

A single flower may be seen as complete in itself – almost like a piece of sculpture. However, when seen in conjunction with other flowers, either of the same type, or of different types, another set of values occurs. Whenever an interaction takes place there is bound to be a dominant element. There is nothing monotonous about an array. Even a field full of poppies or sunflowers can never be regulated and seen as a single colour or texture.

What happens when we take a comparatively simple group of say three or four flowers? Firstly, there is likely to be one flower larger than the one nearest to the viewer. Around this flower will be arranged its cohorts, either partially obscured by the others or slightly set apart, or even entangled in its dominant mate. Stalks and leaves will pass either behind or in front of the flower heads whilst between them there will be a tangle of leaves and empty spaces providing a jigsaw of various greens and petal colours.

The most important thing to note is the shape of the spaces between the flower heads. These shapes are as important as the flowers themselves. The spaces are quite often referred to as 'negative spaces' though there is nothing negative about them. They have an equal substance and interest due to the fact that they interlock the 'positive' shapes and produce a sparkle and interest all of their own. Very often I have seen paintings where these spaces have just been a kind of green blob with no reason for being there other than to separate one flower from another. Actually, it gives the artist the opportunity to create depth. If you look carefully you will note that stalks pass behind flowers, re-emerge and disappear again. Leaves do the same to the stalks at

White rhododendrons
These white rhododendrons act as a soft foil to the yellows of the buttercups, pear and apples. I have used many different changes of greys in the whites, varying from yellow to

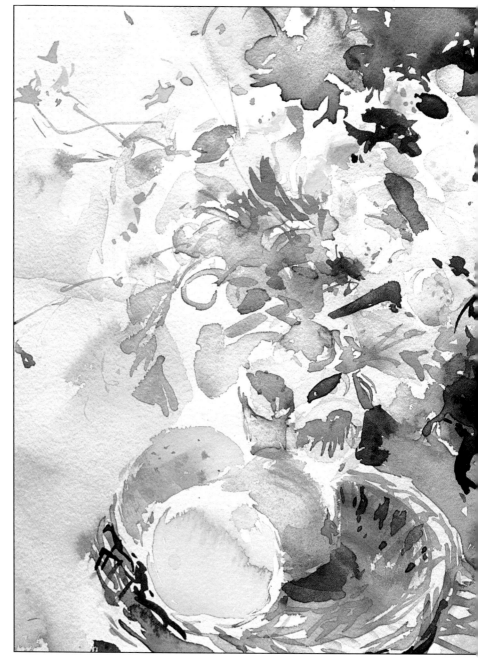

Sunflowers are a classic example of how light affects flowers. Their heads will move with the passage of the sun across the sky. The whole photograph is suffused with yellow. This is how 'field painting' originates where there is one predominant colour.

pink, to blue, to violet. This painting explores these changing tonal values. The white flower in the centre is contrasted with dark blue foliage whilst the white flowers to the right are darker in tone than the background.

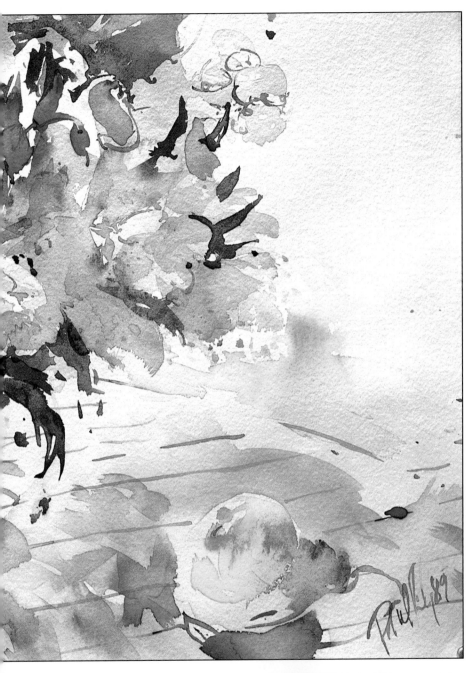

This study shows very strongly the way in which white can be dramatically changed according to the lighting conditions. Within the whites are a multitude of colours ranging from oranges to blues; violets to greens; yellows; and even touches of red.

varying angles and produce a criss-cross of action. This phenomenon is like a jigsaw puzzle. The pieces are all bits of colour; some long and thin like stalks, some trapezoid as with leaves intersected by stalks, some petal- shaped and so on.

Sometimes the colour is uniform and sometimes gradated. The edges of these pieces also vary between being hard when seen close to, and softer where a form is further away, or rounded like the curve of a petal or leaf.

When analysing the colours of these shapes remember the colour is not constant. Take for example a red flower. Part of the flower may be in shadow so that area may be a darker red. Colour is modified by the amount of light shed upon it. The red of the flower is what we call its 'local colour', that is the colour it appears to be whilst the viewer is adjacent to it. This local colour is subject to all kinds of influences that can change it quite subtly, or even dramatically turning red into blue.

However, if we take a white flower – a rose for example, first note that white as such is not there. Parts look either pink or yellow, green, or even blue. Prove it by placing a sheet of white paper behind it. Some of the differences are due to subtle surface pigmentations but the main difference is due to lighting conditions. If you have a strong light full on the flower every detail stands out and its local colour is fully displayed. This condition is not always so in looking at a group. A white flower in the shadow of the group would be dark in tone. This tone may appear grey but on closer inspection that grey is slightly pink or blue. In other words the flower or rather that part of the flower has changed colour. Light affects so many views that it is well worth investigating light properties just to appreciate the colour changes that can occur.

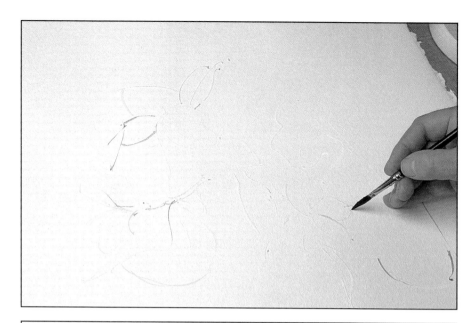

Negative spaces

1 This is a simple study of three flower heads showing the nature of the spaces between them. I start by very lightly drawing in the basic forms with colour, using a thin squirrel-hair brush on 140lb Not surface paper. It is important to keep the line work very fine so it does not dominate the painting.

2 I now begin to put down the light tone of the petals, noting how they change slightly as they turn from the light. The colour is so pale that it is close to the tone of the paper. This will only start to make sense when I add the darker accents after the paint is dry. For certain colour changes I have added colour while the paint was wet, thus enabling soft colour gradations

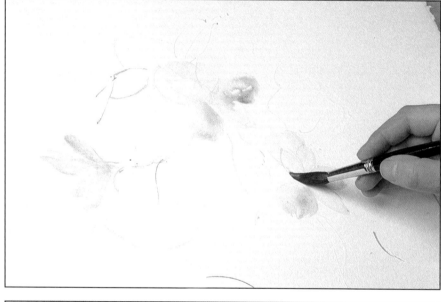

3 Using a large sable brush I now paint in the leaves as they pass behind the blooms. This must be done when the previous paintwork is dry otherwise 'bleeding' of the edges will occur which will destroy the crisp nature of the petals. This is a form of negative painting in which the light areas of the previous stage are left behind. There is no attempt at this stage to show surface details but only to concentrate on the basic colour shapes and note the inter-relationship of one flower head against another. I have introduced the simple circular shapes of the oranges to act as a contrast to the irregular forms of the leaves and petals.

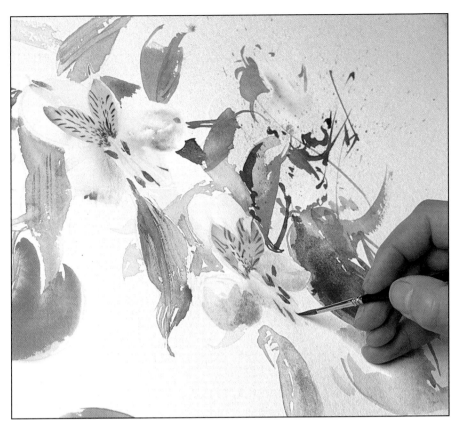

4 Once everything in the painting is quite dry I add my darkest tones. I am concentrating on three flower heads and all else is subservient to this so I have 'abstracted' certain areas to dissolve the picture into the background. I am seen here putting in detail markings on the flower petals using a fine sable.

5 In a study of this kind I adopt a very direct approach with few soft edges. It is mainly about the crisp delicacy of the petals and their patterns. The shapes between the flowers are as important as the flowers themselves.

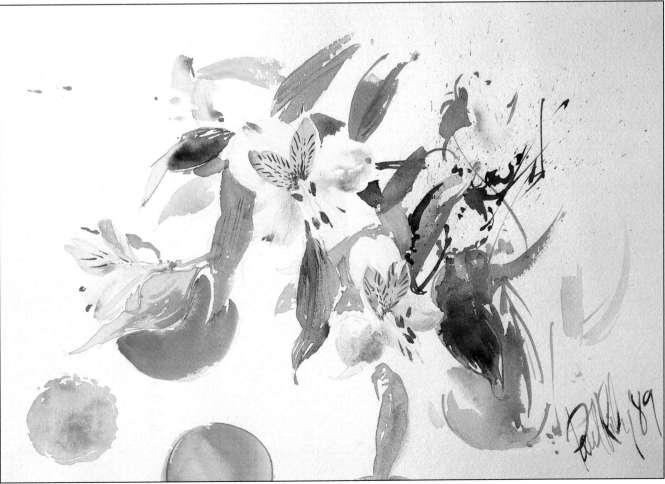

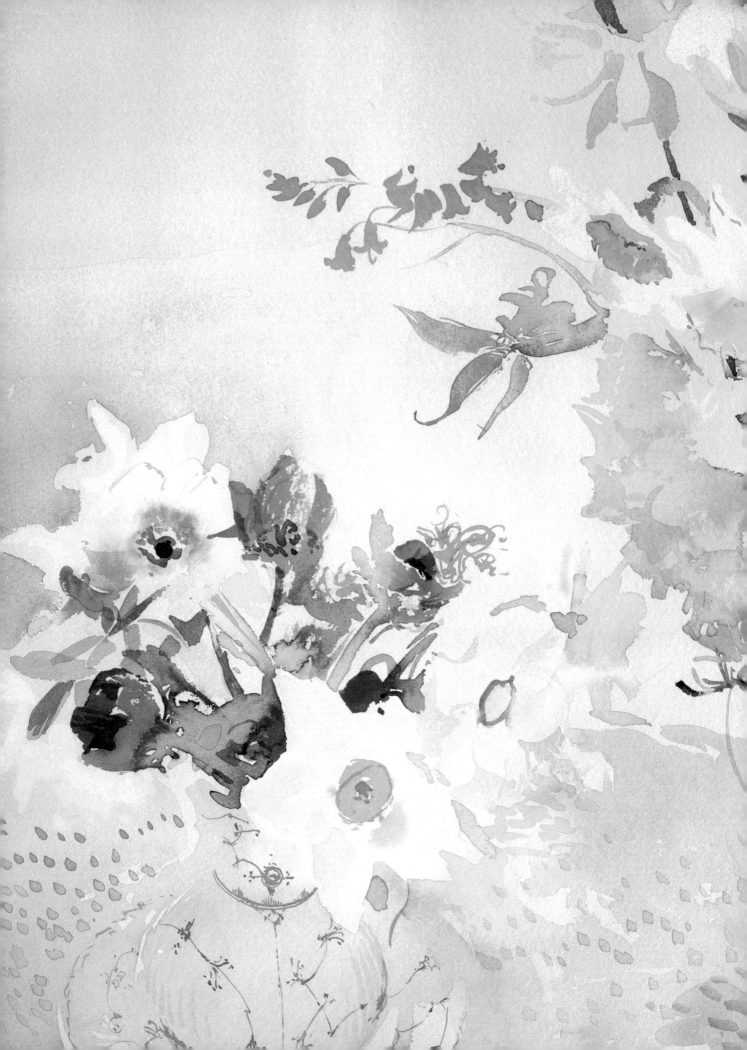

CHAPTER 5

SEEING THE COLOUR

We are now going to see flowers not just as objects but as abstract elements forming a composition. We have to dislocate our minds from the notion of petals, leaves and stalks and concentrate on colour shapes. Abstraction means separating out the colour from all detail. In composing we arrange these shapes to provide the maximum interest to the viewer.

There are two approaches to composition. With outdoor painting the flowers are fixed so you have to choose a viewpoint which best achieves the balance you are looking for. In the studio you are in control. Whichever it is, there are a few guiding principles that will affect either situation.

Colour field and complementaries

If we are to 'abstract' the colour and shapes of the flowers then the first thing to look at is the colour. For most of us, of course, it is the main reason for painting flowers.

In the garden you may be confronted by either a whole group of flowers of the same variety and colour, or alternatively by wildly differing types. Your choice is affected accordingly. In a situation where all the colour is apparently the same, or similar, hue the artist needs to explore all the subtle differences. This is quite often referred to as 'colour field' painting. In this situation there are no strong contrasts, just variations of the same colour. Take, for example, a field of poppies. You would find light and

dark reds. Some will look almost purple and some light orange.

This monochromatic type of colour scheme can also be produced in the studio, perhaps using props which pick out the same colours as the flowers. To start with try experimenting with arranging all white schemes. This will show up all kinds of delicate tonal and colour variations which you would not have thought were there. Experiment further with other flower forms and hues and paint a rich scheme, say in blues. Include five or six different types.

Field painting of this kind can be enhanced by including other colours. These can be chosen for various reasons which relate to

optical phenomena that affect our senses. In some people, including absolute beginners, this is a purely intuitive thing which unerringly produces harmony that is quite breathtaking.

Nature has a way of producing colour harmony that has been a source of both inspiration and investigation for artists. These harmonies, and indeed colour clashes, have been analysed to a point where by following certain procedures the artist is able to maximise the impact of his painting.

It is beyond the scope of this book to go into all the details of colour theory but there are one or two useful tips to help you choose which colours can 'go'. I use the

Colour Wheel
The colour wheel demonstrates which colours are complementary to which. The red of the poppy is complementary to the green of the leaves. The violet of the anemone is complementary to the yellow of the daffodils. The blue of the periwinkle is complementary to the orange of the chrysanthemums. Primary colours (red, yellow or blue) are complementary to secondary colours (green, violet or orange).

Further sophistication in the colour wheel is produced when, for example, the green moves towards the yellow and becomes more yellow. As the green moves towards the blues, the greens become bluer and colder. Therefore the blue-green would be complementary to a red-orange, and a violet-blue complementary to a yellow-orange.

Using complementaries like these attracts the eye and there are various ways of doing this. For example, in the foreground when you wish to bring the subject area close to the viewer; or in a soft gentle way, when wishing to add 'sparkle' to your composition.

word 'go' with trepidation because rules often get broken and the most stunning effects can result.

Theoretical analysis of colour has deduced that each colour has a complementary, and they have a kind of mutual attraction. For example the primary hues – red, yellow and blue are complementary to the secondary hues of green, violet and orange respectively. This is quite a useful aid when planning any scheme involving two or more different coloured types of flowers.

Using direct complementaries can be a little heavy handed at times but with modulation quite delightful qualities can be exploited. One way is to modify one of the complementaries to make the other appear brighter. This can be done by either diluting or making a grey by using a little of its opposite number. I use this technique frequently in my backgrounds. The same technique can be used for table surfaces if they are white. You can subtly alter the

white into violet, or orange, which will be determined by the colour of adjacent flowers.

Desaturating complementary colours when dealing with pale, delicate flowers is another way to produce harmony and give the whole picture a light, airy feel.

You might want to attract the viewer's eye in a very dramatic way. Try putting two colours together of the same tonal value, for example, cadmium red and cerulean blue. Because the eye would not be able to decide which to rest on, due to equal demand for attention, the result would be an interesting flickering between the two.

After choosing the colour scheme, the next most important factor is 'proportion' – how big or how little to make these colour elements. You will find that if you reduce the colour into tonal values of light and dark, you can balance the proportions more easily. For example, you can balance a large,

Blue grey catkin
I have chosen for my field colour a specific blue-grey. This was suggested by the colour of some catkins which my wife picked for me one Spring morning. Everything in the composition is subservient to this colour. I chose a pale, warm, yellow to complement the blue, but tinged it with grey to keep the colour field together. I have used a fairly strong back light to provide additional blue-grey shadows. The daffodils are an extremely pale grey-white tinged with yellow. The beauty of choosing this particular colour for a 'field' painting is that it produces a soft romantic quality.

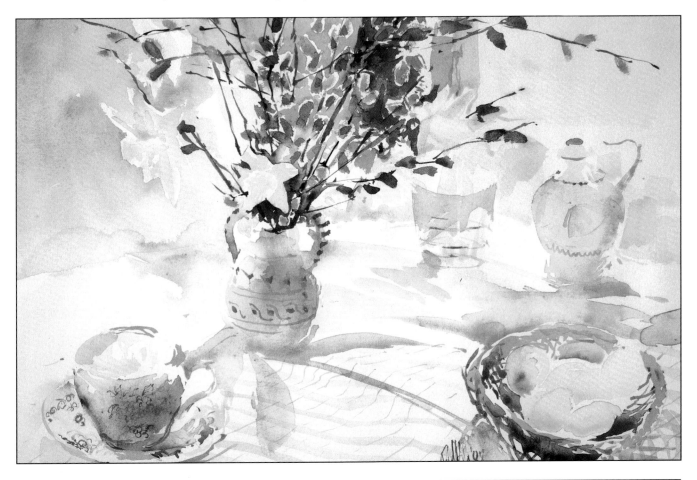

light object with a small dark one – a large, light-yellow chrysanthemum with a small violet. Dark tones in a strong colour attract the eye very powerfully and should therefore be used sparingly. Light tones calm the eye and allow it to explore the intricacies of a mass of blooms. You will see that I use the white of the paper extensively for that reason. It is the interaction of these elements which produces calm and active areas which stimulate the viewer with their variety.

Colour proportion relies greatly on relative intensity – the brightness or dullness of the colour. To achieve full intensity you must use full strength pigment. This is known as colour saturation. The opposite, desaturation, means diluting or neutralising the colour. By these means you will be able to obtain depth even within a single bloom.

To neutralise a colour means to reduce it to a grey either of a similar hue or a complementary one.

In watercolour painting this playing about with intensity is the 'icing on the cake'. It can either be established at the outset to set the scene, so to speak, then everything else is played down to support it. Alternatively it may be added last, by way of accents, to achieve

sparkle. Most often the saturated areas will tend to advance toward the viewer so they need to be at the forefront of the picture plane or in the centre of interest.

The other colour factor which affects depth in a picture is the temperature of a colour. Temperature is the apparent warmth, or coolness, of a colour.

Generally speaking, reds appear warm, and blues cold. Because paint manufacturers cannot produce absolute primary colours they will always tend to be slightly warm or cold. Take yellow for example. The two principal types of yellow are cadmium yellow and lemon yellow. The cadmium has a decided leaning toward orange, whereas the lemon has a faint greenish tinge to it. Reds vary quite strongly between cold types like alizarin and carmine to warm reds like cadmium and vermillion. Ultramarine blue has some red in it, but other blues, like cobalt and cerulean, are very slightly yellow.

In flower painting, as opposed to landscapes the cooling down of colour is more confined to the shadow areas which are dictated by the lighting conditions, although it can sometimes be used to give added depth to a background.

Spring flowers (detail)
All the colours in this particular section of the painting have been desaturated. This means that they have been reduced to their lightest tones. However, certain colours may be dark, for example the reds have been brought as close as possible to the same tone as the blues and yellows. This is so that the greys can register colour at the same time. There are occasions when light appears to produce what I can only describe as a dusting of colour over the whole picture. I was seeking this particular quality of light which tends to produce a slight haze over the entire painting. To achieve some of these effects I had to sponge the colour off and add in further colours as I progressed with the painting. Restraining colour in this way can also teach you a lot about colour patterns.

Narcissi and snowdrops
Can you see where complementary colours have been used in this painting? Here we have yellow with violets, greens and reds, blues with orange. The intention in this painting is to produce a shimmering quality wholly resting on the use of complementary colours.

Sometimes you may need to restrain the colour to keep it light and delicate, but sometimes you need to emphasise their strengths in order to create depth.

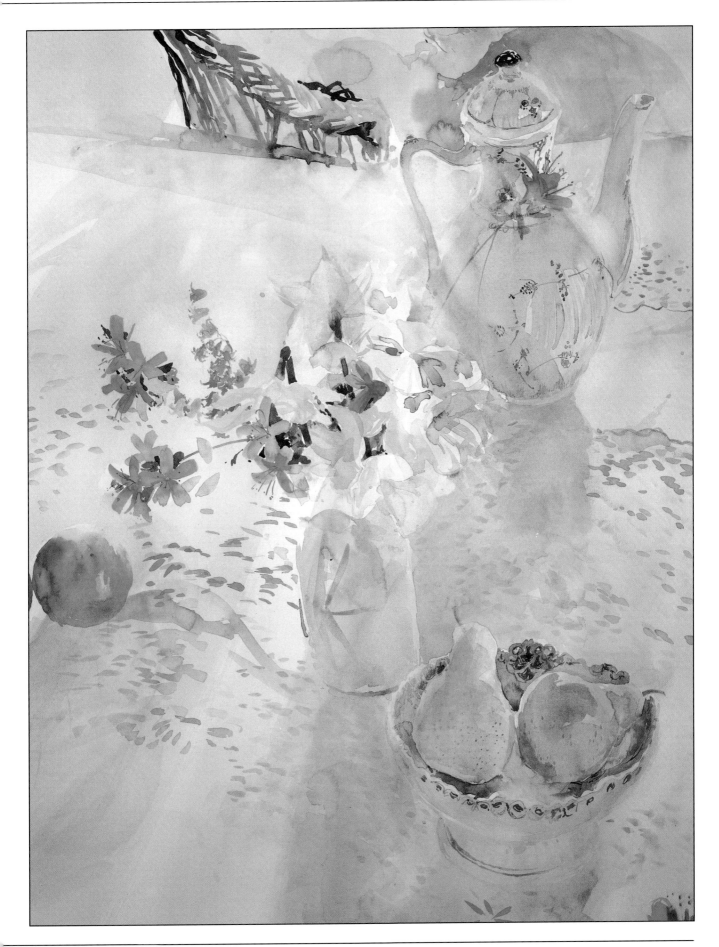

Lighting

There is no colour without light, and lighting can play a significant role in creating interest. We have all seen any number of pictures that look as if there was no light source at all. Everything has a bland, dead look because the artist has not considered how the light has affected his colours.

For me the distribution of light or chiaroscuro, as it is termed, is invaluable for linking up various aspects of the composition. Not only for the interplay of light on the surfaces of blooms, leaves or vases, but also the areas of shadow which cross over objects or planes. Lighting can also emphasise the transparency of certain petals. This may enable you to see where petals sometimes cross over one another, and in so doing create another colour. It may also help determine where a solid – be it a leaf, stalk or bud – passes behind such petals.

It is very important to determine the lighting direction, for it is this that will establish the 'key' in a painting. High key or low key – light and bright, dark and muted. I am forever experimenting with different lighting directions of varying intensity because this playing around can suddenly give me the whole idea for a painting.

The most traditional lighting direction is from the side. The rea-son for this is that it helps to establish form. That way you get a light side and a dark side, and the flowers will look solid. More often than not this side lighting is generally higher than the subject and gives reasonably short shadows. The end effect is a good disposition of tones without heavy shadows. Good enough but a little obvious, particularly if the light is coming in from the right.

Set up a small group of flowers and then, by using an adjustable lamp or powerful torch, try lighting it from the side at different heights and see what happens.

A somewhat less obvious approach is front or back lighting. Front lighting has the effect of bleaching out all tone and reducing shadows to nil. This type of lighting of the subject of the painting presents a decorative surface full of bright colour.

Back lighting, *contre-jour* as it is sometimes called, creates some very beautiful effects. Back lighting is sometimes achieved by placing your flower group in a window where the outside light is stronger than the inside light. This can be created by artificial means by using a spotlight behind the group. The impression that this type of lighting gives is low-key, with a halo of light around the periphery of the objects. The shadows may also be long and dramatic, depending on the angle of the light source.

Another way to achieve low-key effect is to utilise half light, *demi jour*, in any of the above directions. This will cause the colours to be softened and muted. I have sometimes used *demi-jour* with a small pinpoint of light to help pick out my area of interest.

Try experimenting with coloured light, not just from oil lamps and candles, but also the kind that you would obtain if sunlight were streaming through coloured curtains. Used in a restrained way this can be quite beautiful. Talking of curtains, one way of getting textured light is to use lace curtains, or even gauze.

Shadows are always fascinating. They can be full of colour and, when caused by certain objects and flowers, can result in the most fantastic shapes. It is for this reason I sometimes light my studio with more than one light source at different angles. This produces marvellous shadows of differing intensities which intertwine and bind the picture together. I hope this gives you an idea of how lighting can transform your vision of what flower painting can be like, and that you will experiment with your own light sources.

The photograph on the left shows a composition with the main light source from behind casting long shadows. This is *contre-jour* lighting. The overall effect in this instance is coolness, with subtle and interesting shadows.

The photograph on the right shows an oil lamp as the main light source and all of the objects are suffused with a warm glow. The yellow light is echoed in the selection of yellows and oranges in the props.

This view of my studio helps to show the various lighting conditions under which I work. All of which have their own special atmosphere. The window on the wall to the right is where I set up groups for *contre-jour* studies. This gives an effective back light. Above I have fluorescent strip lights which you cannot see in the picture, reinforced with small halogen lamps. These can be adjusted to provide differing shadow patterns. On the table I am working with a group which includes an oil lamp and a candle. Behind and above me I have roof lights which give ample daylight from the north. I also have small portable halogen lamps which I can place low down in any position to suit specific lighting requirements. All this paraphernalia enables me to work in the wintertime and, for that matter, at night.

Atmosphere

In this chapter I have used photographs to help explain what happens when flowers are viewed under various light conditions. This is because unless you have trained your eyes to look for the differences it is not always apparent.

Photography, which uses a lens very like the one in the eye, can help demonstrate what happens when you see flowers. The camera simply records the object, whereas the human eye is subject to the interference of the mind.

Colours in soft focus merge and diffuse into their background colour to produce an altogether different impression of what that colour is. This occurs in misty light conditions where there is water vapour present in the atmosphere, giving a slight blue cast to everything. This has the effect of making reds slightly mauve or even purple. Yellows would tend to appear more green. It is as though blue has been mixed in with the colour on your palette and all the edges have become blurred and softened.

Daylight, which many painters use to study flowers, has in fact a quite cold effect on colours. This will of course vary, depending whether the sun is in or out.

If you bring the same flower indoors another colour suffuses the petals, which may either give rise to problems or enhance the natural local colour. Traditional tungsten light is fairly yellow, making reds slightly orange, blues greener. If you have a very pale yellow flower, however, you might be inclined to put too much yellow in it in order to compensate for the yellow light.

Oil lamps and candlelight, too, have properties that can produce magical effects with warm colours suffusing everything. The light from

This is a good example of how the photograph has captured the delicacy of flowers. The nearest flower is in quite sharp detail but the flowers behind have become fuzzy abstract blobs of colour. Watercolour painting, in order to obtain this depth of field, should create a similar appearance. See also how the background has been reduced to an almost indistinct neutral tone in order to allow the strong colour of the flowers to take precedence.

This is a particularly inspirational photograph, especially because of the way the light has been captured.

The red of the poppies is enhanced firstly by the dark tones of the background, and secondly by the way in which the light passes through the delicate petals. The light, in this instance, is so short lived it takes a photograph to capture the beauty of its elusive quality. Looking at photographs in this way helps us to observe the transient quality of light as Monet often did.

candles is very illusive in that it flickers and flows spasmodically, creating beautiful shadows and twinkling highlights.

The problem with using a very warm colour source is that the painting will appear to change in colour when viewed under a different light. In my studio I have a quite complicated rig which uses several light sources. This enables me to explore all the fascinating differences which occur, and also enables me to move the painting around to gauge what it looks like depending on where it might hang. I have overhead daylight in the form of rooflights which have blinds that can control how much light comes in. This is useful for continuing a painting started in the evening. Daylight also comes in from side windows which helps to compensate for the overhead source. I also have daylight corrected fluorescent tubes which simulate my overhead light to some extent. Adjunct to these I have a gantry of halogen spotlights, some diffuse so that I can direct them to pinpoint areas of interest and also to light my work surface. Finally, I have candlesticks of various types and my favourite oil lamp which looks as though it too has grown from the ground with its twirling decoration on the base and bowl.

All this may seem a little excessive but it does give me a great degree of flexibility and has been evolved over a long period of time. The main thing is to be acutely aware of how light can affect colours and how this can be exploited to create the drama and excitement that seeing flowers produces. Experiment with your own light sources and create your own special atmosphere.

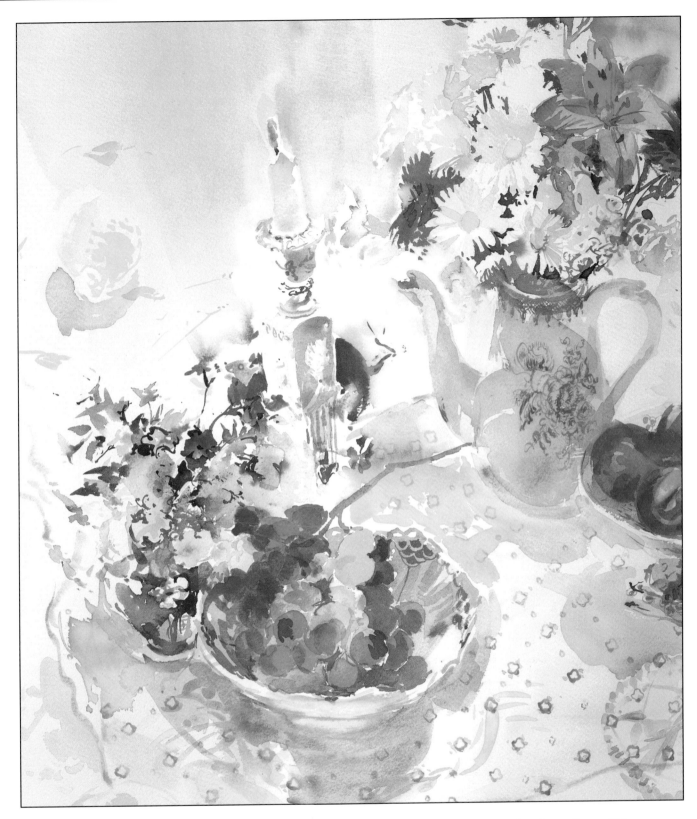

Coffee jug, flowers and candle
Half the fun of painting by candlelight is the fact that the shadows never seem to stop moving! I have not put in a heavy, dark background to suggest the candle flame because this would have dominated the light toned elements within the picture. Instead I have concentrated for my effect on the interplay of shadows and colour on the white flowers. To give the picture a slightly surreal twist I painted the candle flame dark against the light background rather than vice versa.

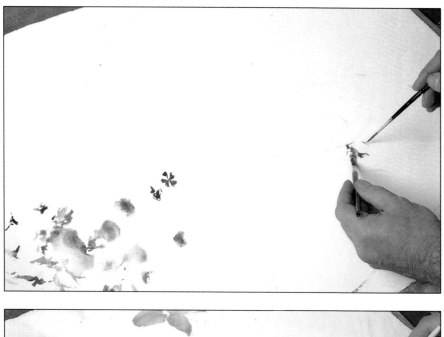

Candlelight

1 I start by putting in all the small blue touches. This enables me to sense the way in which these blue colours trickle over the surface of the paper. I have indicated the white flowers very lightly in a pale greeny-yellow. This drawing in will be obliterated when the main painting takes place. I have used a relatively hard Not surface paper. I am drawing in with two brushes simultaneously in order to show contrast between the larger and finer marks.

2 With a softer, larger brush I start to mass in the cool pinks and reds which form the main part of the composition. It is at this stage that the soft, neutral tones of the various white pots are established. To give emphasis to the candlelight I placed a grey wash around it. The sharp, dark tone of the wick helps to create the feeling of heat. Some of the rich coloured flowers have been painted in at this early stage to allow time for drying when filling in the lighter coloured flowers and foliage. For the pattern on the cloth I made myself a small die of folded paper and literally printed the design on to the painting.

3 I have now come to the stage when the whole painting needs to be brought together. I complete areas like the patterning on the tablecloth and the decoration on the pottery. I also add further delineation to odd elements like the lemon and the small flowers. Then I put down the first light tones for the white flowers. It is important that I wait for specific areas to dry because from now on many of the colours start to adjoin one another. In a large painting of this kind I am able to work from top to bottom and from side to side enabling specific areas to dry.

4 This is the detail stage, so I now look for all the small dark accents and surface patterns that will bring the painting to life. The small blue flowers are given slight touches of realism by drawing in their centres and defining their outside forms with dark background foliage.

5 Great fun can be had with painting by candlelight. The light is never constant, but flickers and changes. In the finished painting I aim to recreate the sparkling, flickering quality of this very special light.

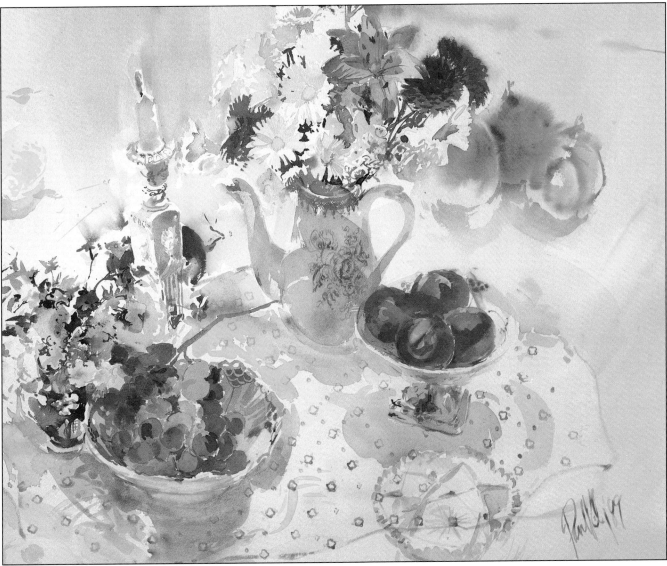

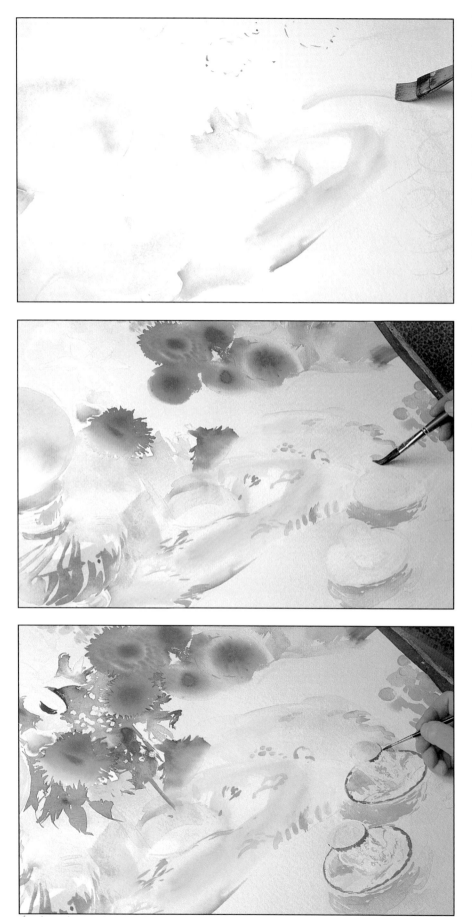

Lamplight

1 As it is intended for this to be a relatively soft picture I have started with a rather wet technique, using an absorbant paper with a Not surface. With a broad hake brush I lay down the 'bones' of the composition. These are sweeps of the basic colours run into slightly damp paper. The detailed areas around the flowers are lightly drawn in colour. I have not drawn around the oil lamp globe for this would fix it too solidly and would not allow it to glow. Instead, I work the colours out from the centre, mainly yellow and violets, and let them blend with the background. I try to cover the paper as quickly as possible.

2 I spread as much yellow as is needed for the lighting qualities to be apparent, and I then add the contrasts. Firstly the bright reds of the chrysanthemums, then the blues of the background. For the chrysanthemums I produce a circle of water into which I drop undiluted colour which then explodes outwardly giving the flowers a 'blooming' look. The flowers are yellow-red nearer the oil lamp and become blue-red in the shadows as they move further away from the lamp. Some of the shadow areas are also established to help me understand how the lighting effect will look. For this stage I am using a soft pointed squirrel-hair brush which enables me to keep the whole painting fairly loose.

3 Once the whole surface of the painting is dry I can start to explore the qualities of depth. I have used a little masking fluid in the foliage to create white spots of light. I now put in the foliage using its dark tone to delineate the petal shapes the chrysanthemum. This is a form of negative painting. It is at this time that I bring out detail in the two coffee cups to the right hand side using the small fine-tipped sable brush. I try to makes the blues of the rims slightly more intense as they come towards the viewer.

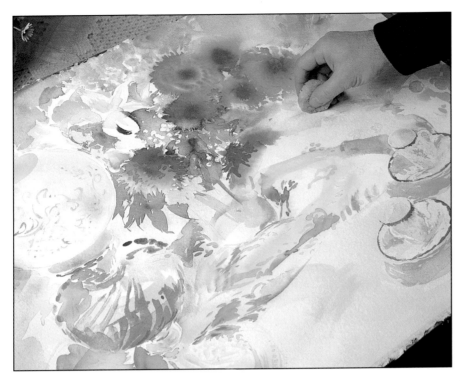

4 I am using a soft natural sponge to blend all areas in the background. Detail is then added to the chrysanthemums, and shadows to the yellow flowers. To create interest in the foreground I have added pattern work to the cloth surrounding the glass jug. A brassy look is achieved to the base of the lamp by wet mixtures of rich oranges and greens.

5 A lot of work is needed to make the chrysanthemums stand out. This means drawing in with a finer brush to express the overlapping nature of the petals. Dark, crisp tones are added to the centres for a second time. Additional shadow tones are added to create the final lighting effect. Remember when exploring light in this way to ensure that the basic colour is established at the outset. This will set the tone for the whole painting through to its completion.

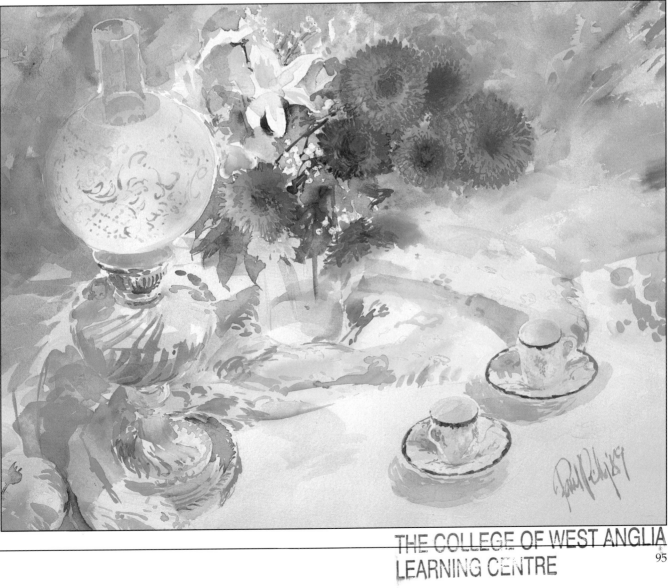

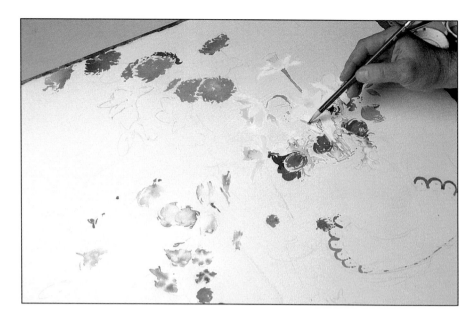

Contre-jour

1 Since the colours are relatively cool I have mainly used a pale blue colour for the drawing in. I then start adding spots of blue, violet and magenta across the surface of the painting. I quickly establish the dark blue pot to the right of the painting. This will tell me how dark the darkest areas are likely to be. Whilst this is drying I then move to the top left and begin to paint in the flowers there. This allows time for other areas of the painting to dry.

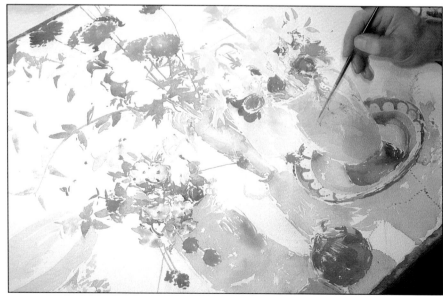

2 This is quite an intricate painting with much detail, so I need to piece it together rather in the manner of a jigsaw by alternating darks and lights. Where the pot stands on the plate I have added a soft yellow tone to create the effect of light creeping around the edge. The leaf forms in the top right of the painting are placed as quickly as possible so as not to lose their natural quality. In this painting I have decided to keep the chrysanthemums as simple silhouettes seen against the light. The reason for this is that there is enough activity in the painting without over doing it.

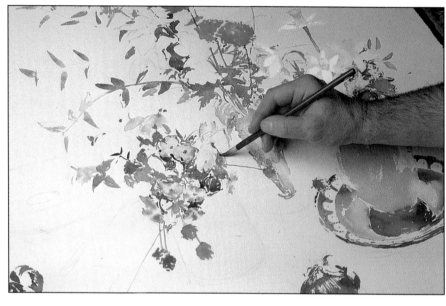

3 Now comes the fun part where I put in the major shadow areas. I am mindful of the nature of the light spilling through the glass vase and use quantities of yellow, green and orange. These are similar to the colours used in the vase to express the shadow. The shadow of the pot on the right has very slightly pinkish hues. These are also added. The shadows for the onions and the plate are stronger because they are nearer the viewer. I am using a fine pointed rigger to paint the detail on the jug. These strokes must be executed rapidly otherwise the springy nature of the decoration will look feeble.

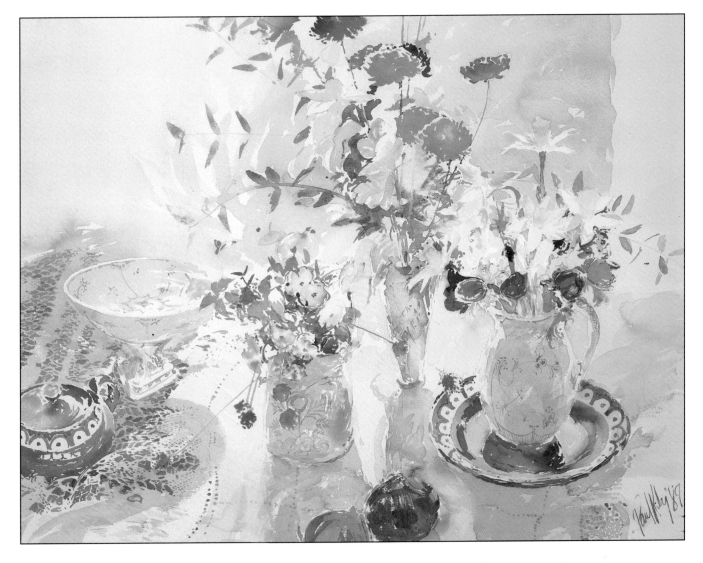

4 I ensured that all the edges of the pots were broken, and managed to create the feeling of sunshine sparkling between them. A few washes of pale yellow help to create this illusion.

I have used the lace work to break up the edges of the cloth and give a soft quality to the whole. All the fine decoration has been added without overstatement because it appears in the shadow areas only.

When painting shadows try to keep them reasonably soft-edged otherwise they will look as if they have been stuck on to the surface rather than having been cast by solid objects. See where I have used little spots of white paper amongst the flowers to create the shimmering light effect.

Planning the Layout

Flowers have a particularly evocative quality when lit by candlelight. Candlelight, by its very nature, is an extremely warm light which tends to tinge any group you set up with a soft pinky orange light. I have deliberately chosen a group of white flowers to reflect this light more readily. The whole group is rich in warm colours and very lightly offset by the blue decorations on the pottery.

We have looked at the arrangement of colour and light but we now need to address ourselves to the business of selecting and laying out our flowers to their best advantage (and yours).

The scope is obviously endless, but a start has to be made somewhere. Much depends upon your ability and time. If you are a slow methodical worker you do not want your flowers to be dead by the time you get round to painting them. If you are unable to complete the whole picture in a day or two then it is best to keep the work area as cool as possible, with just enough heat to keep you warm. This way the blooms, depending on type, will last longer. A useful tip for lengthening the life of cut flowers is to put lemonade in the vase instead of water.

Personally, I have never particularly enjoyed painting just a single vase of flowers, mainly because it seems so obvious. If and when I do, I very rarely set the vase in the middle of my composition. To determine its exact placing I generally do a few small sketches until I get it as I want.

Selecting containers for flowers can be very much a question of personal taste, but points regarding colour and tonal relationships to the flowers need to be borne in mind. If the vase or container is very dark and large it can tend to dominate the eye to the detriment of the flowers. It may be that you have a favourite which has these characteristics, in which case you need to balance its tonal weight with dark foliage and a background which provides a tonal step from light to dark. The colour or decorations on the vase should also relate to the flowers. Remember the points about harmony and complementary colours when selecting the flowers in the first place.

There are many interesting types of containers. Glass presents wonderful opportunities to see through to stalks, leaves, water and background. Ceramics may either be designed specifically for flowers, or

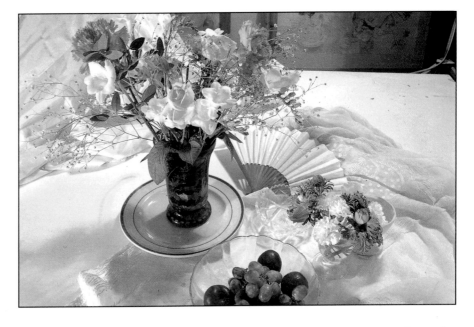

Painting glass can be daunting, but the reflective and sparkling qualities amply repay the effort involved in capturing this illusive material. In this instance an old Bohemian glass vase with delicate decorations reflects the subtlety of the flowers it contains.

My viewpoint is very high so that all the forms appear to be round and reflect the circular nature of the rose and carnations.

even simple jugs are particularly interesting because of their asymmetry. Metal (gold for those who have it!) – silver, copper, brass – these have the attraction of being able to reflect all sorts of colours and textures surrounding the study. The humble tin can, galvanised buckets, baths and jugs all provide further variety. Galvanised containers can even be painted in a colour scheme to suit your picture.

My usual practice with flower painting is to include two or more groups of flowers in a composition. This scheme helps to create more depth because of differences in scale. The flowers in the distance will be smaller and therefore create more interest. Another device is to include other types of objects, which can play a key role in the colour or act as a focal point. Typical examples are: the light source, candles, oil lamps; baskets; bowls; plates; fabrics and anything that takes my fancy, like a Japanese fan or an antique kettle. Whilst I am about it, and depending on the season, I throw in some fruit

or vegetables. These can pick up the colour of the flowers beautifully.

The planning of a group such as the above, is undoubtedly a major exercise and should not be undertaken by the faint hearted. It is rather like creating a landscape. In fact you can treat it as one, and either paint details (small sections), or do several paintings from different view points. I suggest the beginner starts with only two or three items and works up from there, otherwise the challenge may prove too daunting.

In setting out the group you should be mindful of your viewpoint. This aspect is extremely important. Normally painters set their group on a table at their eye level. This gives an elevational view and makes the vase, or container, prominent. Plates are seen as very flat ellipses and almost nothing is seen of the table top. This was the way in which most of the early Dutch masters did their work. You can use this kind of viewpoint when painting *contre-jour* in a window where the light qualities are the

main point in the painting. The elevational view also enables you to utilise mirrors and coloured backdrops. These can emphasise the pattern aspects and pick up colour from your flower selection.

Alternative to the 'face on' approach is the 'plan view' (looking down.) This way you get a more cyclic composition if round objects are used. The insides of plates, bowls and jugs can be seen. The ellipses are more open and you are much more aware of decoration when it is on the horizontal plane. The background becomes whatever you put under your vases. You can use fabrics laid one over the other. Lace may be used to expose layers of colour underneath. These fabrics can be arranged not only flat but also humped up and around the various objects to create a rich tapestry of colour.

Two of my central themes (and indeed my main reasons for painting flowers) are light and movement. We have already experimented with light but we now need to understand how movement can be accomplished.

Plants continually move as you are painting them. Their stems and leaves twist this way and that, and as a result certain rhythms are set up. This is accentuated when looking down on the flowers. The roundness of the shapes both in the blooms and in the objects which contain or surround them set up additional circular rhythms. Add to this a patterned ground cover, plus shadows echoing the movement in the plants, and you have a spiraling motion which energises the whole picture.

You might find you need to introduce some straighter lines to help

Lemon snatcher
This painting is one of those results of an accident of life. My original intention was a painting which considered the relationship between the yellows of the fruit with those of the freesias. As I started working my daughter came and attempted to remove one of the lemons in the composition. Because of her temerity I insisted that she modeled for me. Unfortunately for her she was wearing a yellow jumper which went perfectly with the colour of the freesias. This is an example of a flower composition using a human element as support. Because the nature of the subject matter was very light I decided not to paint in the table as such but to use the shape of the figure's arms to create the illusion of the table edge. I quite often look for points like this to create an illusion rather than stating the obvious.

Flowers with crab

In this composition I have placed two crabs in a glass dish to create a new kind of picture. What I was looking for here was basically two triangles of colour - red and yellow. The red from the poppy, the crabs and the cherries forming one triangle, and the yellows of the peaches, marigold and background light forming another. To link the two triangles I have used a violet blue both in the glass and accompanying flowers. The violet acts as a complementary colour to the yellow whilst the greens of the foliage around the crabs and the apples act as complementary colours to the reds. I have tried to contrast the detailed painting of the crabs with the freer handling of the flowers to focus interest in the subject matter. Note the three different types of shadows coming from the containers.

counter balance this spiraling. You can do this by introducing objects with parallel sides, or include the edge of the table in the composition. I never use dead straight lines as I am mindful of the Greeks who used entasis in their columns (entasis is a slight bulging in the width of the column to counteract the effect of perspective). Furthermore, I find completely straight lines unsympathetic. Again, a matter of taste.

For the more adventurous, why not experiment with figures in the composition? Do not attempt portraits as such but use the natural features of the human face and figure to compliment the flowers. The flowers should take precedence, with the human element acting as support. If you enjoy figure painting you might find to add the 'human touch' gives your flower

paintings greater dimension. This is not a new idea. Look at the work of Odile Redon and that lovely painting by Degas — *La Femme aux Chrysanthèmes* (The Lady with Chrysanthemums).

For animal lovers the same kind of approach can be adopted if you have the kind of pet who will not knock everything flying. In the case of mischievous pets, a study of the animal away from the group can be incorporated at leisure.

Arranging a composition using all the ingredients of colour, form and lighting should give as much pleasure as tackling the painting itself. Having got everything in place, the sense of anticipation is at its greatest and needs only the taking up of brush and palette to realise your masterpiece.

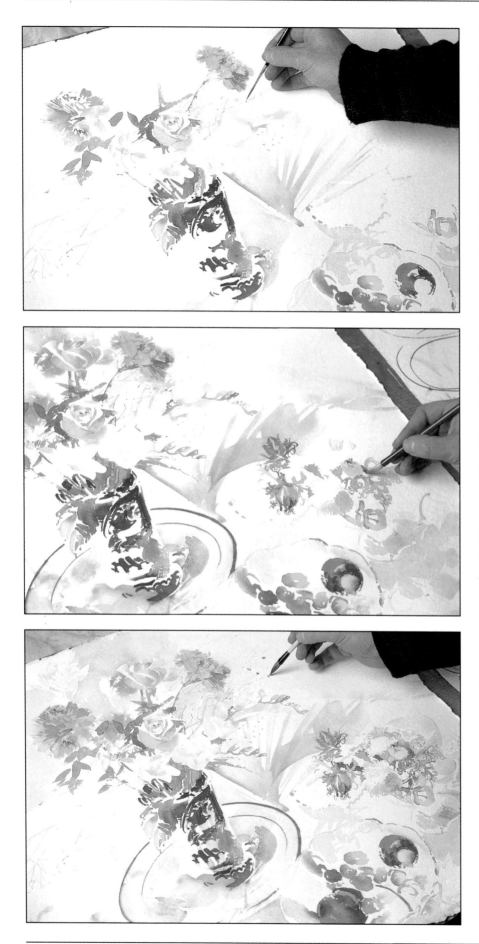

Painting glass

1 Although this is a comparatively light-toned subject I have started with the dark tones. This is to establish the shape of the lighter areas - the rose and glassware. I am working with a fine sable rigger on an absorbant Not surface paper. This enables me to put down a lot of the intricate detailing which is required both in the gypsophila and in the ruching of the carnation petals. For the glass the first few very light washes of varying greys from yellow through to green and blue have been laid. The fan is kept as a very simple gesture in the background. The rose is the central focal point of the whole composition.

2 All the basic elements are in place. I am now concentrating on the anemones, with the greens laid in with my oriental brush, curling and twisting around the anemone buds. I have now worked the flowers in the background. The second rose blends very softly with a violet grey background. I wanted the lines on the plates to be very sharp so I practised on a small piece of paper (to my right in the photograph.) I was not concerned that they should be perfect as long as they had a crisp contrast with the broken edges in the rest of the painting. When painting glass I tend to use very broken marks to indicate how the light reflects and bounces off the various surfaces and facets.

3 The glass is now indicated with further light washes of blues and greys superimposed on each other to create shadow patterns. Where stalks are seen in water I have allowed the paint to merge. I am now using a finer oriental brush to paint the flower heads of the gypsophila. These start off as being reasonably dark but the subsequent stage involves the use of a scalpel. The table has a hard straight edge in the background. I have blended this into a soft curve so as not to distract from the cyclic nature of the composition.

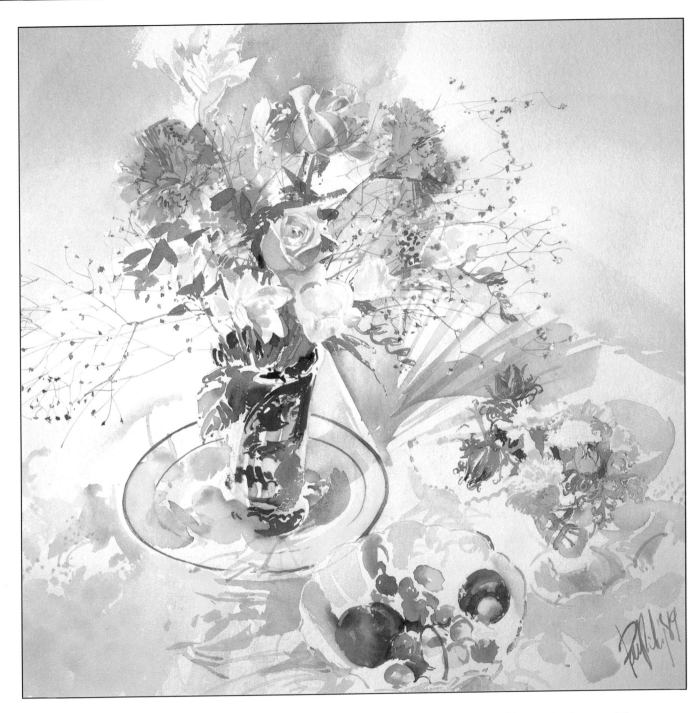

4 The final stage in the painting needs all the fine line work of the gypsophila to be painted in where it crosses over previously wet flowers. Once this has been done all the little dark heads are added and allowed to dry before I use a scalpel to pick out little bits of white paper. The fluffy nature of the paper helps to give the gypsophila a look of realism. The glass in this painting is very simply stated and the whole painting relies on very light touches of grey. I have wiped some of the harshness of the red plate down with a soft sponge. You need to vary the size of the brush strokes to create interest, particularly in the foreground areas of what is basically white cloth. With the fine lace detail I did not try to simulate the lace but used the opportunity to produce dots of colour of very pale yellow and greys. This reflects both the nature of the gypsophila and the cut facets of the glass.

CHAPTER 6

SETTING UP

Setting up is the process where I analyse the subject matter and then draw it in sketch form before transferring the idea to paper. I then begin to paint. Without careful planning even the most spontaneous response will lack depth and clarity.

I believe that painting is to a large extent studying, so I have built up a collection of books, catalogues, even seed packets I have this beside me whilst waiting for an idea to gel, and I can mull over various sources of inspiration in order to stimulate the mind.

I particularly love old books of engravings, sometimes hand tinted, which show with loving dedication the sinuous line and texture of exquisite examples of flora. This does not mean that my work looks anything like them, but it is important to see what another kind of devotion can produce.

Drawing and designing

There comes a stage when you have assembled the forms in such a way that an entirely unique vision of what that flower looks like is realised. How can this be? The only word to describe it is 'drawing'.

This word frightens many students who feel instinctively that they cannot draw. A more accurate word for this process is the French word *dessiner*, which is much closer to our word design, and basically means to arrange or organise. Most of us feel much happier at the prospect of doing that.

Imagine that you are not painting at all but arranging a collage of cut out scraps of paper representing the various hues and shapes of the flowers. Trimming bits off if they look too large, or add on to create more impact. What you are indulging in is drawing — designing in exactly the same way as a knitter or weaver will determine a pattern using threads of colour.

Here is the final selection of items for a still-life which I have co-ordinated in a series of blues and violets. I have chosen warm, slightly orange objects to complement the blues, and there are touches of yellow to highlight the violet. A final splash of red helps to lift the warmth in the hat and basket work.

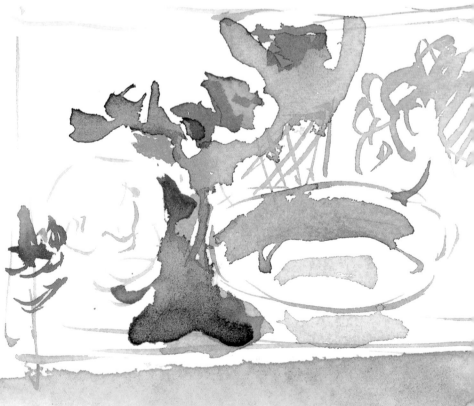

My pencil studies are in the nature of doodling. I let the line meander, picking up small, twinkling shapes and then larger, more flamboyant forms. I am looking for rhythms which can be translated into brushwork, and also distinctive forms which later can be reproduced in perhaps a single brushstroke.

With these sketches I am trying to find a 'largeness' for the final picture. By that I mean really fill the picture space. At this stage I might move some of the objects around because I have noted that one item may be too central, or because the colours are too dominant in one area.

Although these are flowers they are also colours which can work across the surface of the paper - sometimes as small touches and sometimes as large, positive statements. I may need to determine what strength certain colours are, or how much water to add to give a certain pellucid delicacy. At the same time I look at tonal contrasts in certain areas to see if they are likely to dominate at the expense of the whole painting.

Analysis

My research stage is a process of analysis. Part of this analysis is seeing how certain flowers change their shape when viewed full face as against side or rear elevation. Many of the flower paintings I have seen place all the flowers facing the artist in such a way that the painting appears flat. Seeing the flower full face is similar to the way in which the Egyptians saw the human figure, where everything is shown and accounted for. This is a rather primitive way, although it gives rise to a form of pattern which also has its own merits.

Looking at flowers from unusually depicted angles throws up strange abstract shapes which have entirely new rhythms and possibilities. Unfortunately some of these shapes need disentangling in order to produce some kind of logic and avoid the production of a meaningless blob. This is especially important with flowers like the rhododendron or iris. My approach is to take a single specimen of the flower and then make exhaustive studies, sometimes quite dull and boring. As familiarity with the forms begins to develop I find that more spontaneous and exciting images emerge. Quite often when I paint one of these strange shapes the tendency is to think 'surely this will not look right'. It is at that point that the distortion takes place, and sure enough it will not be right. You must trust your eyes and follow what you see. One way is not even to look at your drawing. Place a mask over your hand and, whilst staring intently at the shape, follow its every wrinkle. Just let the hand perform. It is quite astonishing how intriguing the resultant drawing is.

When trying to define shapes there is a tendency to labour the

Detail studies are in no way intended to be finished pictures, but I am still conscious that balance and harmony must be present.

I start off in a very traditional watercolour way by laying down my palest tints. Gradually I build up to my darkest tones. Sometimes these studies can be stiff and mannered, or a little hard-edged, but it does make me stare intently at each object and at the spaces between those objects. Many interesting things happen in the tangly bits behind the flower heads and they are in the nature of a jigsaw puzzle, so enjoy the process of disentangling it!

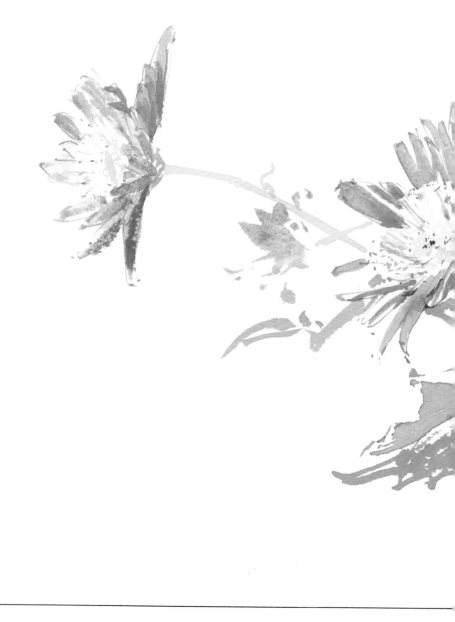

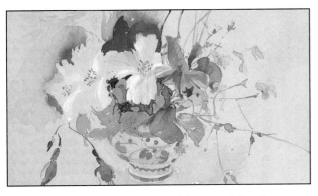

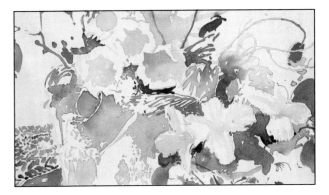

This experimental study involved laying a blue tint over the whole surface of the paper mainly to see what effect it had on the yellow and red primaries. I have adopted a slightly more refined and detailed approach to explore the fragility of the flowers.

Here the forms are treated in a flat manner like a patchwork quilt. This reduces everything to an abstraction of all detail to see how shapes interact. With these sorts of study one can see the actual quality of the paint and how it flows and dries.

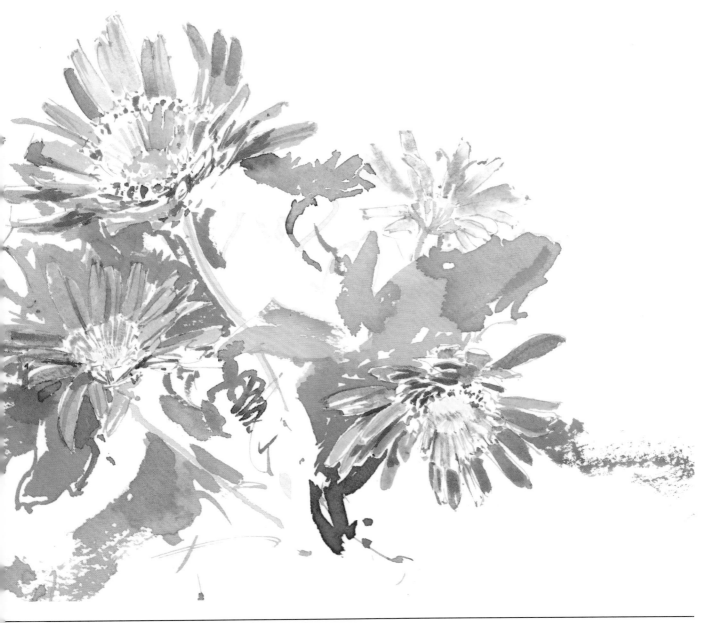

Red Azalea
This is a detail from a larger painting which is quite complex and involved. It mainly centres around a dramatic spray of small azaleas with its tangle of branches. It is in these studies that you can see the influence of oriental painters on my work. Strongly asymmetrical layouts and simply applied colour, which has been allowed to do its 'own thing', create finishes which are peculiar to the medium. Note the use of near black adjacent to the cool reds. It is not really black at all, but a mixture of the opposing primaries blue and red which can be adjusted to merge between the red of the flower and the green of the foliage.

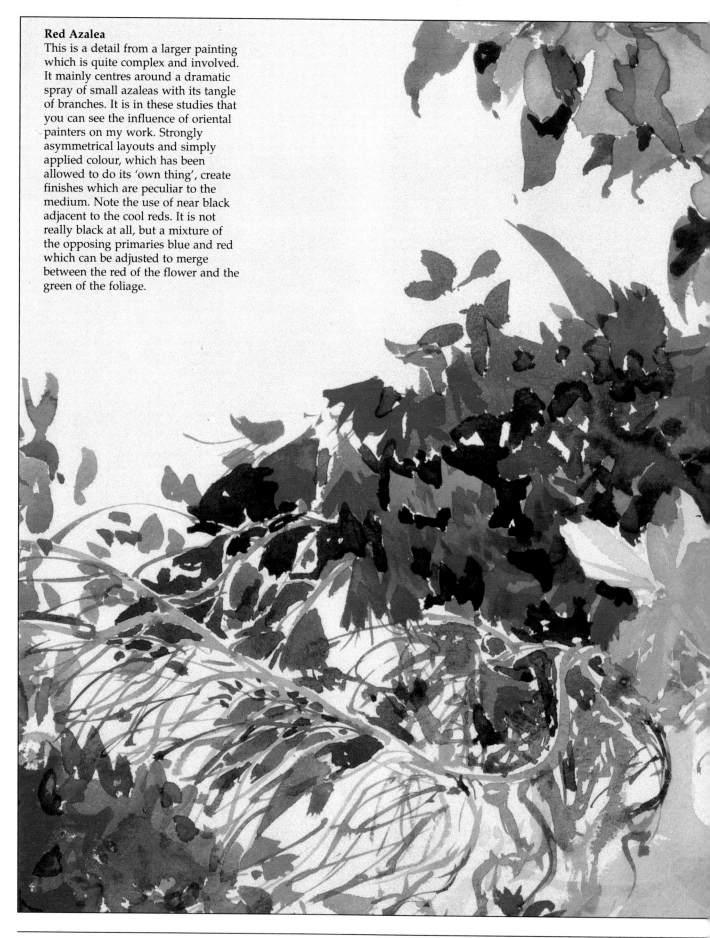

line, or even simply to gloss over the refinements. Without those refinements the shapes are meaningless and clumsy. If you labour the line the forms become dull and lifeless. In attempting refinement look for the balance between the intricate and the broad mass. Look at a Cézanne watercolour to see how he 'felt' his way round a form. No hard or fixed lines are there. This searching is to explore the interrelationship between forms. The colour helps to express the surface of the forms. In the midst of these refinements lies the true character of the plant.

When I sketch there is an elastication of time, where I dwell or pause momentarily on a small detail. Then my hand speeds up to contain a form, but without losing the tension and crispness that is necessary to imply a living membrane.

Delineating a stalk, for example, calls for a swift and sure approach otherwise it will look floppy and inadequate to support the weight of flower or leaf. A shaky or tremulous line can be preferable to a firm decisive line in order to leave room for repositioning elements in space. Here you will find Bonnard is a great inspiration.

When drawing or 'designing' your painting you must bear in mind that it is inevitable that it will not exactly resemble the arrangement in front of you. Flowers may be too big, too small, or not in the right place. Do not panic! Nobody is going to come along and measure exactly what was there and compare it with your efforts. Accept that differences might occur. If there is an irritatingly large section of unrelieved foliage put something there from another part of the arrangement to relieve the area. Who is going to know? And by this time you are arranging – designing!

Composition

Each group of objects presents a number of possibilities. It is at this stage that I rearrange the group or change my point of view.

So, how do we determine how big or how small? What shape? Firstly, for me, it is a tentative probing and exploring with pencil and paper (with the pair of scissors at the back of my mind) and searching for that elusive quality which says 'flowers'. Sometimes it will simply consist of mixing certain colours and watching them dry, or placing different tones down to see the reaction. Also testing to see which flowers need a more deliberative handling, and which a more loose and delicate touch. Although my final paintings tend to be large, (22ins × 30ins or more) my initial notes are very small. The smaller the better, since this stops the tendency to get bogged down in detail. These I refer to as my thumb-nail sketches (not much bigger) and I concentrate on the layout and disposition of the forms – that is the shape and area of the background in relation to the shape of the objects.

The purpose of the thumb-nail sketch is to explore the main lines of the composition. To do this you will find a 'viewer' useful. This is simply a piece of card, or stiff paper (5ins x 6ins) with a rectangle cut out of the middle (say 4ins x 3ins) corresponding to the proportions of your paper size. Looking through this viewer will enable you firstly to cut out any extraneous information and secondly to compose your view, rather like using a camera viewfinder.

In the accompanying set of sketches I try to show which areas to look for in a composition and which to avoid. Always avoid chopping the painting in equal halves, vertically, horizontally or

1 In this sketch the arrows indicate how I want the viewer's eye (as it travels around the edge of the picture) to be drawn in by the elements of the composition. Sometimes the eye is led by 'straight' lines, for example stalks, and sometimes with curved edges of, say, bowls.

2 Intersections at the edge of the painting can help the picture to spiral and create a vortex. Turner used this device in many of his experimental works.

3 Obvious divisions in any composition are where diagonals intercept with the corners of the picture. This gives a static symmetrical quality. The early primitives exploited this and it gives a monumental feel. Sometimes it may lack interest. This device has been used often, but with the addition of subtle asymmetrical elements to stimulate and intrigue the eye.

4 The arrow indicates the light direction. Shadow areas are very important when evaluating the tonal masses. They may not be as dense in the final painting, but it is best to explore their drama before committing oneself.

5 In this composition I have looked for some kind of colour diagonal, even though I have two dominant elements with a strong vertical emphasis. This weaves across the surface and varies in intensity and mass.

Note the red. It starts with small touches, merges with the background, hits strongly off-centre and then sprinkles off the picture frame.

6 In this view I am looking at the same two objects from a different angle but where they have merged to form one strong, vertical emphasis. This time I have used two colours to form the diagonal, with a distortion of perspective to lead the eye into the picture and to give an illusion of depth.

7 In all the above I have been looking at geometric methods of composition analysis. There is a time when passion takes over and one breaks the rules! So I just stare intently at the subject and do the first thing that happens, scribbling and moving to see where the subconscious takes me. Often it is chaos, but then little things happen which may be a complete revelation. I admit that it looks more like an explosion than flowers but then that bursting quality is very much the effect I want.

diagonally, or placing a dominant object right in the centre. The observer's eye should, I believe, come in from the sides of the picture in such a way as to gently spiral around towards a focal point or points. Hopefully it will be a complex and intriguing journey which can be taken from any starting point!

I am often asked about the use of photographs. I find the problems of sorting out the real three dimensional world so exciting that to simply copy a photograph would be both laborious and dull. It would lack life and contain far too much information which could not be analysed by looking or walking round the object. However, for an outright beginner photographs have a distinct advantage. The main one is that all the three-dimensional subjects before you have been reduced to two dimensions. All those awkward flower positions have been flattened for you to copy!

By way of an excercise, if you have access to a Polaroid camera set up your composition and take a photograph from your viewpoint. First try to draw one of the awkward shapes without the photograph. Then copy the same awkward shape from the photograph. Finally, trace the shape using tracing paper. With these three drawings you will see where your assumptions have led you astray and how extraordinary certain shapes are! After a while you will start to believe your eyes!

Photographs can also be used to retain information should you have to go away, or the plant wilts. Only use them to record form. Colour is quite different. Never trust a photograph for that.

Transferring the image

At this stage all your composition sketches and analyses are to be committed to a finished painting, but without losing any of the freshness and excitement of the research phase. Like a conductor with his orchestra arranged about him you need to know exactly where each component and tool lies. The moment before you start is very precious and important – nothing must physically obstruct the flow of expression.

I am amazed that people will quite often work across themselves, like contortionists, whilst attempting to paint. I am right-handed so my equipment is set out to my right. Sounds obvious! Usually I work standing up, allowing my arm and body freedom of movement. My eyes are far enough away from the surface of the painting to enable me to see the picture as a whole. My tools, palette, colours and water are kept at the same level as the painting whenever possible. This enables me to transfer colour with the minimum of delay, with all my wrist motions working on the same plane. My board is set on a very slight tilt in such a way as to allow me to lift up the bottom edge and, whilst certain passages are wet, tilt the whole surface this way and that to move the colour around.

The actual layout is shown opposite, with the natural progression from brush stack to water, palette and painting. The colours are loosely arranged in primary groups so that I can instantly pick up the colour I need. At this stage the pace becomes feverish, so fumbling is out! The brushes, at the outset, also have a loose grouping between flats, rounds, oriental and so on.

Occasionally I use additives like gum arabic or ox-gall, which are prepared in a separate round palette.

When outdoors I work on a board which is much larger than the paper and I stick the palettes and plastic water pot to the board using masking tape.

On a very hot or sunny day I wear a sun hat, not only to stop my head from becoming hot, but to shade my eyes from too much light saturation which would impair my colour evaluation. This is a bit like 'stopping down' on a camera.

There is the likelihood that the proportions in the small sketch may seem disproportionately large in the final painting. Do not worry, because it may gain much in impact. If I have a particularly complicated set up I will 'square up' my sketch and transfer the idea to the larger size to see if the composition holds together. Generally I find that provided I start with the objects slightly larger than I think, commencing just off centre, I can allow the composition to flow and sometimes mutate to maintain the excitement of producing an entirely new picture!

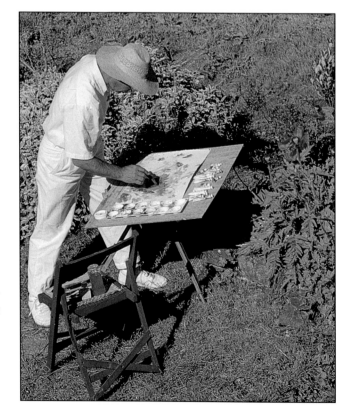

Here I am trying to capture the last of our giant poppies. I usually stand to work, which allows complete freedom for the body to move. The only part of my hand to touch the paper is the very tip of my little finger. This helps to distance my brush.

My materials are laid to my right, with my palette as close to the paper as possible.

I am dressed for comfort, both as protection against the sun and to keep irritating insects from interrupting my concentration.

Opposite is the kind of palette I like, deep pans with plenty of room for wet colour. My water jar is to the right, and my selection of brushes at hand to enable rapid change. I often use a lot of paint so I must have my paint tubes arranged in some semblance of order to avoid fumbling when in the heat of working. This means putting the reds with reds, blues with blues and so on. Any additional materials like gum arabic or ox-gall I put even further to my right.

One thing I do not do is 'draw it in' with pencil, because the paper surface is so delicate that the pressure of the pencil is likely to scar it. If a delicate wash is then applied the line work, even if erased, is obvious and for me distracting.

I always draw in, if necessary, with a brush. More often than not, I go straight into painting the solids as though drawing in lumps! Occasionally it is a mixture of the two. Drawing in is simply to establish where things roughly go and perhaps establishing a complex detailed area. For this I use a delicately tipped squirrel-hair brush, or occasionally a fine sable, held quite loosely and nearly vertically. This allows the tip to dance lightly over the surface of the paper.

The business of the line dancing is very important for me. Rather than a solid line encapsulating, and thereby imprisoning, a form or space I allow it to make and break with dots and short sections of straight or curved lines. This allows me to make changes.

Preparing the brush for any kind of line work needs careful control. It must be well loaded and pointed to the finest tip. This is done by gently drawing the surplus paint on to a spare piece of paper (preferably of the type you are painting on) so that the line is fine but firm. With a good quality loaded brush there should be sufficient paint to complete the bulk of the drawing in.

Choice of colour for the drawing in will depend on the predominant colours in the composition. For example, if you are painting a delicate, light-yellow daffodil then the palest version of this which can barely be seen is best. For a bluebell use a pale cerulean blue, and so on. In this way you end up with a multi-coloured drawing which in itself stimulates and sparks the urge to continue.

To transfer a sketch to a larger sheet draw a diagonal from corner to corner to produce squares. Lay the sketch at the bottom left of the large sheet. Extend the diagonal from the bottom left to the top right of the large sheet and square up accordingly. This is done on tracing paper which has been lightly toned on the back with a soft pencil. Looking at each square and triangle, transfer the marks to the large sheet. Superimpose on to a sheet of watercolour paper. Go over the whole drawing lightly to transfer the image to the larger sheet.

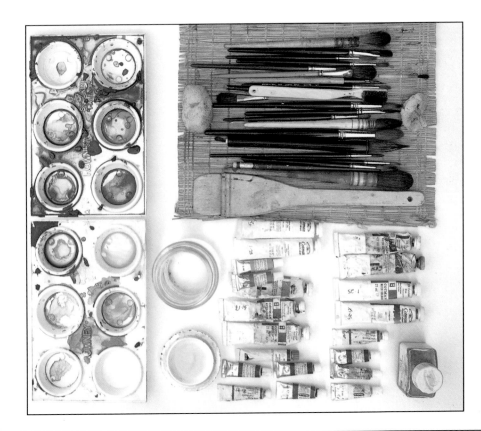

For the drawing in stage I use a fine-tipped, soft squirrel-hair brush and several colours which are as pale as possible. This stops the drawing from dominating the finished result. My movements are as fluid as possible and I try to have the whole thing laid out within minutes in order not to let the composition go stale.

The line work is broken to allow changes to take place and to maintain spontaneity. Note that my brush is held almost vertically to allow me to see the working area clearly.

I am now using one of my favourite oriental brushes which draws to a fine tip and yet has plenty of body for full-blooded strokes. I draw in 'lumps' which form shapes of flowers in one go and which are the product of painstaking research. I work as hard and as fast as possible at this stage because it is now that the picture is made.

Quite often I will push in quite large areas of neutral tone, as under the bowl, to see how it relates to the intense colour of the flowers. I do not stop until the whole paper is wet. If I continue at this stage the colours will go muddy and the freshness will be lost.

Before the paint is quite dry I add colour to the areas where I want soft edges. In this instance to the jug, and also where a little intensity is required in the centres of the petals. When the paint is fully dry I can get hard edges and superimpose colours to obtain secondary or tertiary colours, say blue over yellow for a green in the foliage or yellow over red to get orange.

I now start to establish some of my darkest tones to see what kind of depth can be obtained.

Elements like patterns on the pottery are now worked in using a sable brush, which has the required spring to simulate the markings on the original.

I now stand well back from the painting to see if balance has been maintained. I then soften certain areas with a damp natural sponge in order to blend edges. This helps to push bits of the composition into the background and produces rounded forms.

I touch in any final details like stamens, fine stalks and petals.

Here we have it! This is the stage where I may leave it for an hour or so to completely dry. I still tend to twitch with the compulsion to adjust certain areas, and will do so if necessary. I have to fight the urge to fiddle with it or to overwork any area. I would rather it were slightly unfinished than flogged to death!

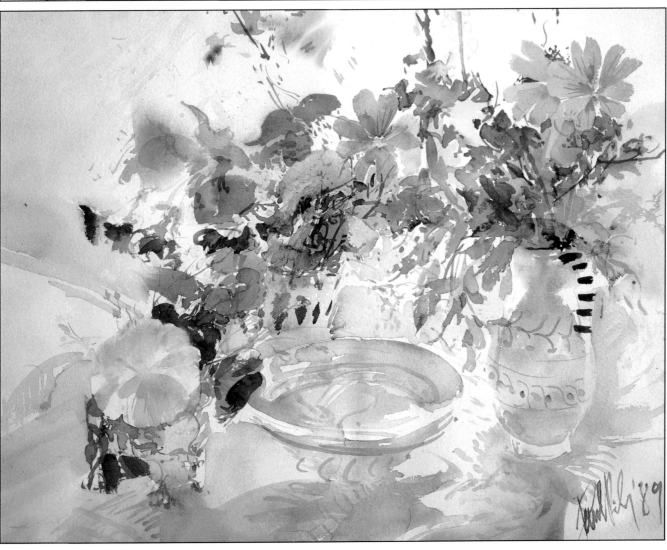

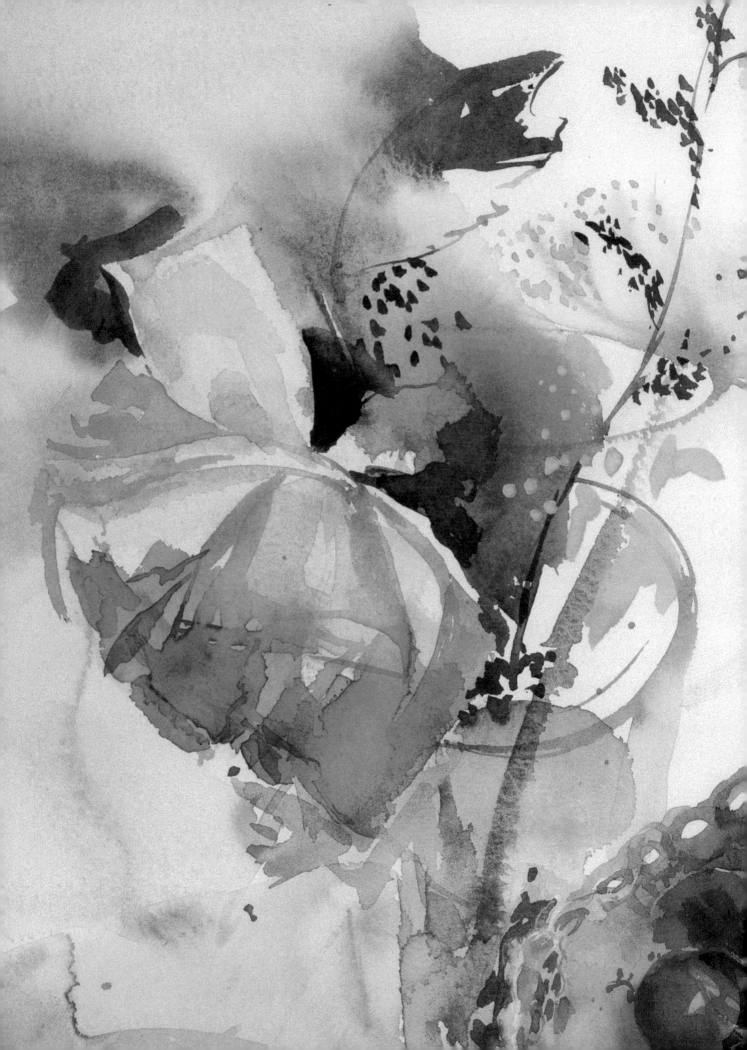

MOOD

You may well have carefully set up a still life of flowers, and followed step-by-step a method of painting, but the final result is not as you intended. There is still something missing.

My students frequently ask me, 'What is missing?' They assume I have a simple answer which will make it all come right. The answer is inside yourself.

I can only describe it as a state of mind. You are concentrating so hard on the subject matter that you have not given any thought to yourself. How do you feel? Happy or sad? Are you wide awake or tired? Hungry or replete? Do you feel hot or cold?

If you are not physically and mentally relaxed, or comfortable, it can be as big an impediment as having inferior materials. Creating the right environment for work is essential.

Ways of seeing

Cennino Cennini, writing during the Renaissance, suggested that the aspiring painter refrain from strong drink, and even that the male of the species avoid the company of women lest his hand should flutter! Without a doubt you need to relax and slowly digest all the information you have before you.

Does the choice of subject matter suit your mood? A cheerful cacophony of different coloured flowers would best be depicted in a joyful mood. If you are feeling a little contemplative perhaps a single white rose in a glass jar would suit your mood better. If you are aware of your state of mind when you approach your subject it will help you maintain the impetus to complete the work.

I refer to the next stage as 'winding' up. Many sports enthusiasts are expert at this – 'psyching up' in order to reach a pitch where they can explode into action. It does not necessarily mean pouring adrenalin into the system so that you are in a complete froth. You really need calm appraisal of the subject matter before you gradually focus on a point which is the central theme of your study. Then you start. Sometimes I feel quite heady at this stage, as if I have almost levitated on to another plane. This is when the blood begins to flow and your hand flies through the work as if directed by some other force. Of course it does not always happen like that, but I do aim for it.

One of the ways to achieve this is by a process of lateral thinking. For example, you could give your flowers names, not botanical ones but human ones. The big, bold one could be 'Henry'. The small timid one 'Henrietta', and so on. This way the flowers assume a personality

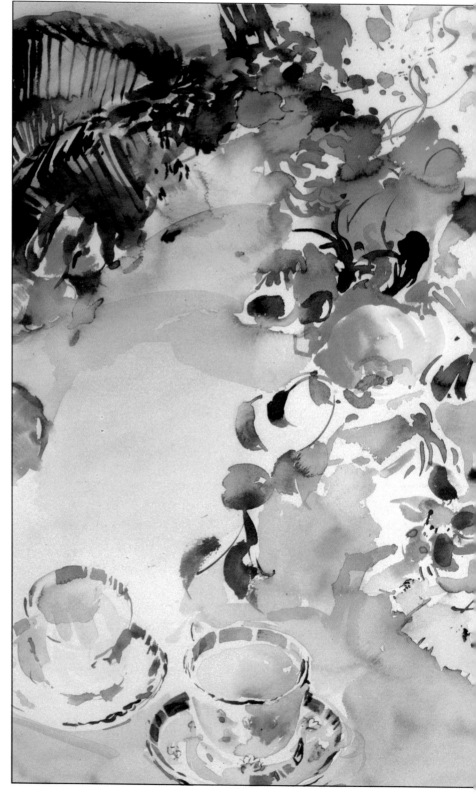

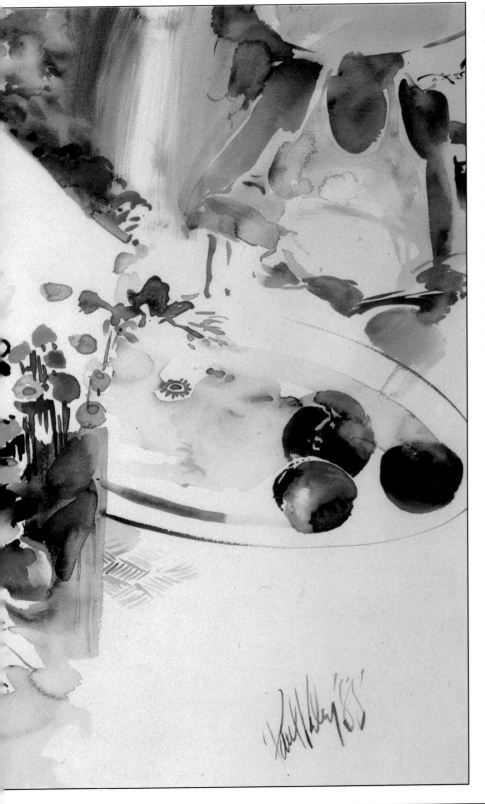

and you will be able to relate to them accordingly. I have been caught out talking to the flowers on a number of occasions! Another method is to imagine that the scene before you is on a much grander scale, like a huge landscape. Think of walking into it, climbing up the stems and shading yourself under petals. This will enable your mind to explore the minutiae of the surfaces and give you an almost tactile appreciation of their qualities.

You could weave a story, or poem, about the scene and even set up a group based on a piece of literature. It could signify melancholy, drama or passion. One painting I did called *coffee for two* was actually an excuse for using a beautiful art deco coffee set with flower colours which matched. It was an exercise in pattern and colour. But I also had an image in my mind of a romantic morning, where these two cups had been abandoned for something else.

What you are doing with lateral thinking is conjuring up ways of seeing and feeling more acutely about the subject. This helps to fix a complete picture in your mind. The execution of it should then be a relaxed pleasure.

Tina in a yellow shirt
It was a bright sunny day in France and we had just finished a light lunch. To establish the mood of this painting I took my cue from the hat worn by the figure in the top right. This shape is echoed both in the large dish and in the negative shape on the left hand side of the picture. I used buttercups as friendly echoes of Tina's shirt. In the handling of the paint I convey the sun-drenched day by bleeding the patterns on the pots, and by reducing the shadows to nothing. All the time at the back of my mind I was saying 'Does it feel hot?'

Colour preferences

We are all individuals, thank goodness. Our eyes react differently, and our feelings and preferences vary. If I were to set up a flower group for a mixed company of students it is certain that someone would not like it. The reasons are many, and affect our choices.

Colour has many inferences. Certain people have particular preferences for some colours and other colours are an absolute anathema.

My wife cannot stand particular types of orange and purple. I know if I use either of them she will not like the painting. Certain strong colours or combinations of colour cause some people to react. They can even induce nausea. These conditions may be a result of childhood or traumatic events. They definitely influence our way of seeing colour.

Some painters seem to have a fairly consistent palette as a result of preferences. Van Gogh favoured strong complementaries. He would use red/green, and blue/orange. Matisse used pink, purple and orange. These preferences act as a kind of filter which you place in front of your eyes to allow only the colour you want to show. This is not a bad thing. In a way it is an expression of your personality and it is worth finding out what exactly you do like.

White magnolias
It is ideal to paint outdoors in perfect weather, and it can put you into a receptive mood. A subject such as this is exceedingly satisfying though complicated. If you hold that strong feeling of pleasure inside you whilst working it cannot fail to pervade the entire picture.

All sorts of ideas entered my head while working on it. Some of the magnolia forms appeared like fishes swimming in the sky and others looked like courtly ladies. Somehow I felt the picture needed a purpose, so I included the table and chairs in the background to the right to give a sense of scale and intimacy.

Coffee for two
Quite often a personal incident can spark off an idea for a painting. In this case one fine Spring day my wife and I were able to enjoy the first rays of sunshine whilst drinking coffee in the garden. The rest of the day was especially pleasurable and I commemorated it with this painting. All the elements within it, the colour, the shapes, the forms, were designed to express my feeling of that time.

When painting flowers you can exploit whatever emotional reactions you may have to a special moment.

In handling the flowers here I have reduced them to almost abstract shapes in order to evoke an atmosphere of colour rather than botanical detail.

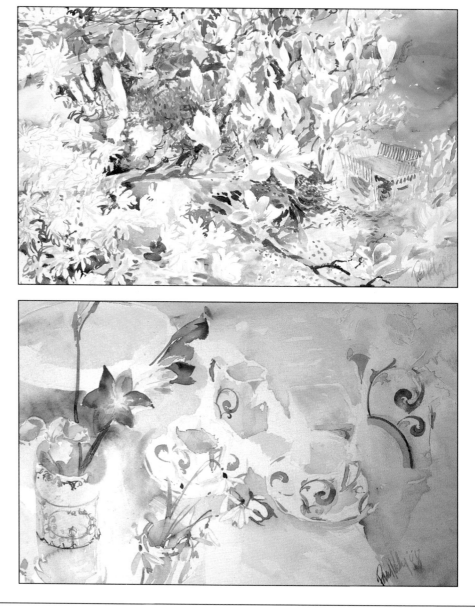

Some people theorise that it may have something to do with your eye colour. I am not sure, but it is true that people will often choose the colour of their clothes to match or complement their eye colour. Awareness of your own colour preferences will help you analyse your perception of the colours around you.

Fashion has quite an influence on our colour and flower preferences. Although some artists say they are above such things, I do notice that certain influences are present in their work. The disadvantage of fashion trends is that they can result in paintings which look contrived and dated.

The condition of your eyes will affect colour choice in quite interesting ways. Some people do not see certain colours at all. For example, cyanoblepsia is a condition where you cannot see blue, therefore you cannot see violet or green. Being short-sighted, as I am, can be useful when it comes to summing up the general overall impression of the composition. It seems the colours are more intense without my glasses than when I focus on detail. The condition of our eyes has a part to play in our perceptions. This does not necessarily mean that you are in any way disadvantaged. It simply means that your view is unique.

Rose poem

Establishing mood in a painting is undoubtedly one of the trickiest aspects. Provided you keep a strong idea in the back of your mind it is surprising how this central theme can come through. This particular picture was inspired by a poem by Thomas Hardy. I was looking for a feeling of melancholy, so I searched a friend's garden for a sad looking rose. These two roses had just gone past their best and the edges of the petals had a burnt appearance. Using poems in this way to stimulate an idea can prove extremely fruitful.

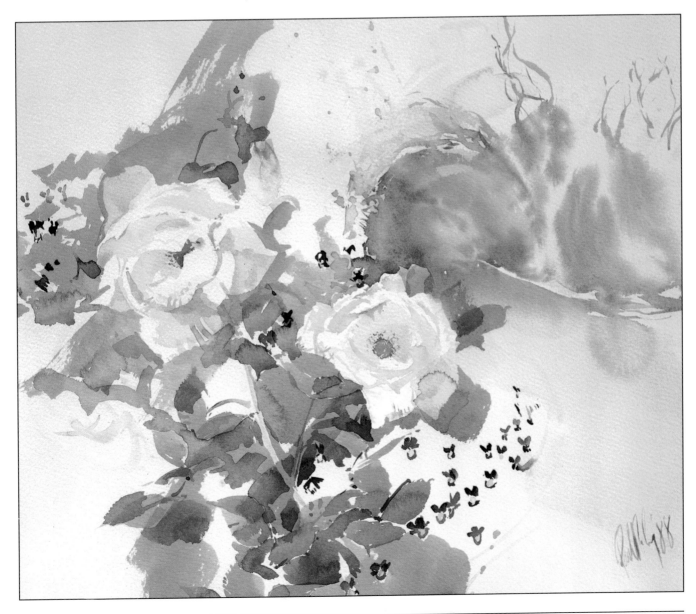

Colour symbolism

Whenever there is a discussion on symbolism in painting you find that you are on dangerous ground. There is no doubt that symbolism has played a large part in the artistic endeavours of all nationalities throughout history.

Again it is colour which has played the major role in evoking all kinds of emotion from sadness to happiness; passion to serenity. It has also determined points of the compass. The Pueblo Indians of North America believed that North was yellow, South was red, East was white, and blue was West. Yet the Cherokee Indians put blue to the North, white to the South, red to the East and black to the West.

You can ascribe whatever symbol you like to a colour and believe it. The only problem is that you cannot expect anyone else necessarily to also believe it. The notion that red is like fire, and therefore hot, is a common one. However, the colour itself is not hot. It is what people associate with colours that sometimes makes a painting seem attractive or otherwise.

The association of ideas about colour can affect our choice. The Egyptians, who evolved a dream symbolism based on colour, said that a pale blue meant happiness and a dark blue meant success.

Dry grasses with onions
Using a variety of techniques I have created a fine network of line work with soft, pale tones in between. The intention was to give the painting a dusty, autumnal feel. Several of the earth colours were used in this painting, notably burnt sienna, burnt umber, raw umber and yellow ochre. Very pale touches of primary colours were also included, especially lemon yellow and alizarin crimson.

Perhaps that is why blue paintings seem so attractive. Reds, as you might imagine, evoke love, passion and tenderness among their tones. A self-conscious knowledge of these various symbols will only confuse if taken to extreme, but there is nothing to stop you ascribing whatever meaning you like to a colour if it helps you to develop an affinity with colours in general.

'Colours in vibration, pealing like silver bells and clanging like bronze bells, proclaiming happiness, passion and love, soul, blood and death', wrote Emil Nolde.

Form also plays a part in the development of symbols. In the past, form was the overriding concern of painters who were aware that light only revealed its contour. Colour was solely 'local' in nature and was simply laid over form. Forms, therefore, had powerful implications similar to that of colour. They could express aggression, calm, fluidity or solidity. Understanding the expressive qualities of certain forms is indispensible to the flower painter.

Words like 'tension', when related to a flower stalk, means that the form must express this tension. In delineating that form, an appropriate action must accompany your thoughts about it. Nowadays, we can thank the Impressionists for merging colour and form in a way that makes us responsive to the interaction between the two. In expressing a particular form we can feel the colour associated with it. Heady stuff indeed, but if it helps to sustain your efforts toward the completion of a painting then good.

It may be that when producing a particular form that you make associations with another similar type. For example, you could be painting

a leaf in such a way as to remind you of a fish you had seen swimming in an aquarium. Or notice how an abundant spray of forsythia, with its host of yellow flowers, looks like a firework you have seen gushing yellow sparks. It does not matter how ridiculous the association may be provided that it makes what you are looking at seem more real.

What to leave in or out? Quite apart from your imagination, there is the imagination of the viewer. It is quite erroneous for you to assume that the viewer needs to have every single bit of information about a subject before they can enjoy it. Admittedly, there is something fascinating about a highly detailed rendition of groups of flowers, particularly when they seem hyper-real. More often, most overworked detail can become boring. Many painters feel that unless they have provided every detail the picture is not worth anything. In fact, viewers quite like to work for their pleasure. If you have areas in your painting which tantalise and stimulate their imagination you will find the picture will endure in their memory because they will feel that they have almost painted part of it.

I call this process 'visual clues', which means giving just enough

Red basket

A large proportion of this painting has no colour in it at all. The important work is done by the white paper. I have sprinkled the colour over the surface of the paper to create a mosaic-like quality.

The idea behind this was a result of seeing a basket with its thin canes leaving behind interesting shapes. These gave strong contrasts when compared with the delicate transitions in the flowers, bowl and rose.

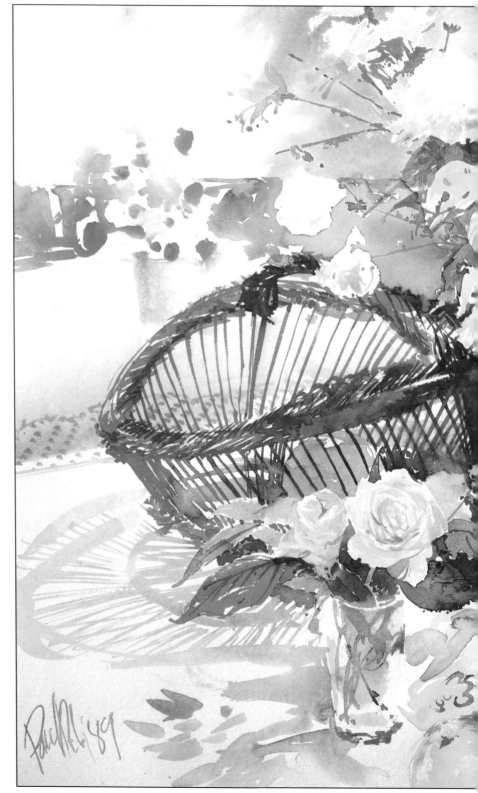

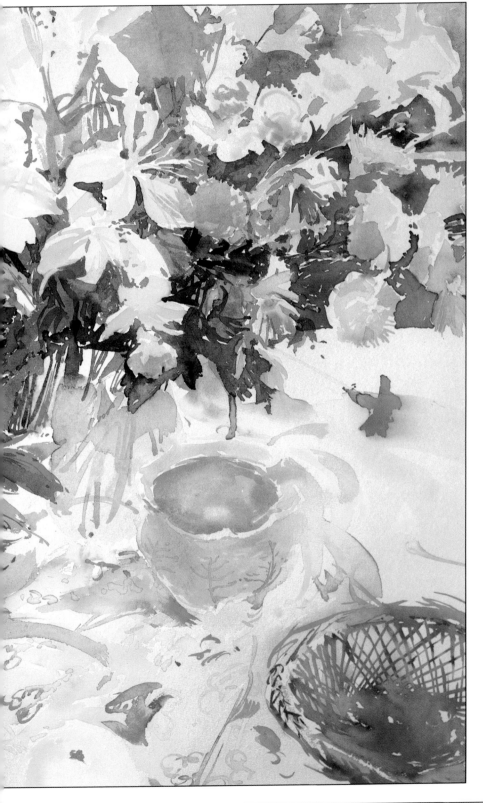

information to say what both the plant looks like and how I feel about them. This is especially useful with complicated flowers.

One example, the hydrangea, has numerous florets which are all slightly different in colour. To paint the whole thing as it looks would be very time consuming and quite possibly boring. Whereas a general indication of the colour variations, seen as an amorphous hydrangea-type shape, with a crisp blue and red drawing of some of the florets superimposed, may give just the impression you need. There are not any specific devices for each flower type. You will need to determine how little is needed to say it all.

Many people feel the unconscious urge to cover the whole picture surface, — 'Fill it in'. Sometimes I am asked, 'when are you going to finish it?' It may be that the preponderance of white paper in some of my paintings has something to do with it! I frequently leave sections of the paper uncovered to allow my composition to 'breathe'. Sometimes I use a gradual merging of light key colours with the white paper. On other occasions I use the strong contrast of a particular form against the white paper to add drama. Filling in the whole picture can kill it, especially if you have large areas of unrelieved tone. My best advice is if you do not know what to put in, leave it out.

The same goes for overworking. If it is getting boring, or you are fiddling, or going over an area more than once, or spending a long time in one area without looking at the picture as a whole, then stop.

Dramatic colour

I have set up this group to reflect my own colour preferences. Seeing these yellow chrysanthemums, with their long spiky petals, I was immediately attracted; firstly by their colour and secondly by the extraordinary nature of their flower shapes.

I was compelled to show them against my favourite colour, which is blue, so I placed them in a window and illuminated them with a powerful side light. The orange-brown of the woodwork helps to complement the blue.

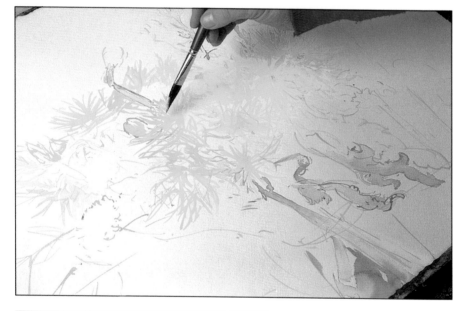

1 The excitement of using your favourite colours enables you to work with great freedom and pleasure. I find that yellow paint has a particular quality due to the very light nature of its tone and the control needed to make it shimmer.

I am using an ox-hair brush with a fine tip on a 140lb Not paper which has a reasonably hard surface. I am allowing some of my line work, where I have used a blue and green, to show through the yellow tones. The green of the foliage is kept very simple with some of the orange of the woodwork beginning to bleed with it.

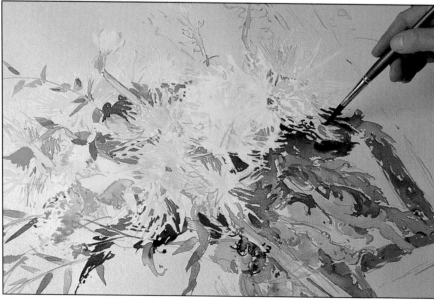

2 Because the chrysanthemums are so spiky I need to concentrate hard on negative painting to produce the effect of all the thin tendril-like petals. For this I use a strong phthalo green and keep my movements as rapid as possible whilst looking for those illusive shapes. I have painted the leaves to the left with very simple one-stroke touches. These leaves twist and turn, showing light and dark sides as they spin off the composition. I am trying to express both my pleasure in working with these colours and a sense of drama.

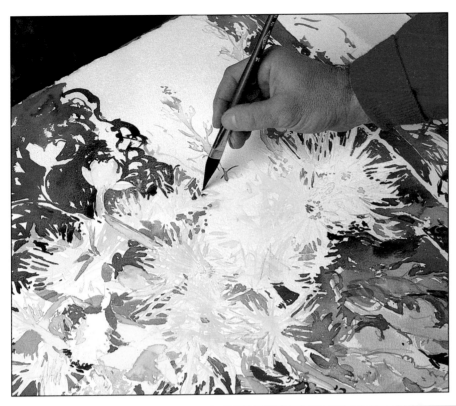

3 Everything so far has led up to this dramatic stage. All along I had a strong idea in my mind as to what I wanted to do with the blue.

This is an exercise in negative painting, and I had deliberately left small, white spaces in order to create and direct movement. The orange brown of the woodwork has also been introduced to see how it would relate to the blue. Shadow areas have been created with the same intense, blue grey colour.

4 Primarily I wanted to show the bursting nature of the yellow and blue against each other, so naturalism was sacrificed to this end. Even the shadows have a wild look about them.

Try combining your favourite colours to form a picture which would best reflect your feelings about them. Choose forms that stimulate and excite you personally.

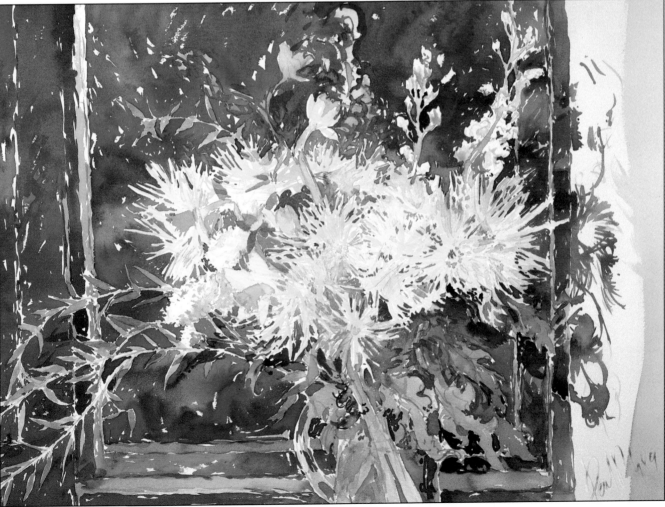

CHAPTER 8

DECORATION & IMAGINATION

For many centuries flowers have been used to decorate our man-made environment.

The very reason we want to paint flowers is so that some of this colour can be used to decorate and enliven the home or workplace. This decorative approach might be looked down upon by 'serious' artists as being too flippant or shallow. Although I may have been expressing a serious approach in the previous chapters I would prefer you to think of flowers as joyful things. 'Serious' painters like Matisse and Klint have taken the art of flower painting right into the decorative realm with no fear of criticism for lack of seriousness.

Two-handed painting

In the past, before the days of rapid transport and technological advances, flowers were not available in winter. People felt a need for a substitute. As a result, they decorated their homes with facsimiles of their favourite blooms. Some people may think that their efforts were rather primitive. That may be so, but the way in which they designed their forms was actually very sophisticated. One of the reasons for this sophistication was a result of having to carve the flower shapes to suit materials such as wood or stone. This type of decoration extended to clothing, furniture and food, and a whole new world of forms and colour combinations developed.

Exploring all the manifestations of the home decorator will undoubtedly unlock a visual feast which will make you look at your subject matter with refreshed eyes.

Central Europe has a rich tradition in this form of decoration, which has come through the centuries from Arabia. Islam has forbidden the depiction of human physiognomy and so a tradition of designs based on invented and natural plant forms has developed.

In a country like Czechoslovakia, for example, a whole range of flower decoration was practised. Much of it was of an ephemeral nature. Soap was used to draw on window panes. Sand was trailed via flower pots on to pathways. They even used tin

1 Here you see me preparing to work on a large panel to demonstrate the two-brush method. I have placed my palettes, one for each hand, either side of me, with the same colour range mixed in both. I am working on a 140lb HP surface paper with two fine-tipped ox-hair brushes. These will give me a great deal of flexibility whilst working. It is important to have your work upright so that you can cover a large area comfortably. The paint should not be too wet in case it dribbles down the surface of the picture.

2 Although this looks difficult the brain has a perfect system for co-ordinating both hands. A little practice and you will surprise yourself just how easy this method is. Here I am working in a small area exploring the heart of the painting. You should try at first to work within your field of vision so that you have complete control at all times. I am holding the brushes at their extreme ends to allow me to see the tip whilst the brush works in all directions.

3 To fill in larger areas you will need a pair of broader brushes say two ox hair filberts. You can see how I have very broadly indicated these colours. It is obvious that tight control is necessary. After all, we are looking for the decorative effect .

cans (after puncturing a hole in the base) which were filled with water to trail wet flower designs on their sun-dried paths or courtyards.

In looking at some of the designs that were produced by these fluid methods there is a similarity with the rapid movement of the water-colour brush. Needless to say, some of the shapes are simplified and quite often spiral in design. There is a swinging motion in the way the arm is controlled, which suggests that the work is carried out standing up. I tend to adopt the same pos-ture, and this allows me to use my whole body when executing a par-ticular brushstroke.

One of the more extraordinary methods of painting used by the Czechs is to hold two brushes, one in each hand. They draw an intri-cate and symmetrical design simul-taneously with both hands. As an exercise in co-ordination I do not think it can be surpassed. The first time I tried it I experimented with symmetric designs. After a little practice I tackled more informal compositions.

It is a fascinating way of main-taining concentration. If you wish to try it you will find it easier to stand up and begin with two pencils. Do not worry if the whole thing looks crazy – most first attempts are. Keep the design simple, then after a while you will be surprised how the mind starts to adapt.

Above all, enjoy it!

5 This is to remind you that painting can be pure fun! The design is reminiscent of early Persian or Arabic miniatures. Because of the two handed working it is traditional that the design is symmetrical. However, the symmetry is never precise because of the different ways in which your hands are likely to respond. This subtle lack of symmetry is what gives it its great charm. Avoid worrying about whether or not you make a mistake. It is important to enjoy the process, and then stand back and see what has happened.

4 Now you can see the colour build up which gives the full range to this particular painting. I have used a phthalo green for the stems, cadmium red for part of the flowers, alizarin crimson for some of the central line work, and violet for the grapes. I am now working on a small detailed area with a strong phthalo blue. All this line work needs to be fairly bold for it to stand out.

As in a lot of decorative painting, the idea is to achieve a balance between the white areas and the solid mass of decorative elements. An exercise of this kind is very useful when tackling a more conventional painting.

Invented Forms

However inventive our minds, we seem unable to match nature's variety. Perhaps because of this, there are times when we feel the urge to create something unique; something hitherto undiscovered. As a child I remember being entranced by the story of the Phoenix, the mythical firebird. I tried to imagine what it was like and painted several fanciful ideas. From there I graduated to orchids which I thought had the same mystical quality. Some of my designs were most improbable and an excuse to cover the paper with as many squiggly lines and exotic shapes as possible.

You can derive much pleasure from entering the realm of fantasy as a means of exploring and developing the shapes and patterns of flowers – even if the outcome is sometimes bizarre.

In fabric design there has been a long tradition of invented forms which have taken the natural into the supernatural. Islamic arts and crafts provide brilliant examples, as do the works of William Morris, Raoul Dufy and others.

You will find that by extending the forms of existing plants you will be able to see them in a new light. Many of these devised shapes

Blue and white pots
In this detail from a larger painting I am exploring pattern and decoration. The approach to the patterns in this instance is formal and is used to contrast with the very simple abstract handling of the flowers.

When you see pattern on rounded forms such as these try to let the pattern describe the form. When choosing patterns and shapes to form a composition try also to get their colours to relate one to another. If you cannot find exactly what you want use your imagination and change it accordingly.

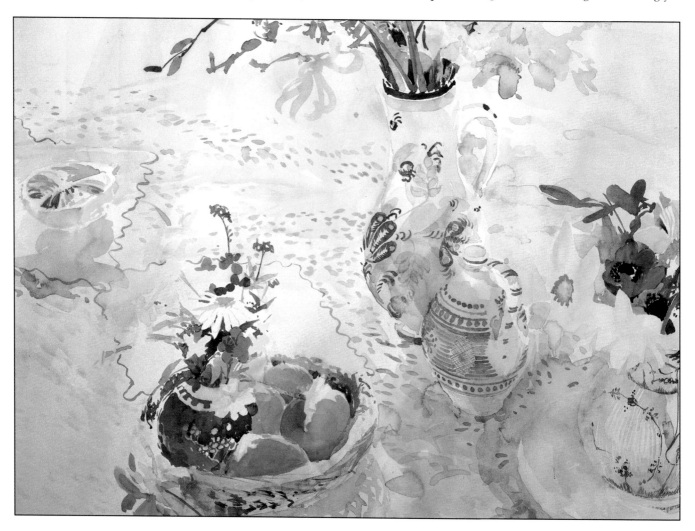

Oranges in a yellow bowl

The opportunities to invent forms and colours are many. Particularly when you 'abstract' a background in order for the flowers to be thrown forward. You can also play with the forms to produce items with great character. In this picture I was immediately struck by the similarity between the bowl and the flowers, and I exaggerated some elements in it to achieve this. You can derive much pleasure from looking for these similarities and thinking up ways of distorting shapes, and even colour, to fulfil your aim.

produced patterns which could be either simple repetitions or complex, convoluted types whose repeat was hard to discern. It is because some of these patterns are so curious that I use them in my more informal compositions. You will find that the informal with the contrived can be an interesting combination of contrasts, especially where the two can merge at some point. Flower patterns on ceramics are another excuse for me to saturate a scene with colour and line work that reflect the natural world.

Along with invented forms, there is the opportunity to invent colours. Why have all the leaves green, or all the daffodils yellow? It may seem tempting the surreal, but I often change colour either for the sheer joy of it or to force the colour composition toward a particular range of hues. I can give an example of a

still life being painted by one of my students. She had placed some flowers in a vase on to a green painted chair. We were outdoors and surrounded by green countryside. She was lamenting that she could not separate the green chair from all the surrounding green grass. 'Paint it blue', I said, meaning the chair. After some mental readjustment, the job was done and a very nice study it was too. She could have painted the grass blue instead, the result may have been more interesting.

You have great manipulative opportunities with colour, even when producing a representational painting. It seems strange to me that if people find it easy to be inventive when they are being decorative why should it be so hard when painting a picture? Try red leaves for a change.

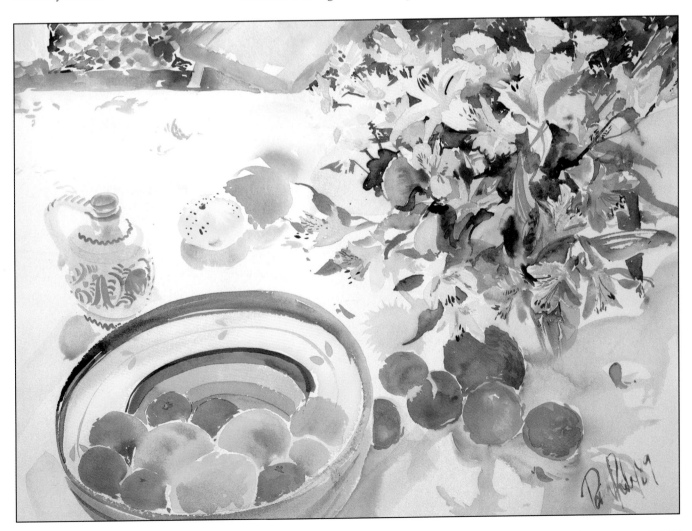

Sources of Stimulation

Spring, Summer and Autumn each in turn presents us with ever changing displays of flowers. We then have the options, when the weather permits, of either painting outdoors or indoors. Even those without their own garden (or window box) can take advantage of the gorgeous displays which most of our public parks offer. Some of you may be lucky enough to live in a climate that enables you to grow flowers all year round, or perhaps you have a large greenhouse which provides abundant fresh blooms whenever you need them.

Unfortunately, this is not always the case and if you have the burning desire to produce the next great masterpiece three days before Christmas the cost of the flowers may be prohibitive. What to do? My father, who is a very keen flower painter, designs whole jungles full of exotic blooms. Whilst exercising your imagination you can turn your subject matter to all kinds of flights of fancy. For this you will need several sources of reference. Photographs of rare plants, old prints gleaned from botanical journals, even a visit to your nearest public botanical greenhouse. It will give you the opportunity to study the beauty of the astonishing cactus flowers, or of plants with variegated leaves. You can try combining your various sketches in a purely decorative manner or in a generally informal composition. Incidentally, greenhouses are a wonderful source of inspiration in their own right.

Quite often trying to paint pictures of flowering gardens in situ can be a little disappointing. Sometimes the flowers are not quite where you want them, or there are not enough of them. (Monet designed his garden with his paintings in mind). With a

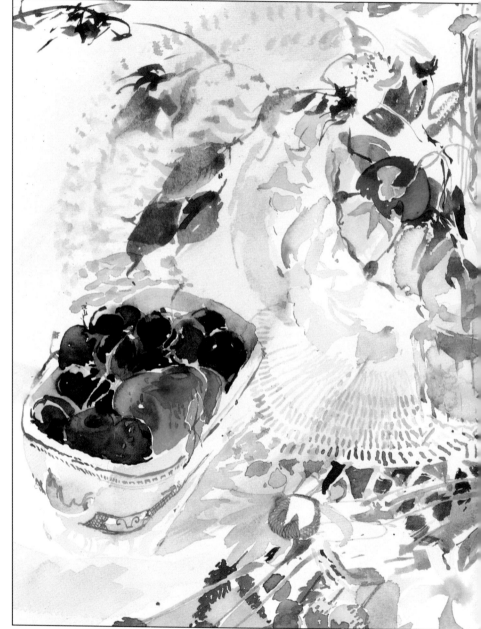

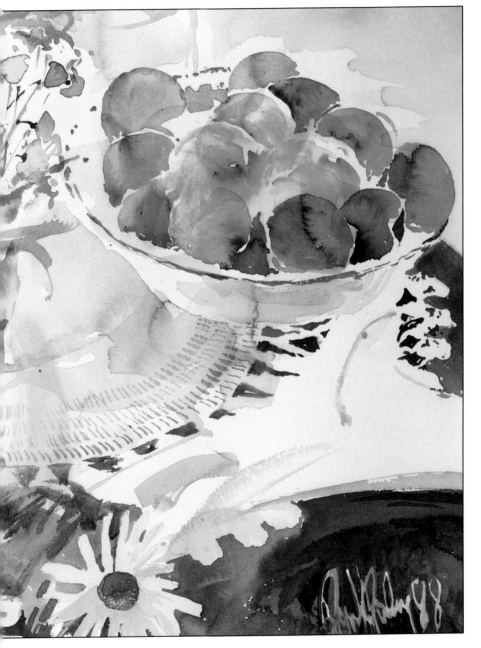

little imagination, even indoors on a cold winter's night, you can design whole gardens which are full to the brim with every type of flora your heart desires.

If you are not certain what the flowers look like simply get an illustrated seed catalogue. Generally there will be enough source material to fill a hundred pictures.

The great masters at this kind of creative design were the Indians and Persian painters whose designs for their future gardens were stunning paintings in their own right.

The way in which you can compose pictures like these is to use a purely formal layout, with grid-like paths and waterways. You could even include a fountain to act as a focal point! Should you wish for more informal layouts you will need to utilise concentrations of whatever flowers and foliage evoke the nature of a freestyle garden.

Monet designed a huge encircling wall of· paintings depicting his favourite water lilies. This was entirely produced in a studio specially built for the purpose. It is obvious that his imagination was fuelled by an intimate visual knowledge of his subject matter. No doubt he had paintings executed on the spot, together with photographs, but from then on he was able to exercise his imagination to an extraordinary degree. So much so apparently, that he felt he could not finish and constantly overworked the painting. I am not suggesting you should necessarily undertake quite such an ambitious scheme, but there is food for thought.

I often use my imagination when it comes to designing a different kind of interior for my home. Some of my ideas are downright impractical and expensive but when it comes to the

Summertime

In this painting I have attempted to explore all the various elements mentioned in this chapter. I have placed the subject in a French garden and imagined a hot, summer day. All the elements, including the abstract interpretation of the flowers through to patterns, have been explored. See where I have tried to link the pattern areas between plants and man-made objects. For example, the heart of the daisy in the bottom left in relationship to the decoration on the bowl containing the cherries. It is touches like these which can intrigue the eye of the viewer and should be explored by anyone contemplating decorative aspects in their painting.

1 I am taking this opportunity to demonstrate the fun that can be had with painting one large flower head, in this case a large red chrysanthemum. I want to get the feeling of it literally exploding from the centre of the paper. To do this I wet the paper and then add the paint, working from the centre outwards. I leave small white particles on the outside edge to create the feeling of the sunlight coming through the petals.

For this exercise I am using my red-handled oriental brush on 140lb Not surface paper with a reasonably hard finish.

2 I start with a rich mixture of carmine and cadmium yellow which spirals outwards getting redder as I progress. Then I introduce the green at the last stage. The green I keep quite neutral to complement the power of the chrysanthemum colour. Whilst the paint is still wet I flick yellow outward from the centre.

Having allowed the colour to dry, I now begin to add detail to the outer edges of the flower.

cost of a little watercolour paint and some paper, why not? It is not often that I am privileged to stay in a Florentine palace, or eat in a rococo dining room, but with suitable architectural references I can transport my bunches of flowers anywhere.

Some flowers simply cry out for a suitable environment to show off their splendour. What you need to do is sketch a suitable interior. It may be only a window, or mantleshelf over a grand fireplace. Use this as your backdrop to the flower study. You can even be your own decorator and paint the walls whatever complementary colour you wish.

These decorative inclusions can be either quite explicit and detailed or sufficiently vague to simply

3 In order to combine these subtle colour changes together I am using the tip of my brush to draw in. For this I use a stronger mixture of the carmine and commence from the centre with short rounded strokes. I work outwards producing lance-like shapes towards the edge of the flower. Using various mixtures of cadmium yellow and cadmium red I start to fill in some of the shapes to express petal forms. I observe many things as I work, for example, the way in which the light produces different shapes on each side of the centre of the flower.

4 For the final painting I use the brush flat to simulate the actual petal shapes. Rolling the brush slightly from side to side produces a tapering form. I use my two-colour painting method with more concentrated pigment at the tip of the brush than in the body. This further helps to define the form of the petals.

Exploring a large flower head like this can be great fun. Choose, as in this sample, a radiating flower to begin with and then try more complex forms as your confidence grows.

evoke an historical flavour. In the past some of the shapes, arches, columns, dados and entablatures were more harmonious with flower shapes than the rather severe architectural details of today.

Do remember, when allowing your imagination to wander, to make sure your flowers are big enough to explore in detail. Make them life size or bigger. They will have much more impact and you can work in as much detail as you want. For an experiment, try doing a painting of a single flower head which completely fills the whole of your paper. It will assume an exaggerated reality and may even look like something altogether different, like an aerial landscape.

Exploring decorative patterns

Purely decorative patterns can be combined in a painting to explore the pattern possibilities in the flowers themselves. I have chosen a range of objects here in order to exploit these pattern aspects. I have laid the group out in such a way as to create a

'wraparound' composition. The idea being that the flowers on the left will magically change into the patterned plate on the right. Try finding a range of patterned surfaces and containers and see how these can be used to enhance your flower schemes.

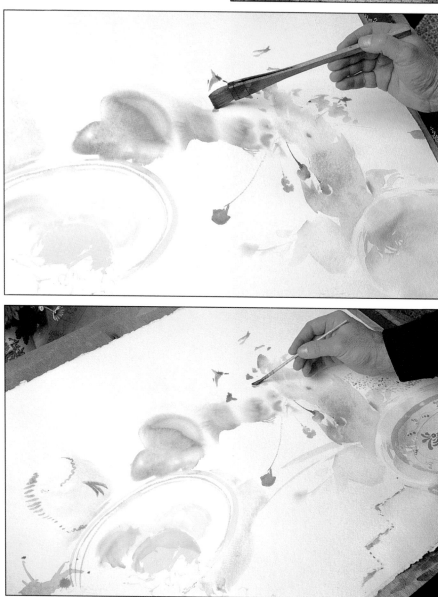

1 To get the 'wraparound' feel of the composition I deliberately worked quickly from right to left across the paper. I am using a 140lb Not paper with an absorbent surface. I paint as fast as possible and wet a lot of the areas as I go in order to produce diffuse marks. This is to force a contrast between the patterned surfaces and the soft solids. For the blues I used a mixture of manganese blue together with a little cobalt violet, green tints were added using veridian. The oranges were a mixture of cadmium red and cadmium yellow. The yellows vary between lemon yellow and cadmium yellow. The yellow ring of the plate on the left was added in a very saturated manner.

2 In order to see how the pattern effect is going to develop I commence adding spots of it around the picture. For the plate on the right I use a fine rigger to simulate the sinuous lines of the decoration. Some of these lines are echoed in the stalks of the plants above. I have drawn in the flowers on the left using a light cerulean blue. At this stage, I alternate between quite detailed areas and broad brush stroke regions. This stops me from becoming too tied up in any one particular area. At the moment I am using a small squirrel-hair brush to put in the clover heads and the little blue periwinkles.

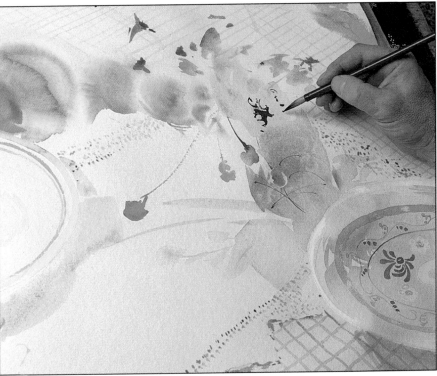

3 For patterned areas I use different width lines, dots and shapes. This means different size brushes. For small dots I use a soft squirrel hair tip. For lines I use riggers to trail along the length of the line. Small shapes can be put in with an oriental or squirrel brush. I try not to let the pattern dominate the painting but to let it act as a compliment to the whole.

4 To tie the whole painting together, and to give the feeling of streaming light, I have used a broad hake to apply a unifying wash. For this wash I used a mixture of cerulean blue, manganese blue and veridian. Whenever you have a regular geometric pattern try to contrast this with loose abstract forms to give variety and interest in your compositions.

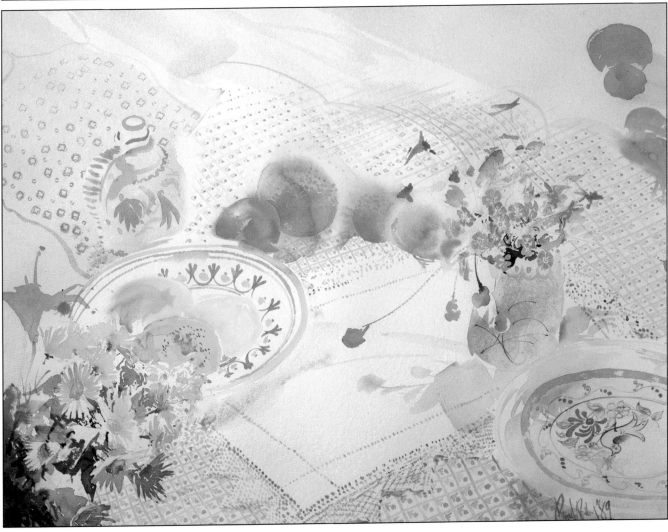

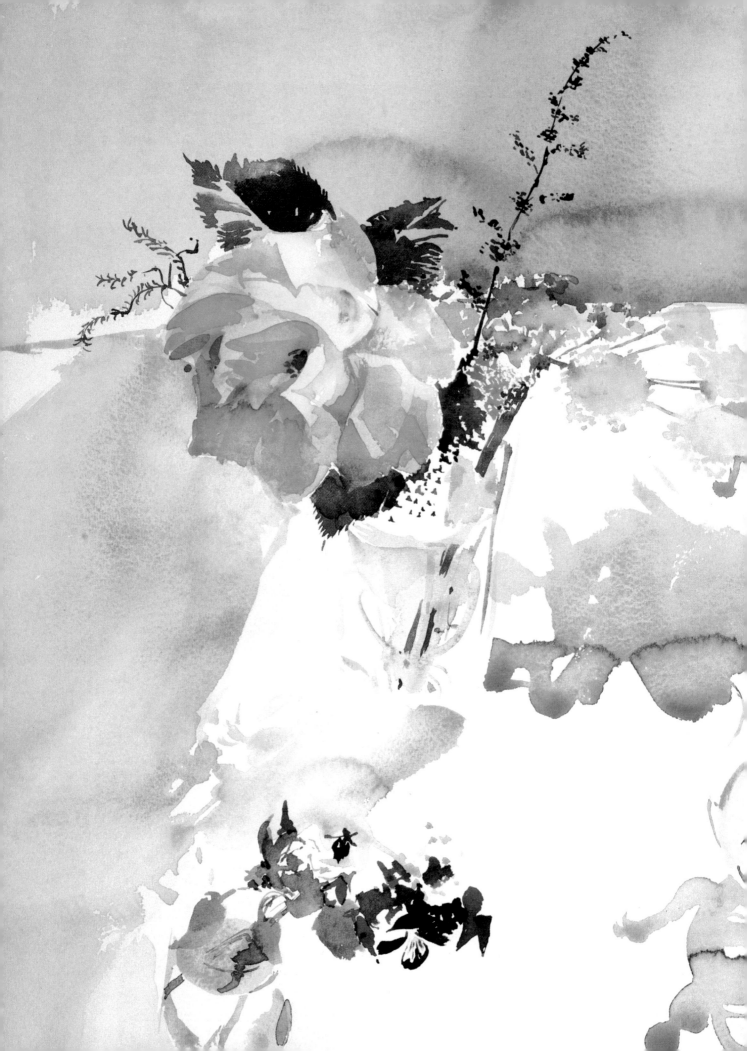

CHAPTER 9

PERSPECTIVE

You might think that thoughts on the frightening science of perspective are not related to the art of flower painting. True, the business of linear geometry is more applicable to townscapes and landscapes. However, it is surprising how it crops up, and how at the same time perspective 'rules' can be modified to suit flower painting.

One of the commonest errors encountered with 'classic' perspective is that associated with objects. This especially applies to vases, plates, bowls and anything which is round in shape. The error is in not seeing the difference between the shape of the ellipse at the top of a vessel compared with the ellipse at the bottom. Before I explain the difference, let me first try to point out some of the fundamentals of 'western' perspective.

Western and other perspectives

Western perspective

The phenomenon we all know as perspective has been developed as a geometric principle since the Renaissance. Broadly speaking, if we are looking at a particular scene from a fixed viewpoint, objects diminish in size the further away they are. This also assumes a fixed eye-level. If you are looking down from a high building you have a high eye-level. If you pop your head out of the ground like a worm you would have a low eye-level. If you are staring straight at an object then it is on your eye-level. Accepting these precepts enables you to view a group of objects, and then reproduce them in a similar way to that of a camera. It does not take into account any head movement, or your body moving amongst the objects. This type of perspective assumes that straight-edged objects from houses to cornflake packets are drawn as straight lines and that information from these objects

comes to our eyes (in the form of light) in straight lines.

Let us consider a vase. If we assume that the top of it is just below our eye-level you will notice that the ellipse has a very shallow, minor axis. The ellipse at the foot of the vase will be deeper in its minor axis due to the fact that you are looking down on it. This perspective would also affect any decoration encircling the vase. The difference in the ellipses is accentuated the closer you are to the object. The further away you are the less apparent the difference is.

There will be occasions when rectangular objects will need to be drawn — table tops, planters or support objects to your composition. These can present problems if your perspective is rusty or non-existent. Beware if you want to show several of these objects at different angles to each other. This is probably best left to the virtuosos.

For those who are a little rusty I have provided a few diagrams

which should help. Simply remember that all the straight lines emanate from points at your eye-level, unless the object is set square to you. If it is set square then you will see the front aspect as a rectangle parallel to the bottom of your piece of paper.

You may recall my references to aerial views in previous chapters. This gives rise to another type of perspective which we refer to as three-point. For example, you may have placed your group of flowers on a chair and want to look down on it. In this situation the legs, and the uprights to the back of the chair, will not be parallel to each other. They will appear to taper toward your feet. Imagine an aerial photograph of a skyscraper. The top of the skyscraper is much bigger than its base. Again the diagram will explain more explicitly.

The student is not alone in experiencing difficulty with this confusing science. Teaching it is very difficult. Artists through the ages have

Cottage fuchsias

This flower painting has inadvertently strayed into the path of perspective drawing. These fuchsias were seen in a cottage garden and I wanted to contrast them with the adjacent building. The perspective in this building, though slightly distorted, is simple one-point perspective. If you trace the lines in the heads of the window and to the left of the porch you will see that they converge at my eye level. The perspective is heightened by the fuchsias in the foreground being somewhat larger than those in the background.

Using perspective in this simple way can give great depth to a painting. Avoid using a straight edge to paint the lines as it tends to make the picture rather mechanical. Keep the lines and the brush work fluid to help it relate to the flowers.

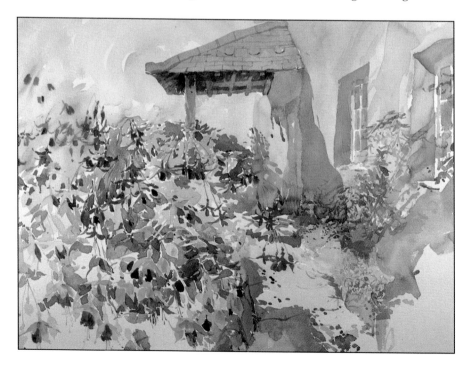

been evolving systems to attempt to simplify it. If you have a practical turn of mind, you might like to try one or two of the following suggestions based on some of these ancient discoveries.

The first is a relatively simple tool which will help you to set up some of your basic construction lines. It consists of a simple frame, or mount, made of acetate or something similar. Draw a grid of fine lines approximately one inch (25mm) apart. Fix this upright in front of you. The paper you will be drawing on should have a similar or larger grid drawn on it corresponding with the same number of lines across and down. Keep your head in a fixed position. Perhaps you can rest your chin on your hand and help your elbow stay in one position on the table. Alternatively, line up your eye from a fixed point on your side of the frame. All you need to do is draw what you see, using the grid for reference points. It takes a little getting used to, but remember a similar device helped Albrecht Dürer – that great German genius.

The other system involves a kind of camera obscura. For this you will need the same frame fixed upright on your drawing table, together with a large sheet of black material pinned all round the three exposed sides of the frame. This will act as a light-tight cape to your frame. The frame now has an infill of thick tracing paper or oiled paper. Arm yourself with a soft pencil and pull the cape over your head. You should see the image of your group illuminated on the tracing paper. All that is required is to draw it in. 'Cheating,' did I hear you say? Well, it was good enough for Canaletto.

There are all kinds of similar devices on the market which

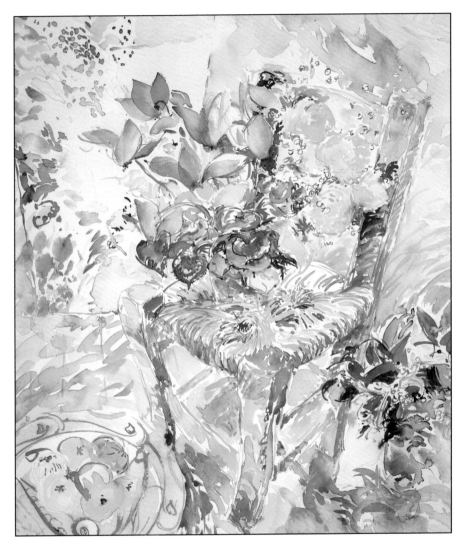

involve overhead projectors. They are used extensively in the commercial art world. The trouble is you have to be a rich, successful artist to afford them.

Another device, somewhat easier to construct, involves two mounts. They should be the same size, interleaved with a narrow, cardboard strip longer than the width of the mount. The two mounts are taped all round their outside edges. You should then see a rectangular opening with a strip of cardboard across it. This strip may then be adjusted

Flowers and chair
I deliberately positioned this chair to force the three-point perspective. I wanted a looming composition. As the lines spread out from a point below my feet the image of the flowers is thrust towards the eye of the viewer. Using perspective in this way can give greater drama to a composition. I have tried not to let the chair dominate the flowers, so I have enlarged their size to give greater emphasis.

to a variety of different angles. If you hold up this mount and look through it at your subject you can align the cardboard strip with whatever awkward straight line you have before you. You then lay the mount square on your artwork and 'hey presto' you have the correct angle.

All these devices are aids which will help produce artwork which reflects the world as we think we see it, and as the camera confirms it. There are other ways of seeing. Some are simple, others more complicated. I shall refer to them briefly in order to give you a taste of their rich variety and, who knows, one of them may give you the answer you are looking for.

Other Perspectives

All the above presupposes that we see life from a fixed point of view which freezes our perception into a moment of time. One of the reasons why many photographs cannot sustain our interest is because of this fact. When we sit down to do a painting it takes time, so unconsciously we absorb with our eyes subtle changes which take place in the scene during that time. When I look back at some of the sketches I have done on holiday and compare them to the snapshots taken at the same time I always seem to derive more pleasure, and for that matter more information, from the sketches. The photos always seem to have too much of not very much.

I, and many artists before me, have been aware of the fact that we do not naturally sit in a rigid position. In fact we move around, and our head turns and explores all about us. How can this be expressed? Well, surprisingly enough, the ancients and artists

from India and the Orient used devices quite different from ours which went some way to explain, or at least attempt to explain, this kind of moving viewpoint.

In early Japanese work, for example, they used a kind of axonometric form of drawing in which a rectangle would be expressed as a parallelogram. This resulted in a relatively high viewpoint which would enable the spectator to see more of what was happening on the ground, or table top. Sometimes they even reversed our notion of the fact that objects diminish in space. So instead of parallel lines converging to a point on our eye level, they opened out from a point behind the head. This resulted in some strange distortions which may appear odd to our eyes but it was perfectly natural to them. After all, your eyes will only believe what you have conditioned them to believe over a long period of time.

Artists from India used a type of 'rotary' perspective which attempted to put into one picture several different views. Imagine you were walking through a market and were viewing and sketching each individual market stall. If you then stuck them down in a line in the same order you saw them you would get an idea of what is meant by rotary perspective. Most of the ancients were aware of single-point perspective, but two-point seemed to elude them so they tended to combine axonometrics or isometrics with single point to explain as much as possible about a scene before them.

One interesting painting I saw by an Indian artist showed what he saw when walking around an oblong garden with formal pathways and plantings. He had used a single-point perspective view look-

ing in from each side of the garden. He then laid each view out on the paper in the form of an oblong to create a fourway view of the whole garden. When looking at the painting it is as though the garden goes right over your head. Sometimes in complicated garden paintings the artist will combine several perspective notions; single-point, parallel sided, straight elevation and just plain distortion where the sides of objects just go every which way.

Photography has also liberated another perspective notion. You might be familiar with the fish-eye camera lens which was so called because of its ability to emulate the sight of a fish. It is considered from the straight-line western perspective principles that our cone of vision (the included angle of all we can see with our head in a fixed position, although some people have a wider angle of vision than others) is approximately 60 degrees after distortion takes place. The fish we are told has a much greater angle of vision of up to 180 degrees and this is what the camera lens simulates.

The result of seeing the world in this way is that all straight lines get bent. You can test this for yourself. Stand in front of a straight wall. First look right to the far end, then left to the other end and you will note that the height of the wall is less than the height of the wall in front of you. This assumes the wall is in fact the same height throughout. You can only express this on paper by curving the top of the wall upwards and the bottom of the wall downwards. We call this type of view 'orbital' perspective.

I like it because it produces lines more in sympathy with plant forms and I can include more of my view into a composition. To understand

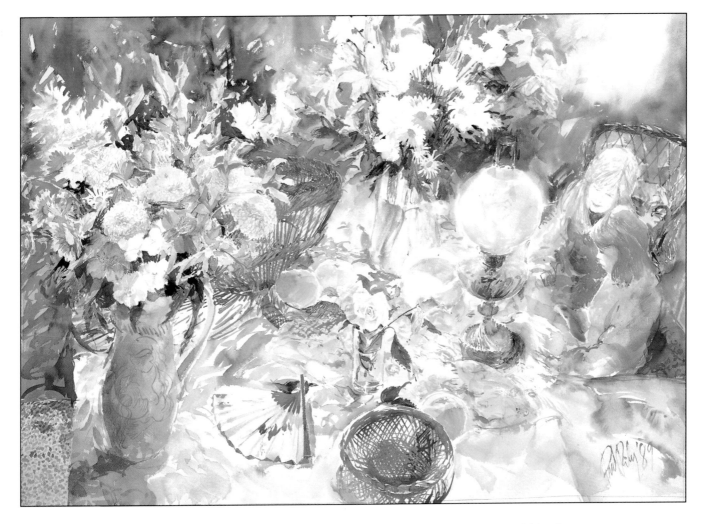

orbital perspective and how it works you need to study photographs taken with a fish eye lens, or an extremely wide angle lens. I have included a perspective grid that goes some way to explain how it works.

Simultaneous Perspective

The best way to describe simultaneous views would be if you were to take a camera with a standard lens (60 degree angle of vision) and take shots of various views of your subject. Take views looking down and straight at it. When the photos are developed you can then attempt to form a montage. Paste up some of the views to see what interesting aspects are best displayed. You may find you will have to do infill drawing to make interlinks between the various shots. It was this kind of simultaneous viewing that Picasso explored with his portrait heads and it resulted in the distortion which many people got so upset about. I do not think they will get so upset about applying it to flowers.

This chapter should give you much food for thought and may enhance your understanding of how other artists see and depict the world around them.

Lara and friend

I have used various perspective devices to overcome many of the problems encountered in tackling a subject of this complexity. In it there are various circular objects and their ellipses change in relation to my eye-level. In some instances, I have used a simple axonometric handling and in others a single-point perspective view. Depth is further implied by the diminution in size of some objects as they move back into the picture plane.

When the basic object of the painting is to create a rich tapestry of flowers and objects you can distort the perspective in any way you feel.

Ellipses

When beginners attempt to paint vases they encounter two problems.

Firstly, the ellipse at your eye-level is a straight line (shown by the horizontal red line to the right of the diagram). As the ellipse drops below eye-level it opens out, as shown by the yellow merging towards red. If you join three of these ellipses together to form a cylindrical shape you will see that the top ellipse is shallower than the bottom.

Secondly, when drawing a vase shape the tendency is to make it asymmetrical. You may avoid this by lightly indicating a centre line (shown by the vertical red arrows).

Take a series of offsets (the horizontal dotted lines) from the centre line to the side and you will find the symmetry much improved. Any decoration following the outside of the vase conforms to the principle of the opening ellipses.

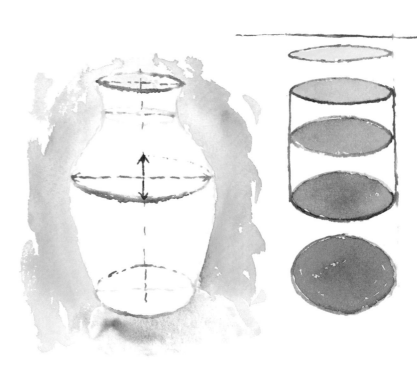

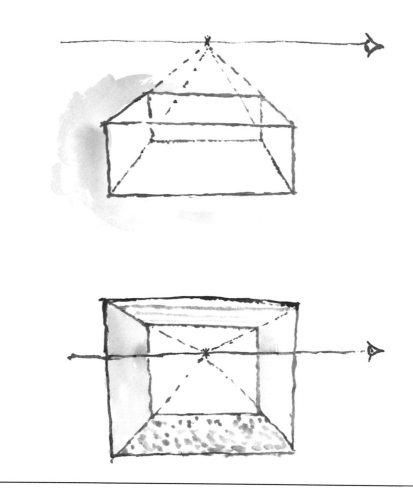

Single-point perspective

When I talk of single-point perspective I refer to the fact that all the lines which go away from you in space converge at a single point at your eye-level (shown here by the red line).

The top diagram describes the shape that would be produced if you were to draw a solid rectangular object standing in front of you. The basic principle is that the further away something is from you the smaller it is. This is demonstrated here by the fact that the panel of the box at the back is smaller than the one at the front. Set yourself a cardboard box on a table to observe this.

In the bottom diagram you can see what I mean by a single-point perspective with this view of an interior. The speckled section is the floor, the yellow is the two walls, and the stripes the ceiling. Assuming your eye-level is three quarters of the way up the wall, the sides of the room would converge to a point at eye-level.

Two-point perspective

In this instance a cardboard box has been set at a slight angle to the viewer. This results in all the lines converging at two points on our eye-level . The lines that reach these points are indicated by the numbers 1 and 2 on the red line. This kind of view is more obvious the closer you get to an object. Try this for yourself and see what happens. This view is achieved by looking down on the box and is similar to the two-point perspective you would encounter in a flower study containing rectangular objects.

Three-point perspective

To further enhance the effect of looking down on an object a method of three-point perspective is involved. Here we have the same two points as indicated on the two point perspective but this time the verticals also converge to a point below you. These are indicated in red numbers 1, 2, and 3. This kind of perspective is obvious when, for example, looking at an aerial view of skyscrapers. To get the same impression put a cardboard box on the floor and look at it from a slight angle.

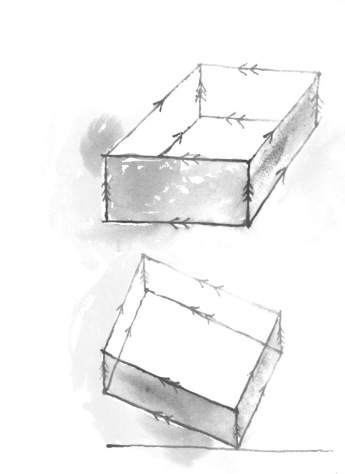

Axonometric and isometric

In this instance the front and back frame are the same size but the two sides go away from us at 45 degrees. This is a very simple way to render perspective and is perfectly legitimate when using simple objects in a flower painting. Early primitive painters often used this device before the advent of western style perspective.

In the bottom diagram is an axonometric view which sets the box at 30/60 degrees to a horizontal plane. Here all the sides of the box are parallel and give you an aerial view. Again this device is useful when doing a planned view composition.

Orbital perspective
An orbital perspective view is a somewhat exaggerated one. It enables you to see very much more in your field of vision (your field of vision is approximately 60 degrees without moving your head). With orbital perspective you are simulating the kind of view you would get if you used a fish-eye lens on your camera. Because these distortions produce curves it is quite fun to experiment with them in flower paintings. I have produced a basic network grid to help demonstrate what would happen to our box if seen in this way.

Rotary perspective
In this diagram I am demonstrating the kind of perspective that was employed by Indian painters, or the view that you would get if you walked past a series of views. What we have here is a linked series of single-point perspectives. These can be joined in any way to help describe a journey around a particular theme. Early religious painters used this device in forms of diptychs or triptychs when trying to describe different scenes assembled together.

AFTERWORD

I am sure that not all of us are going to be famous artists, but we are all artists.

In this book I have told you about all the tools I have at my disposal, both physical and mental. Not enough emphasis can be placed on the importance of research and observation. These acts are fascinating in themselves. We spend a lot of time chasing our tails, glossing over the impact that certain impressions have on us. To stop and simply stare may be considered a childlike exercise but I can assure you that the pleasure of seeing something new is as exciting now as it was when we were young. It is this newness or suddeness of vision that gives me the irresistible itch to pick up a brush and record it. Flowers in all their colours and innocence are so fitting for this purpose of looking. The more you look the more you see. The fact that they grow adds to the pleasure.

Painting the results of your observations is only easy if you are prepared to work at it. After all, a violinist needs to practice to be perfect and our job is no less difficult. You will find that by following the exercises in this book, and giving them a little time, your ability to produce particular shapes and effects will grow rapidly.

With regards to composition, play with it. Arrange objects and flowers and use your viewer, noting what looks good to you and what looks clumsy. You do not have to paint those experiments, just make pencil notes and jot down colour themes.

If you are stuck for ideas go to exhibitions, read poetry, listen to music. All these activities feed the mind. I find that after a long period teaching or painting I feel drained and need topping up. I go to the big city and look at anything and everything, museums, galleries, botanical gardens, concerts and people. I often walk in the countryside, soaking up not only the vistas but also the minutiae of hedgerow and undergrowth.

'Thanks to the human heart by which we live,

Thanks to its tenderness, its joys, and fears,

To me the meanest flower that blows can give

Thoughts that do often lie too deep for tears.'

From *The Small Celandine*
WILLIAM WORDSWORTH

GLOSSARY

Aide-Memoire
A memory jogger (a sketch or photograph).

Aquarelle
A pure watercolour without the addition of body colour.

Axonometric
A form of three dimensional drawing where a plan is set 30 – 60° then projected vertically.

Body colour
Pigments that have been rendered opaque by the addition of chalk white, for example gouache.

Camera Obscura
A device used by early painters to project objects on to paper so that they could be traced.

Chiaroscuro
The treatment of light and shadow to produce form and tone.

Collage
A form of art where photographs or pieces of paper or various materials are arranged and stuck down to form a pictorial surface.

Complementary Colours
Colours which harmonise and are opposite on the colour wheel, for example red, green, blue are complementary to orange, yellow and violet, respectively.

Contre-jour
Against the light.

Cross Hatching
A way of introducing tonal variation by using parallel lines of monochrome or colour. These lines are generally laid firstly at an approximate 45° angle, then overlaid with further lines at a steeper angle to produce a darker tone.

Cyanoblepsia
The inability to see blue.

Demi-jour
Half light.

Entasis
A device used by the Greeks to make their columns appear parallel. This involved introducing a slight convexity to reduce the visual illusion of concavity in the column.

Ferrule
Usually a metal sleeve enclosing the bristles of a brush and attaching them to its wooden handle.

Form
Solid form is expressed in painting by using tonal variations in colour.

Gum Arabic
A resin from various trees which is soluble in water and is used to bind pigments to the paper.

Hue
A colour or tint which is either a primary colour or a mixture of colours.

Local Colour
The true colour of an object, for example green leaves or blue sky, which is unaffected by atmosphere, reflected light or the mind of the artist.

Palette
A surface or containers used by painters for mixing colours.

Pigment
The basic colour constituent in paint before the addition of a medium such as oil, gum arabic and water.

Polychromatic
Many coloured.

Primary Colour
The basic red, yellow and blue. (Secondary colours are a mixture of two primaries, say yellow and blue to make green. Tertiary colours are a mixture of all three primaries and generally produce browns.)

Symbolism
A form of painting that attempts to ascribe ideas which have alternative meanings to objects and colours.

Resist painting
Using substances like rubber or wax which are insoluble in water to resist wet watercolour. Used for highlights and negative painting.

Splattering
Using a toothbrush or stiff hog-hair brush dipped in colour and then drawing the fingertip across the bristles to flick random dots of colour on to the picture surface. Areas may be masked off using cut out newspaper.

Temperature
In painting this denotes a hot (red) or cold (blue) bias in colours, for example orange yellow is a warm yellow.

Tone
Gradations from light to dark in a painting.

Tooth
The textured surface of paper (or canvas) which 'takes' the paint from the brush.

Wash
A layer of evenly distributed watercolour laid in a series of horizontal overlapping strokes.

Watermark
A papermaker's identifying mark, sometimes including the date of manufacture. It can be seen when the paper is held up to the light. It also indicates the face side of the paper. The side you can read is the side you paint on.

Wet-into-wet
A technique of watercolour painting which involves putting wet paint on to damp or wet colour in order that the two blend.

Wove
A type of paper finish, so named because of the method of manufacture. The screen from which the paper is couched is a woven mesh.

BIBLIOGRAPHY

The Artist's Handbook of Materials
& Techniques
by Ralph Mayer.
Faber & Faber.

The Craftsman's Handbook
(Il Libro dell' Arte)
by Cennino Cennini.
Translated by Daniel V. Thompson, Jr.
Dover Publications.

Monet: Nature into Art
by John House.
Yale University Press.

Papermaking at Home
by Antony Hopkinson.
Thorsons.

Lidové Uměni
by Jikka Staňková & Ludvik Baran.
Panorama.

Flowers in Art from East and West
by Paul Halton and Lawrence
Smith.
British Museum Publications.

Theory of Colours
by Johann Wolfgang von Goethe.
Translated by Charles Lock Eastlake
M. I. T. Press.

The Chinese Eye
by Chiang Yee.
Methuen.

Colour: Basic Principles and New
Directions
by Patricia Sloane.
Studio Vista.

Renoir, My Father
by Jean Renoir.
Collins.

ACKNOWLEDGEMENTS

Preparing this book has been an especial joy for me. It has also given me the opportunity to thank several people who have been instrumental to my development as an artist. Firstly, my wife Tina who has always helped me through the lows and shared the highs. Secondly, my parents who taught me the most about painting.

I would also like to thank Bel Mooney, Tim and Dorothy Dix, and Ron and Dil Travers who have encouraged me and my work in a very special way.

For help in writing this book I am indebted to Sally Christiansen, who typed, checked my spelling and edited with amazing speed. Also to David Porteous, my publisher, who showed marvellous restraint when dealing with an unruly artist!

Especial thanks go to Stephen Bond, photographer, who managed to keep a low profile whilst 'shooting' me at work, and to Ski Harrison, photographer, for her contributions to Chapters 4 and 5.

Also to Billy Kerswell for supplying me with flowers off season, and to Jilly and Pedro Sutton for their beautiful garden.

The paintings by the 'masters' which appear in Chapter 1 are through the agencies of the Bridgeman Art Library.

Several of the paintings in this book have been generously loaned to me by kind patrons and I thank them:

Ray and Pat Stannard, Paul and Pam Burdon, Gay and David Cranmer, Tim and Carolyn Brice, Roderick and Gillie James, Ski and Antony Harrison, Bill and Penny Martin, Louis and Yvonne de Grouchy, Mr and Mrs Dixon, and my dealer, Chris Beetles, for many of the paintings from the gallery collection.

Finally, the support of the rest of my family Mark, Antony, Lara and Mimi has been fantastic and I thank them with all my heart.

INDEX

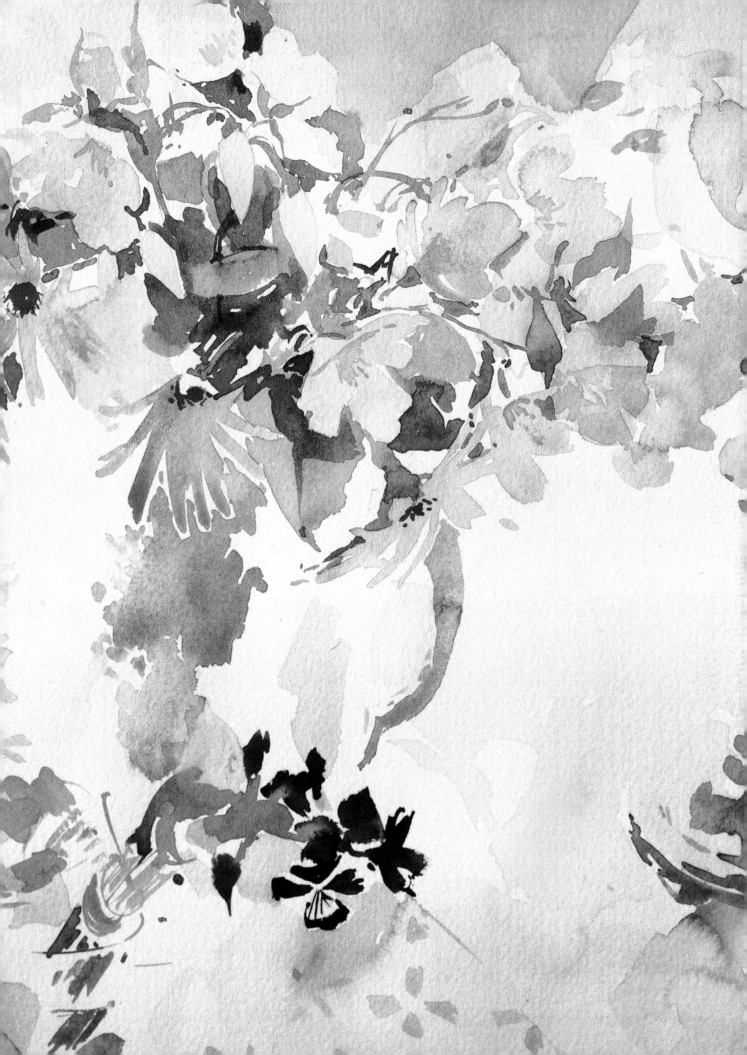